DOOMED

AND

FAMOUS

Adrian Dannatt

DOOMED
AND
FAMOUS

SELECTED OBITUARIES

Chiefly
of
Contemporaries

ADRIAN DANNATT

With Illustrations by
HUGO GUINNESS

sequence PRESS

Sequence Press
88 Eldridge Street
New York, NY 10002
www.sequencepress.com

C. P. Cavafy excerpts from *C. P. CAVAFY: Collected Poems, Revised Edition*,
translated by Edmund Keeley and Philip Sherrard, ed. by George Savidis.
Translation copyright © 1975, 1992 by Edmund Keeley and Philip Sherrard.
Reprinted by permission of Princeton University Press.

Illustrations by Hugo Guinness
Designed by Geoff Kaplan, General Working Group
Edited by Katherine Pickard
Copy edited by Rachel Valinsky and Kari Rittenbach
Printed in Turkey

ISBN 978-0-9975674-7-2
Library of Congress Control Number 2020906604

JUSTIFICATION du TIRAGE
This limited first edition is reserved for confidential circulation and
no other form of wider commercial distribution.

Distributed by the MIT Press
Cambridge, Massachusetts and London, England

For my mother & father,
Trevor and Joan

Bookes receive their Doome according to the reader's capacitie.
WILLIAM CAMDEN

Digression is the soul of literature.
HÉLÈNE CIXOUS

A plea for a life invested in preservation rather than destruction,
recognising that maybe strangely, creation and
preservation are all bound up with differentiation;
and destruction is all bound up with sameness.
FRED MOTEN

It is time we started narrating the periphery.
FOTEINI VLACHOU

PREFACE

"**B**UT this is my *obituarist*—he *has* to come in with me." Saying so, my friend led me through the velvet ropes of the most exclusive nightclubs of Manhattan. And it is true, for when he dies I will gather together the many details I have jotted down over the years about his extraordinary life, blotched notes from dawn bars and midnight wharf walks to write his story, one unlikely to be told otherwise; diamond smuggler, punk rocker, Tibetan motorcyclist. "I am here with my *obituarist*." There is a pleasure in the phrase, faintly ghoulish, slightly grand, your immortality assured by my patient presence at your side writing it all down on these old shards, scraps of foolscap, cancelled envelopes.

For decades I wrote obituaries for national newspapers, magazines, newsletters, websites, about people who would not normally receive such attention: the truly marginal, utterly obscure, mad, bad and definitely worrying. Actively avoided by others, many were dear friends or at least dangerous acquaintances. Penning a short-form summation of someone's long existence—though often my subjects led lives brief as they were intense—was difficult in one thousand words, and the real satisfaction was in granting unexpected gravitas, formal shape and a public forum to such otherwise chaotic beings.

There was something perverse or titillating in being a professional obituarist, as if I were chasing the dead, running after every random ambulance, waiting—scheming—for those I knew to fall off their perch. I make no clichéd claim that I was "celebrating life" rather than feeding off the deceased, because a stink of mortality drifts above the job like carrion, forever linked to the undertaker and the cemetery. Thanatos was my daily God. Here lies, blatantly, the lure of the dead and my own descent into this underworld, this tenebrous obscurity, to mine some deep structural connection between mortality, everyday existence and oblivion. As "the obituarist" I came to enjoy a little bit of dying daily, though to quote the poet Tyler Hayden, "Death spread over a lifetime incrementally is still death."

Unlike some obituarists I did not write my work in advance. It was not held on file, as in the case of my father Trevor Dannatt, a distinguished architect who at 100 had already outlived at least three of his own obituarists. My father's dossier was still regularly updated. I even had the pleasure of meeting a friend in St. James's, employed on the *Daily Telegraph* who jovially informed me, "Oh, I was literally just updating your father, good stuff." Perhaps there does seem something odd in a young man polishing up, refreshing and juicing the life story of someone three times his age as if owning or controlling it. Furthermore my father also wrote obituaries on occasion, and like myself, usually for friends and acquaintances. But these were of such an extremely different character as to be the polar opposite of my own, his subjects having been hard-working, long-serving, dutiful and upright citizens of utmost integrity. Only his old friend Finn Juhl — the famous Danish designer — had some crossover with my team through his penchant for stately homes and the drink, although his other great friend Edgar Kaufmann Jr. also shared some of my favoured traits such as highly-refined homosexuality and gigantic wealth. My father was wry about my preposterous peeps, claiming they were all really the same person. He even wrote his own spoof, an amusing parody included in this book for the eagle-eyed reader to detect.

I did not file my dead in advance but was aware when my interest in someone's life coincided with ill health or advanced age. And yes, there were occasions when I sat with an ancient Kabbalistic rabbi or nonagenarian snuff actress knowing that the notes I was taking, and anecdotes eliciting, would soon be used to fashion a written memorial. At times I did find myself irresistibly drawn to the very old or terminally ill, hanging around the eccentric star of the retirement home, the hospice guru, or lingering at funerals to meet the longest lasting mourner. "Get away you vampire — you're not going to *obit* me — I'm immortal!" Thus spoke my old director friend whose own movies were all about his refusal to die. As a British Army Guards officer, Olympic skier and Blues singer, he also

knew he was precisely my prey and actively fought my necrological curiosity: "I refuse to let you kill me, I'm not going to tell you another thing." And though I did of course write his obituary – *nail him* – a year later it did not stop my weeping, entirely genuine and not at all journalistic, at his wake. I loved my people in the rich oddity of their lives; their deaths were just a peg and hook, worthy of a pirate.

I was already collecting the living – hunting them down by going to visit them in distant bedsits or forgotten Georgian mansions before it was too late. But in some deeper sense they were already dead, turned to words, flattened, reduced to blurred newsprint as I myself, on the quest for immortality, had volunteered to become one of the dead already. "You have become a beautiful myth – a kind of unnatural uncomfortable unburied *mort*." Those were the words of Henry James to Robert Louis Stevenson, a figure counted amongst my collection, not only for the vivid liveliness of his writing, which I read to my children (my son named Louis in his honour), but also because he was a distant relative of my great-grandmother, an Stevenson from Edinburgh. One of those ludicrous points of extended family pride, but enough to have made Patti Smith cry. For as I admired the daguerreotype of RLS in her home shrine and admitted my own tenuous lineage she pleasingly replied, tears in her eyes, "of course I can see it – I see it!"

"Good for the obit!" became my mantra on hearing some unusually bad news, improbable catastrophe or odd demise. It might seem dreadful now – the sabre wound, Argentine abduction, our friend the philosopher forced to become butler to a rap star, that leg blown off in a hunting accident, overdose in Torino, the academic Arabist daughter turned *jihadist* – but it would make a damn good closing sentence. Death is less threatening when transmuted into amusing anecdotage, or as Isak Dinesen put it, "all sorrows can be borne if you put them in a story or tell a story about them." Everyone's life was eventually composed of paragraphs, openings and endings, rich fictive marrow, fine segues between early promise

and final disappointment, hilarious reversals, picturesque poverty. And I was there to jot it all down, stitch it back, boil down the mad decades to half-a-page.

"Bio" is "obit" backwards (almost) – it is only death which scrambles the letters of these near anagrams. Although regularly accused of promiscuity for knowing too many people too superficially, here I can only quote my grandfather, the writer Howell Davies: "A Welshman cannot be in the same room as someone else without wanting to know all about them." In fact the requirements for someone to enter my "collection" were stringent; I would speak to everyone, engage anyone on the street, but I was always searching for the secret ingredient, for the perfect mystery. It was not enough to be billionaire nor beggar, but required some combination of the two: to have failed or succeeded in a way that made such terms intriguing once again. A pretty face, maybe; but it should come with a resonant name and a backstory as improbable as romantic, the whole thing should sing and sing some aria yet unheard, wild and high. I was looking for someone who might be both a lyrical watercolorist and an international cyberbank thief and on occasion I was lucky enough to find one.

Admittedly there were far fewer female subjects than male, an imbalance reflected in the reality of published obituaries, including my own, and the writers of obits themselves, few of whom were women. Why do women not write about the dead? Of late much has been attempted to correct this disparity, especially amongst mainstream publications all too aware they employ only one female obituary writer, at most, and that their assignments had mostly

 always been that venerable White man, dead, of lore. Thus *The New York Times* undertook a valiant campaign to atone for this sin and feature as many important dead women as possible. But this had nothing to do with my case, my own "lack," as it were. Such publications sought to memorialize successful females of the most

consensual stripe, so as to counterbalance the male bankers, surgeons, politicians, lawyers.

These were the very opposite of the dead humans I hunted. I myself knew highly successful women in such careers, and was surrounded by many of the most ambitious and impressive. As it happened the first obituary I published was on just such a figure, Sandy Broughton, whose early death in America shocked her many equally flourishing friends. But for myself I would rather side with those avant-garde feminists who questioned fundamentally whether the male system of "success" was appropriate or amusing when it came to judging their own sex. My problem wasn't unearthing women of status and significance, but rather of truly independent oddity and singular scandal. It seemed the figures I sought—mired in poverty, perversion and poetry, or dedicated to disobedience and revolution—were rarely ladies.

Happily there were many examples of such fascinating females in history: Tina Modotti and Emma Goldman, Lee Miller and Annemarie Schwarzenbach, Unica Zürn and Ithell Colhoun, Afeni Shakur, Savitri Devi or Nina Hammett. But I met far fewer in my own life. So many of my female contemporaries, like the males, were disappointingly committed to easily identifiable, communally agreed versions of achievement. I lit upon the "art monster"—that now famous phrase of Jenny Offill—and pondered anew the clichés of male bohemianism: "My plan was to never get married. I was going to be an art monster instead. Women almost never become art monsters because art monsters only concern themselves with art, never mundane things." Reluctantly I began to suspect the urge towards destruction might in fact be gendered, that this death drive was inherently male, for in some metaphysical manner it is always the man who dies whilst the mother remains immortal. Women are on the side of birth, life, love; whilst I lingered, alone, on the other side of the rusty gates with my old boyfriend, death.

My perversion was not even really gerontophilia or necrophilia but the more fatal *marginalia-obscura*, a taste for failure guaranteed

to bring down its devotees to the same level of hunger and ignominy until the stain of destitution taints them, too, with its eternal black spot. I was interested in failure—albeit glamorous, heroic, handsome failure—because I considered myself a failure or wanted to be one. I did not love the dead but the living dead; those without the money, power, recognition or respect which for so many constitutes living. I loved the nearly and the almost, the-could-have-been contender, the friend of the friend of the great.

I loved the actor I met at a downtown party who recounted how he had won the part of Travis Bickle, he was going to *be* "Taxi Driver." But as he left his audition, triumphant, he passed the young Robert De Niro on his way in and knew instantly that the dark wing of history had passed its shadow over him, that his life would be otherwise forever. How many times had he told the story? Despite the pathos and tragedy of its trajectory it was still true, he had so *nearly* been Bickle and by extension nearly De Niro; his thespian victory, his movie star career still existed in some alternate dimension. These were my people, I sought them everywhere.

I liked con men and courtesans, radical revolutionaries whether fascist or Maoist; I liked African *sapeurs*, homeless nobles and penniless heiresses; I liked military adventurers fallen on hard times, anarchist bibliographers and B-movie matinee junkies, basement occultists, Midwestern Surrealists and Caribbean Situationists. Many of my chosen people were Jewish, but Sephardic rather than Ashkenazi, with exotic or preferably invented names suggesting their long exile from the fertile crescent—the warm Bombay days and Alexandrian nights. My people, whether Welsh or proudly Patagonian, ended up living in odd places with criminal records and fake identities, and spawning illegitimate children in defiance of time and convention. They rarely had formal employment and may have been spies. I disagree with Jean d'Ormesson who wrote, "*La mort n'est pas une anecdote*"—for me it was exactly that, anecdote upon anecdote, a rich *mille-feuille* of just such stories. In death everything comes together as one giant, cosmic anecdote.

My cast were cast from anecdotage itself. They did lots of different things and were never paid for them, they wove their magic from the margins, or beyond the margin in the vast white emptiness on the other side of the page, they cropped up as footnotes in biographies of others and appeared in old photographs beside the famous listed merely as "unknown friend." And they were all, of course, better versions of myself, if wilder, more magnified and potent examples; for we ourselves are never more than avatars or alibis for the dead who went before. My cast were also clearly that, members of a thespian troupe happily playing themselves, theatrical mummers trying on the role of a real person, and as such their strength was in their very fictive nature. Hence this book has attempted to avoid any hint of academia, the curse of footnotes and page references and accuracy, for it is intended to be closer to a novel – dream – than any collection of factual journalism. Those who live as footnotes require no footnotes to break the fiction.

Inevitably it was my own death I was writing about, rehearsing, mimicking. For to use the current terminology, I "self-identify" as one of the dead. When I wrote my first obituaries I was relatively young, aged 30, and though I naturally assumed death's rules and obligations were not for myself, I had already stood as precocious witness to a brutal swathe of mortality within my own generation. It still seems hard to reconcile with the consequences of AIDS, that so many amusing, brilliant, beautifully dressed friends died so young, so horribly. Even then it felt like some science fiction scenario or inexplicable dystopian fantasy which could not continue, and from which we would awake with a jolt, thinking: how weird, what a nightmare.

By 1993 when I published my first "professional" obituary I already had a legion of dead male friends, following almost a decade of systematic attrition, all young and from much the same milieu

as myself. But in my own immediate family there had also been the death of my grandfather, the aforementioned Howell, with whom I had been very close. Born in 1896, he served in the First World War, with the Royal Welch Fusiliers no less. He lived a long time, and I spent much time with him. But at his funeral in Highgate Village I remember thinking callously that this was normal or necessary. We all die; there was no fear, no regret. That was the stupidity of youth or rather the biological imperative that ensures the young remain immune to the reality of mortality. At the time I had none of the rage and hatred of death that Elias Canetti so bravely stoked. But like Canetti or E. M. Cioran I also pondered that other possibility, what might be termed the ultimate aristocracy of suicide.

Friends of mine killed themselves. A school friend's sister who I sort of loved and who I like to think sort of loved me accompanied me to an orchestral performance of Abel Gance's *Napoleon*; her head on my shoulder, I can recall the clean teenage smell of her hair even now. And we lay together on her bed in the old family house in Chelsea, in the same room where she later died of sleeping pills. Accident or suicide, it was heartbreaking. How young could she have been, not even 20? One of my best friends, a brilliant, tortured intellectual, one of those great brains who find it hard to navigate the normal world, Balliol scholar, linguist, *littérateur*, finally snapped and jumped from a tower block. He was 22, as was I. I took the call from his distraught mother and went to bed with Proust, Proust himself in bed also, the favourite book of my favourite dead friend. All I have left are the cards, written in tiny script with elegant deletions: "Switzerland 1985 — This is the fourth postcard I have embarked on. Generally rather depressed, but so far managing to convince myself Hari-Kiri can be postponed. Spent the day lying in the sun, going for walks, reading *The Way of All Flesh*, a good book but not calculated to lift gloom."

Or Lukáš Tomin that sardonic and cruel writer, a political exile from Czechoslovakia with whom I sat up all night talking death in Fitzroy Square, who once walked into Brasserie Balzar in Paris to find

me eating *poulet frites* and snarled, "Ah the English, wherever they go in the world it's always chicken'n chips." He returned to Prague and leapt off a cliff, I think, a decade older than the others at 32. But much as I mourned, I was aware of a certain steely glamour, the secret *chic* in the act of their self-assassination. Having already dead contemporaries when you are still young seems special and sophisticated. If the very term to "top yourself" implies a superlative, theirs was the top alternative to old age and decrepitude. And I myself, to paraphrase The Notorious B.I.G., was indeed, "Ready to Die."

Yes, I always liked suicides, preferring those who die either very young or very old, and likewise those who perish in improbable places, ideally having been received into some esoteric order. Naturally I spent a great deal of time in graveyards, small ones behind railway tracks or in the saddest suburbs, reading names and checking dates, zig-zagging after a good story amongst the mossy stones which stood like stacked index cards. I knew what I was looking for: a name, a poetic combination of syllables and vowels, or as Lawrence Durrell put it, "The name … had a curiously obituary ring already, though he was not as yet dead." Or there could be the grandeur of a title or some exotic zing which caught the eye, a romantic place of birth or death, the Arctic Circle say, expiring aged 101 in Montevideo or 22 in Macao.

I particularly favoured the forlorn Cimetière de Vaugirard where the annual event held in memory of Marius Plateau, the Royalist militant of *Les Camelots du Roi*, gathers a fine selection of sinister survivors of *l'Action française* who lurk about in mackintoshes and paramilitary riding boots amongst the misty tombeaux. Every love story should start with a funeral, whether *The Third Man*, *The Big Chill*, *Gran Torino* or *Passed Away* itself. For there is something pleasingly Greeneian about a graveyard, akin to the provincial funeral of some near acquaintance attended by the shrouded beauty (presumably the last mistress), the drunken outlier in an impeccable suit (surely the secret son), and oneself in darkest glasses seated way at the back, like a sort of spy.

I cannot go past a graveyard, war memorial, or any sort of inscription without automatically checking, jotting the names down. And there is nearly always one of interest, with some linguistic or biographical flourish. Here is Père Job Inisan at the spooky Art Deco Parisian church of St. Jean Bosco; or Arthur Isaac Smith, a very boring name who passed at 101 and somehow won the *Legion d'Honneur*, or Excelsior Algynon Newson, who died on August 29, my own birthday, both lying at sleepy Darsham in Suffolk. Nearby in the lost city of Dunwich I discovered the wonderful St. John "Jock" Horsfall with a suitably young date of death, at Silverstone no less. On looking him up that afternoon I saw, improbably, he was mentioned in that week's *New Yorker* as a racing car hero. The bucolic graveyard at St. James's Church also contains the tomb of a local woman who died aged 96 and her daughter, who I worked out from the dates was 68 and had died the day after her mother. Had she killed herself in grief? Maybe they had been in a car accident and the daughter, who was driving, lasted one night more? Or perhaps she had smothered her mother and then decided to die also? Or was it possible both mother and daughter were terminally ill and just so happened to die one day apart? A gravestone can be an entire novel, a mystery, a stone poem in itself—so much to be detected from so few words and numbers.

I always preferred unusual and exotic names, the sort held by only one person of extremely obscure nomenclature. This mad name-game extended to my own sartorial rules. I would only wear what had belonged to other people, ideally men of intrigue—in the widest sense—and would never dream of buying a new item of clothing *sans* provenance. This had begun with my grandfather's Sam Browne belt, tightened by the man himself out on the Western Front and now buckled with pride, in peace. How I regretted the loss of his helmet, pierced by shrapnel, though it would have been hard for me to sport on Civvy Street. At university—an all male

theological college notorious for its old-fashioned homosexuality and reactionary politics—there were others who wore such associative finery: one chap with the red tie given to his father by C. S. Lewis at Cambridge, where it was a signifier of communist sympathies; another with a moth-eaten coat supposedly worn by Christopher Isherwood on leaving for China.

As with my gravestones what I liked in a garment was a name, a place, and a date written on the label, proof that it had not been purchased off-the-peg; a concise story. To compound my perversity I would sometimes be given, or boldly request, items of clothing from those whose obituaries I had written. Thus the son of the Parisian-Cuban connoisseur Jean Claude Abreu generously granted me some prize items from his wardrobe including his hand tailored guayabera and a whisper-weight summer suit from H. Harris, the fabled tailor to JFK, with the inked-in date of 1961 rendering it both older than myself and *avant l'assassination*. Likewise from the son of Robert Velaise, a Swiss playboy and film producer, I had an actual hunting coat made by Huntsman, the proper old one, as ordered for a long Rothschild weekend, and Velaise himself was proudly Hebraïc, a religious and sartorial confluence worthy of Frederick Seidel. For the simplest item of clothing can suggest the outline of a life, to quote the great Arthur Machen, "I rescued the hat and gave it a glance as I went towards its owner. It was a biography in itself; a Piccadilly maker's name in the inside, but I don't think a tramp would have picked it out of the gutter."

Pushing it all ever further I even checked on those whose clothing I found at thrift stores and in rummage sales. Thanks to the digital miracle of the internet, I could instantly dial up each name stencilled or stitched inside a battered garment. My greatest triumph, a thick tweed double-breasted coat from 1939 turned out to have belonged to a Covent Garden *répétiteur* (that word alone worth the £14.50) of ambiguous sexuality, as I explained to the bafflement of the dandy who stopped me on the street in Milan to ask where it was from, before revealing himself as a member of the

Etro family. At the celebrated Bargain Barn of Sharon, Connecticut, I fell for a pair of plaid shorts, a snip at $4, and liked them even more for their blurred provenance, the name of Tavish Warde II. This I eventually realised was "Wardell" whose pleasingly WASP background included the Stowe ski team and an impeccable grandfather, Mason Beekley III, who graduated from Princeton in 1949, the forties being the most inherently preppy of decades. Mason lived at The Parsonage above New Hartford and left an eponymous library of skiing literature. And all that from some tartan cut-offs at the bottom of an old box.

From a perversely young age I was an avid reader of obituaries, cutting them out—often with the kidney and bacon scissors in my flag-stoned kitchen haste—and filing them away in my archives. Yet the ones I enjoyed most resisted just such filing, and could not be easily put into any one of my boxes, individually labelled, *Writers*, *Filmmakers*, *Artists*, *Military*. My favourites were those who managed to be all at the same time and none in particular. I also relished the impossible juxtaposition of different lives on the same page, the sheer variety of human existence captured in chance proximity. I recall a Neapolitan nobleman, the great historian of his clan who had published endless tomes, created his own genealogical library in his family palazzo and whose death was published next to that of a Midwestern divorcee

whose sole claim to fame was voicing the slogan for the infamous Wendy's commercial: "*Where's the beef?*"

But the mainstream obituaries were not enough to feed my voracious taste for oddity and obscurity. Instead I found myself reading the tiny columns of local newspapers and became a firm fan of school magazines, without need of any connection to the school itself. My mother, who went to Bedales, had no interest

whatsoever in her late contemporaries and binned the *Old Bedalian* as soon as it arrived, only for me to hook it out of the wicker basket and devote myself to its back pages. These proved particularly rich in bohemian and radical figures though often more Quakerish, do-gooder and vegan than my ideal subjects and very different, say, to those more rakish failures published in *The Trusty Servant* or the numerous narcotic casualties noted by my own school magazine, *The Elizabethan*.

From adolescence I had been a keen book collector, more hoarder than bibliophile, with a particular fondness for onetime bestsellers, from Sapper to Michael Arlen, Maurice Dekorba to Baroness Orczy, once household names now completely eclipsed through no fault of their own. Perhaps this taste led directly to my inability to bang out my own bestsellers or even a slim, limited-edition volume of verse, for I was too aware of the pitfalls of any literary career. If those onetime giants could be so utterly redundant—I thought often of the state funeral of Anatole France, once the most famous French man in the world—what chance did one have oneself, what was the point of even trying? I also loved the "little magazines," literary journals devoted to new talent where one could find the first short story of some modernist great and the brilliant work of others who at the time were so filled with promise their immortality seemed certain, just imminent.

Listed in the reviews, starred in the publisher's advertisements, singled out by Cyril Connolly, were countless exceptional first novels, dazzling tomes of essays, outstanding collections of short stories and so many others that were "best of…groundbreaking…unique…." All those classics-waiting-to happen never quite became classic at all. And how I relished the idea that these writers were still alive somewhere, in their 70s, on an island off Ireland, spending every long weekend at their crofter's cottage soaked in too much whisky—the downfall, the downfall—and too many of the same stories: Cambridge with Amis, teaching with Trilling, the

could-have-been and the roaring mornings, the warped boards of the first edition of "the defining novel of its generation" sat on its crooked shelf.

As if some ultimate pervert, all of these interests were allied: the haunting of tertiary auction houses in the quest for unusual works of art, forgotten names which only I might recognise, scouring newspapers for the obituaries of minor figures, hours spent in abandoned graveyards hunting names and dates. In the end it was all *death*, all my jotted scraps, archive files and boxes of cuttings filled with these variant notes from the dead. Enough of an amateur Lacanian to recognise the barely disguised *jouissance* of my own death drive I was trying to cure death by immersing myself fully within it, to ward off by some homeopathic *juju* my own demise, or the certain death of my impressively ancient parents. Gathering all this pointless data, this system devoted to obscurity and oblivion was somehow meant to reassure myself about my own inherent failure, my inability to hit liftoff. I would collect marginalia about the marginal, illegible traces of the invisible, so that I would not have to sit next to my father on his deathbed and say "I love you" without weeping. Death is embarrassing except when it happens to other people – and then it is fascinating.

Death is so terrible that it cannot be a cause of sadness, so awful that it is not worthy of anguish, it can only be ignored or defiantly celebrated with a cruel dandyish relish. It takes a certain type of superior human to cut death down to size, slice it fine with irony or disdain, like my friend Rob Bingham, a wealthy writer who knocked himself out of the race with a classic junk upper-cut in his early 30s. He was amongst the few who could manage such an early demise with a suitably dismissive élan. Of course every writer is in every way trying to outwit the thing; when he knew death was near, Albert Von Le Coq obtained, unbeknown to his wife, black-edged stationery and addressed envelopes to his many friends. In his memorial Paul Pelliot recalled the moment he opened one only to discover it was an obituary notice of Le Coq's own death.

Finally, *finally*, there are only a handful of eccentric resistants able to sneer at the obligations of extinction; decadents and Symbolists, Dadaists, absurdists and renegade Surrealists, those of almost superhuman black humour and diabolical *sang froid* strong enough to treat death with the coolness it requires, to outwit it, quite literally, with regal insolence. If you write a book about and for death, dedicated to death both as a topic and actual dedicatee, it may with luck guard its distance in respect of your homage; to write thus a "Book of Death" so definitive as to halt it in its tracks. We should believe that there is somewhere—still to be found or formulated out in the world, past or future—a single line of literature, a theological phrase or Talmudic incantation which might prove strong enough to overcome death, turn it away and bring it to its own end, here.

And may you visit many Eqyptian cities
to gather stores of knowledge from their scholars.

Keep Ithaka always in your mind.
Arriving there is what you are destined for.
But do not hurry the journey at all.
Better if it lasts for years,
so you are old by the time you reach the island,
wealthy with all you have gained on the way...

C. P. CAVAFY

ALEXANDER IOLAS

THE best art dealers all have a fictitious quality.[1] As if slyly tiptoeing from the pages of a novel, ideally long and untranslatable, their very presence, their mystery, their history is a rich mélange of whispered anecdote and cruel rumour, a life itself literally built of stories, some many-storied mansion of being. Alexander Iolas was the ultimate exemplar of just such an exotic existence, a literary construct so fabulous that even the most Baroque of prose stylists might feel obliged to tone it down a tad, an personage whose dramatic self-presentation was sufficiently extreme to still resonate today more than twenty-five years after his death, like a sort of nelly Big Bang whose long-range queeny shock waves are still vibrating, tingling amongst us e'en now.

Iolas is also representative of a whole historic generation of such personalities, dealers not just in art but carpets and arms, film producers, mystics, charlatans, confidence men and oil tycoons. All of these figures emerged magically from Central Asia and the Balkans, an Eastern Mediterranean stew of merchants and storytellers, a brew of Jewish and Armenian, Copt and Orthodox, Slavs and Tatars. This "fertile crescent" was of such cosmopolitan sophistication that charm and criminality came to seem almost indistinguishable as the fictional and the real commingled, creating such personalities as Gurdjieff and Mr. Arkadin, Armand Hammer and Alex Korda or Keyser Söze.

Iolas was born in perhaps the central capital of this potent culture, the fabled Alexandria of yore, a city whose mytho-poetic status is only rivalled by such other trading-posts as Trieste and Livorno, and like any great personality of that place and era he was, of course, born under an entirely different name.[2] Though still a young man Iolas was already demonstrating creative flair when he chose his new nomenclature; for "Iolas" in Greek mythology was

a Theban divine and even one of the Argonauts, those legendary voyagers who remain amongst the grandest of the grand.

Even more intriguingly in Greek history Iolas was the butler of Alexander the Great, his personal cupbearer, and as such a long-rumoured assassin of Alexander; implying, perversely, that one part of the name is the killer of the other, a perfect psychoanalytic paradigm for a man who was "his own worst enemy." Indeed with his adopted name, ambiguous nationality, and resolutely fraudulent date of birth, Iolas comes to seem like a floating signifier of the Old Orient itself, an ageless and stateless representative of a vanished world, his refusal of categorisation casting him as an avatar of postmodern identity.[3]

As a member of that fabled community, a Greek of Alexandria, the story of Iolas cannot but recall that very long and deliciously ornate novel, *The Alexandria Quartet*, and in fact it is entirely plausible that the character of Balthazar, a lovelorn adventurer, was actually based on Iolas, perhaps crossed with the more scandalous Scobie. Certainly the exoticism and above all heady romanticism of that novel captures better than anything the world in which Iolas grew up, a very specific and highly recognisable milieu whose citizens took it with them wherever far-flung places they went on the globe. A key figure in the book, its central ghost, is the poet Constantine Cavafy, a real person (whatever that might mean), who is not only seen today as a perfect representative of the Alexandrian Greeks but also as the symbolic embodiment of a specific homosexuality. As such, he shadows Iolas like some imaginary double, some uncanny doppelgänger made of verse and melancholic memory.[4]

This question of homosexuality remains key, not due to any current emphasis of academic gender studies, but because Iolas *loved* the stuff, loved, loved, *loved* it, indeed with Iolas it was never a question but always a statement. Being an homosexual in that world, the tightknit Greek family culture of Egypt, was a gigantic, fundamental, all-changing issue, something

of nonpareil significance and Iolas assumed the importance of this role with a lifelong magnificence, playing it to the ultra-max. Even at the end Iolas was actually loudly proud to have AIDS, not least because it proved he was still fully sexually active even in his 80s, and thus whilst many were hiding their illness, Iolas boasted it to everyone, putting him in the company of the most militant gay activists of that era. To quote Cavafy himself:

> When I went to that house of pleasure
> I didn't stay in the front rooms where they celebrate,
> with some decorum, the accepted modes of love.
> .
> I went into the secret rooms
> considered shameful even to name.
> But not shameful to me—because if they were,
> what kind of poet, what kind of artist would I be?

Back in his youth being a male dancer was immediate shorthand for an homosexual and Iolas had wanted to be one ever since he could remember, a natural "performer" in every sense who knew his destiny was to show himself, to show off before as wide an audience as possible, all over the world. It is impossible now to judge just how good a dancer Iolas may have been, some vicious rivalry having spread the rumour that his roles were less dependent on talent than on certain favours, but what cannot be denied is that he had a long professional career not just in Europe but the Americas also.

This is very important to remember, that Iolas had already enjoyed fame and fortune, already known adulation from packed paying audiences, already had his press clippings and his souvenir programmes, had already given out autographs and interviews, long before he opened a gallery. As such we should think of Iolas as one of those relatively rare celebrities who come to art dealing from an entirely different world, we should compare him to John McEnroe

or Italian footballer Jonathan Zebina, or Sir Elton John, with the difference that he went on to be the most important dealer of his era. Not only was Iolas exceptional in his abilities as an art dealer but he was also highly unusual in having come to it after a highly successful first career, without even mentioning just how dazzling and unique he appeared merely as a "personality."

All this is to say that even if Iolas had done nothing with his life, which by the inbred parochial standards of the art world means if he had nothing to do with "art," he would still be a character worthy of record, a figure immortalized in vintage photographs, oral history (a term Iolas doubtless would have relished), documentary films, a plethora of footnotes in other people's biographies, or a starring role in some renowned *roman à clef*.

Any figure of quite such extreme sartorial flair, such outrageous dandyism, and such brilliant wit and repartee, let alone such erotic notoriety, yes, anyone who can hold the salon spellbound in five different languages, is bound to carve their own niche in history. Yet the fact remains that on top of all this, on top of being so over-the-top, Iolas was absolutely one of the most important art dealers of the second half of the twentieth century. Forget the abundant anecdotage that surrounds Iolas, dismiss all the scandalous stories and comic reminiscences and instead acknowledge that he worked with, and helped create, so many truly major artists. This track record is almost preposterously rich, beginning after the Second World War in New York with the Hugo Gallery, which gave Andy Warhol his first ever exhibition, right through to the punk Paris of 1976 where Iolas was just as instrumental in the career of an equally representative figure, Paul Thek.

Having been intrigued by Iolas for years it was still a surprise, when visiting the Thessaloniki Biennale in 2011, to come across his eponymous donation to the local Museum of Contemporary Art and to realize that even if much of this collection was, to be honest, something approximating unsold stock, he had clearly worked with a far wider range of artists than I had previously imagined. Amongst

some fifty works on display were strong geometric abstractions by Roberto Crippa, sculpture by Mattiacci and the wonderfully named Novello Finotti, not to mention Warhol's 1981 screen print of Alexander the Great. On discovering quite how many highly diverse artists had exhibited with Iolas over the decades, it almost seems that *everyone* at some point had something to do with him. Certainly, for many, Iolas is associated with the Surrealists, especially Magritte and Max Ernst, yet there are also those who think of him primarily in terms of the somewhat faded glory of such neo-romantics as Eugene Berman, Bébé Bérard, and Tchelitchew. Produce instead such names as Beuys and Pino Pascali, Kounellis, Ed Ruscha, and Lucio Fontana, and an entirely different image emerges. What remains shocking is just how many people have never heard of Iolas at all, even in some of the more elite corners of the contemporary art world, as if his extraordinary career – not to mention persona – had simply never existed; "The Most Famous Dealer Nobody Has Heard Of." To have been the prime dealer of such aforementioned artists, to be the main-man for, say, just such talents like Warhol, Magritte and Ernst should surely grant some lingering reputation? But no. For it must be admitted that in the guessing game of posterity the art dealer plays with perilously low stakes. Thus even if the society portrait painter is usually the first to be forgotten in terms of art history, even the most successful gallerist comes a close second. It is curious just how rapidly and completely dealers vanish from the consciousness of even their most loyal clients and artists almost as soon as they stop trading; those names once constantly on the lips of *le tout monde* never spoken again.

And whilst the automatic amnesia of the contemporary art world has its obligatory corollary in the perverse pleasure of hunting up and reviving overlooked artists, attempting to make them stars once more, the dealer, once out of business, is punished for their absence, or their prior success, by a vacuum of neglect. Unlike his immediate contemporaries, and amongst the few dealers with

whom he could be compared, Leo Castelli and Ileana Sonnabend, Iolas did not have any long-time client such as Claude Berri who wished to make a film and a book about him, nor did he leave behind a collection of sufficient import to ensure a direct financial imperative to maintain his memory. Rather, being as mercurial and messy as he was charismatic and brilliant, Iolas hardly left behind any archive, and certainly no systematized inventory nor chronological list of exhibitions, which adds to the complexity (and pleasure) of trying to plot his life.

And even in the "new" art history in which the private collector and museum curator have come to assume almost equal import to the artist, the gallery-owner still lands oddly low in the academic rankings, as if presumèd wealth and good living in the glory days must be sadistically revenged by oblivion. But of course what remains of any of us? That is precisely why art and architecture ultimately exist, to leave some material trace of our existence, a physical representation of our presence. Perhaps the continued persistence of visual art, its curious survival amongst the devastation of every other form of commerce and economy, may be precisely because it exists as a tangible and unique object which can resist not just the historic obliteration of death but also the living-death of an entirely disembodied digital future. As all that was once solid—and as such can be traded as a three dimensional commodity—melts into air, into information, the sheer physicality of the artwork becomes the last graspable trace of those who made them, or traded them, or ever owned them. Those who have the money and will to buy enough of these things can be guaranteed their own eventual museum with their name attached, a gigantic actual object filled with more objects, representing their corporeal presence on earth long after their bodily vanishing. The question of survival is uttermost, in a way it is all that eventually matters, what we will leave behind, and how long we can extend the memory of our names artificially into the future when there are no longer any living witnesses to speak for us.

As such the purpose of this obituary is almost an exercise in cryogenic life-support, to try and capture just before it vanishes, just before the last friends and acquaintances go silent themselves, to conjour and recreate a truly extraordinary existence. And just as the current role of art must be symbiotically tied to changes brought about by the entire digital culture, so likewise this attempt at biographical exhumation, at summoning such a spirit from beyond the grave, is indubitably linked to issues of computer obsolescence, search engines, online archives, and cloud memory. Thus to conjure Alexander Iolas, a man who may well have been born in the 1890s, before the motor car, and plane, and radio, let alone computer.

Part of the enjoyment in assembling this memorial was to have to deal on a daily basis with people who did not necessarily have computers, nor iPads, nor Smarty-pads, for whom information and knowledge have an entirely different texture and music, for whom the library of books on the shelf and the single telephone on the eighteenth-century hall table will more than suffice. What they had instead were their own memories, available without any obligation to press "enter," the dignity of their own histories and the dignity of their own time. Somehow this came to feel like an unintentional investigation, an archaeological dig, into a last generation—one that every future generation will aspire to and envy precisely for what they did *not* have, for what they were not obliged to deal with.

The banal cliché would be to claim that "people like Iolas don't exist any longer" or that no contemporary art dealer could withstand such comparison, but even if that were true it would be too reductive and simplistic a conclusion. Instead might we suggest that here we are all gathered in this darkened auditorium, in the hush before the first bars of the overture, as ever, "Waiting for the Barbarians." And though they may well have already come amongst us, may in fact already rule us (for all we know), to quote Cavafy one last time, "What's going to happen to us without barbarians? They were, those people, a kind of solution."[5]

1. At the risk of self-plagiarism I first advanced such a line in an obituary for the late great art dealer Guillaume Gallozzi, a French-American expert on the more extreme backwaters of *tardif* Surrealism and Neo-Romanticism and himself a brilliant fictional construct as well as flesh-and-blood friend. Gallozzi was the first person to ever speak to me about Iolas who was high in his Parthenon of art world heroes, along with Julien Levy and Arturo Schwarz, and whom he regarded, despite Gallozzi's own militant heterosexuality, as a guiding kindred spirit. Any retrospective exhibition on Gallozzi's life and times and the range of artists he represented would doubtless, as with Iolas, require several decades to elapse. See pages 59–61.

2. At the risk of yet more self-plagiarism I first advanced such a line in an obituary for the cinema mogul Robert Velaise, boldly stating at the time that "like any proper film producer he was born under a different name." Other figures of a similar milieu mentioned in this obituary included the Hakim brothers, Emeric Pressburger and Rouben Mamoulian. I might well have added such delightfully named character-actors as Alexander d'Arcy, Akim Tamiroff, Eric Pohlmann and Grégoire Aslan. See pages 245–48.

3. To quote another of my own obituaries this resistance to the dreary formalities of time and place recalls the autofiction of Count Michael Florescu,

whose date of birth, name and nationality were all as he, rather than anyone else, so wished. A relatively youthful Genovese aristocrat, according to his own wishes, Florescu ended up as a gentleman-farmer and chef at his own private restaurant on an estate in rural Wisconsin, but as an art critic and antique dealer in Manhattan enjoyed an acquaintance with Iolas. See pages 249–50.

4. Cavafy plays a shadow role in the work of many artists, from David Hockney to Duane Michals. Leonard Cohen is another such Cavafy-quoter, and the song "Alexandra Leaving" a direct adaptation of his lyrics. As a longtime resident of Greece himself, and no stranger to the romantic, Cohen sung on occasion of a mysterious dealer whose mystique echoes that of Iolas. "And the dealer wants you thinking that it's either black or white, thank G-d it's not that simple in My Secret Life." Or thus: "like any dealer he was watching for the card that is so high and wild he'll never need to deal another."

5. This sense that we are already living under the "barbarians" is highly developed today, especially in the art world where everything is assumed to be inherently worse — meaning paradoxically, financially better — than it ever was before. As in Cavafy's poem we are all absolutely implicit in this secret longing for the barbarians, much as we suspect we may well be them ourselves.

Alexander Iolas, dancer and art dealer; born Alexandria, c. 1897–1907,
died New York City, June 8, 1987.

SANDY BROUGHTON

IN the milieu Sandy Broughton worked, the New York art world, precocious death has almost become the norm, but largely amongst men and her sudden demise at age 43 was a reminder of the larger rules of mortality. Sandy was at the time working for the BBC Late Show, but her entire life had been spent mining that curious interface between contemporary culture and the media, working with such a wide variety of theatre companies, performers, musicians and artists that to categorise her career by her last employment, or indeed to categorise her by employment at all, would be reductive or banal.

After studying at York University, Sandy worked with the Ugandan Resettlement Board in the early 1970s, at the time of peak immigration. She then began working for a string of theatres, starting with the Hampstead Theatre Club (the district where she was born), and moving on to The Bubble, The Unicorn and Stratford East, a roll call of the great alternative London spaces in that long vanished epoch when such venues had an integrity and importance now hard to imagine. Sandy's job titles may have been vague, in those more flexible times terms such as house manager or publicist covered a multitude of tasks, from walk-on parts to putting up tents, but she was never less than essential to the company's life.

In 1978 she began her long association with the ICA which would last until 1986, and where her role was loosely hinted at by her title of Publicity Director. In fact Sandy was vital to every department of the organisation and already seemed far too shrewd, too knowledgeable to fit the cliched notion of a publicist. Sandy wanted to work in television and did so, on the programme *Signals* and subsequently with the BBC, but her enthusiasm and commitment for the arts in general meant that whatever capacity she served, the end result was always infectious delight, in her company if not

always in that of those she was promoting. Notably droll and noto-
riously dry, Sandy was often funny about those she worked with
but never disparaged the validity and importance of their creativity.

Her life was devoted to the difficult task of convincing others
of the worth of the artists she chose, spending much of her time
getting others to support the more extreme avant-garde; she had
rare talent for a publicist, genuine enthusiasm for the arts in their
widest variety and remarkable intelligence. It is possible that her
talents were not fully exploited by encouraging the endeavours of
others, and certainly she seemed to be more of an artist or per-
former than many she represented. The range of her interests and
knowledge, her mordant wit, and vast range of friends led to the
paradox of not knowing quite what Sandy "did." Finding it hard
to believe she was a publicist, one assumed she must be director,
producer, programmer, curator. In fact Sandy covered all those
areas and it is significant that it takes eight people today to do the
job she ran by herself at the ICA.

Undoubtably her increasingly frenetic time at the ICA exhaust-
ed her, and was probably partly responsible for her first bout of
illness at the Cannes Film Festival in 1985. After spending some
months in hospital in Nice she returned to Britain for a brief con-
valescence and then yet one more job, this time in television. New
York was obviously Sandy's natural abode, a place where the level
of art activity was matched by that of the socialising, and where she
made as many new friends, acquaintances and contacts in her short
eight-month stay as any SoHo native. Sandy was very much part
of the British cultural diaspora to Manhattan, and it was hard to
imagine she would ever return to England, let alone in this manner.

I have two strong memories of Sandy. Of a night in Cherbourg
to witness a performance by Station House Opera, where the
physical exertions of the spectacle were nothing compared to
the ferocious arguments that broke out in the bar afterwards and
which, fuelled by Calvados, lasted till dawn. Throughout Sandy was
mischievous, witty, continually stoking the debate with her own

aperçus; however it was also only due to her presence that the long night did not end in violence. More recently I was with her at a lunch at The Barnes Foundation in Philadelphia where we found ourselves, entirely by error, sitting down to eat with the director of the Foundation, the director of the National Gallery and Mrs. Walter Annenberg. Sandy carried off the role of ambassador of British culture with great aplomb whilst at the same time playing out the full comedy of our incongruous situation.

Sandy had extraordinary energy allied to an almost boundless curiosity; her enthusiasm for the architecture of the new Holocaust Museum in Washington, DC as genuine and inspiring as her interest in some new acquaintance. That she chose to devote her talents to the promotion and dissemination of others' work without ever becoming cynical or bitter is a mark of character in this egotistical era. It is fitting that LIFT (London International Festival Theatre), for whom she did so much, dedicated a season of The Wooster Group – those archetypal performance stars of her adopted city – to her memory.

Sandy Broughton, arts publicist; born London, February 5, 1950, died New York City, June 20, 1993.

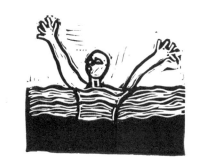

RAY JOHNSON

HE was once "New York's most famous unknown artist" but with his elaborately staged, inexplicable suicide Ray Johnson became notorious as the artist whose final, most important work was his own death. There is still no official verdict on why Johnson drove over fifty miles across Long Island in order to throw himself off a bridge at Sag Harbor, but in its place are hundreds of burgeoning theories, paranoid plots and underground conspiracies. By his suicide Johnson has become a one-man cult of daily expanding proportions and the most talked about artist in Manhattan, something he studiously avoided for decades. For though his collages and mailed art works have been shown in the world's most prestigious museums, Johnson deliberately refused fame and fortune. His off-and-on dealer Richard Feigen put it like this: "I don't know if his suicide was a final grand art work or not, all I do know is that he's now becoming very famous. For years I could never interest anyone in his work, now the phone rings ten times a day with people wanting to talk about Ray." Johnson's work was all about coincidence, parallels, punning connections, and he constantly made use of numerical and verbal games, to the extent that it is impossible not to imagine he was setting deliberate clues with the circumstances of his death.

Since his disappearance his friends, colleagues, collectors and dealers, as well as investigative journalists and art critics have been trying to untangle these potential connections, or possible clues as to what his death was meant to mean. Even the normally hardheaded Sag Harbor Police Chief, Joseph Ialacci admitted: "It's one of the strangest cases I've been involved with. I have been working on this ever since. The investigation parallels a homicide investigation – we were very thorough. It's like doing a gigantic puzzle." Johnson contacted several people the day before he died, including Feigen, who he asked if he would be interested in buying some of his best-known collage work from the 1950s. He also rang a fellow artist to tell him: "I have a new project, the most important one in my life, the biggest I've undertaken."

As an artist Johnson was enigmatic, elusive and impossible; he refused gallery and museum shows or would turn up and remove all his work hours before the opening, but he was collected by some of the most important modern American artists and considered by them to be of seminal importance. Indeed, his collages of Elvis Presley, James Dean and Marilyn Monroe were produced in the mid-1950s, before Pop art made such subject matter familiar and Warhol, who didn't paint his own versions of Elvis until almost ten years later, acknowledged him as a key influence as well as friend. But Johnson always shunned the fame and wealth lavished on his collectors, such as Johns and Rauschenberg, preferring to operate by allusion, intrigue and stealth.

Johnson had invented what is known as "Mail Art," whereby an artist posts objects, collages or scraps of poetry to recipients who may be other Mail Artists or total strangers with some connection to the thing sent. Despite having retreated into internal exile Johnson still had a vast network of Mail Art correspondents across the world, from which many of these elaborate theories on his suicide have been put into play across the global post. Shortly after his death, a postcard turned up at his house with an LA postmark, the date 1-13-95, Ray Johnson's signature and his own bunny logo

used on all his correspondence. The message ran: "If you are reading this, I must be dead." It could be a clue but is more probably a contribution to the enigma from one of countless collaborators linked by the postal service.

Johnson was 67, digits that add up to 13, and it was on January 13 that he drove from his home in Locust Valley, on the North Shore of Long Island, over to Sag Harbor at the extreme eastern end. He took several ferries on the journey, and in his belongings a ferry ticket was found with the time stamped on it, despite the fact that none of the ferries have stamping machines. At 5:30 p.m. he checked into Barons Cove Resort in room 247 (which adds up to 13 again) and after using the bathroom and lying on the bed he left after an hour and a half. Now outside his door a summer recliner sags with snow, and with all the lonely poetry of an off-season motel by the ocean. He parked his van in front of a 7-Eleven store, numbers which have subsequently been closely analysed for mathematical meaning, and more importantly opposite the Post Office, nerve centre of his art practice. At 7:15 p.m., two teenage girls were next to the Sag Harbor Bridge and heard someone fall in. They saw Johnson floating in the river though he made no gesture of distress and seemed to be trying to swim, nor did he shout anything at them. He was apparently at ease, as if casually bathing. The girls ran off and tried to find a policeman, with no luck, then told an adult who was far from interested. Forgetting the whole thing the girls went to the cinema — a supremely Johnsonian touch — and it was only the next morning that his corpse was seen out in the water although initially mistaken for a mannequin, which would also have delighted him.

Johnson left no note and no will, and despite living by himself in apparent poverty, $400,000 was found in various bank accounts. This money, and an artistic estate worth potentially hundreds of thousands of dollars, will be divided between ten cousins with whom he had no contact or correspondence, the latter very rare for him. Though the case has now been closed and a verdict of suicide

rendered, the mystery has not been resolved and all those who knew Johnson feel sure it was both made by him and designed to be decrypted. Everything Johnson did revolved around coincidence, numbers and puns, which makes the wild attempts to solve his suicide less crazy than commendable.

Once you enter into the game it becomes possible to read everything as another clue: "I want to die like an egg" was Johnson's motto, and it's easy to imagine that his entirely bald, shaven and gleaming head bobbing in the water must indeed have been very egg-like. Johnson lived in Long Island very close to Great Neck, made famous in *The Great Gatsby* under the name of Egg. In the context of Gatsby, who like Johnson made himself notorious through invisibility and social mystery, a link between Egg the place and Johnson the "egg-head" seems possible. One only has to recall the last words of the novel: "So we beat on, boats against the current…" hardly far removed from the image of a man in the tide of a river, arms beating.

These strained connections become conceivable only in the context of Johnson's work, a punster who made art out of coincidences in life — funny, bizarre connections without aesthetic or financial value just to amuse himself and like-minded friends. He would take a taxi across downtown Manhattan from Harbor Bar to Barbara Bar just for the sake of the pun or make a phone call at a certain time knowing that someone called Jay Johnson would answer, but never speak to him.

In fact the mysteries of his death have obscured the achievements of Johnson's life and early career, a textbook example of a twentieth-century American art star. He won a scholarship to the Art Students League in New York and from 1945–48 studied at the fabled Black Mountain College in North Carolina where he was taught by such modernist luminaries as Josef Albers, Robert Motherwell and Ossip Zadkine. His fellow students, who remained friends and collectors throughout his life, were figures who would transform postwar American culture: Jasper Johns, Robert

Rauschenberg, John Cage and choreographer Merce Cunningham. Rauschenberg in particular championed Johnson as a neglected young artist even when he continued to be neglected but failed to remain young.

In 1948 Johnson had his first solo show at the One Wall Gallery in New York City, and from 1949–52 he was a member of the key "American Abstract Artists" group, exhibiting with the likes of Ad Reinhardt. But beginning in the mid-1950s Johnson began to change direction, producing "moticos," small collages of ink and paint on news photos of emergent popular celebrities like Monroe and Dean, works way ahead of their time. He painted over a publicity photo of Elvis back in 1955 when he was still a new star. Johnson had also begun to use the US Postal Service, which would become the core of his art-making activity. He was also a key participant in early Fluxus, taking part in the now legendary concerts given in Yoko Ono's loft in 1961.

But Johnson was always a loner, opposed to movements and to the gallery system. When he set up The New York Correspondance (sic) School in 1963 it was a perfect means through which he could remain isolated outside any commercial context, whilst distributing work worldwide. Johnson would spend hours a day mailing envelopes containing objects or fragments he considered of some relation to the recipient. These works, with their decorated edges, franking and stamping, were either returned to him with additions, mailed on to someone else or well guarded. Almost everyone in New York of any cultural pretension seems to have their own private Ray Johnson collection, the paradoxical result of his being simultaneously reclusive and in contact with thousands of people daily. The correspondence that his school dealt with was obviously both in the sense of letters between people and correspondences between things, though often the punning connection between his letters and their receivers was hard to crack.

In his personal list of favourite things, number twenty-one is: "To mail a nail. There is nothing to compare with mailing a nail." In

fact Johnson would mail anything anywhere, nails being the least of it, live lobsters the most, as if pushing the postal service to the limits of patience and weight restrictions. Though the school had no rules he once sent out a list of people who'd been dropped from NYCS for infringements, and once he was questioned, to his delight, by a Lieutenant Johnston of the rival NYPD, about sending indecent images to a young woman. Johnson's activities were manifold and preposterous; he set up spurious Shelley Duvall and Paloma Picasso Fan Club meetings in empty galleries. When asked why the members had been gathered, Johnson explained it was just because he wanted to get a precise number of people in a room. To add to the mystery he would admit that the right number of people had, magically, not shown up.

Johnson claimed, "I deal in invisibilities and anonymities," and certainly managed to make himself both invisible and anonymous over the years. "I am interested in the art of greatest simplicity" was another semi-ironic motto, for if his mail pieces and wordplays and scribbled collages were indeed always very simple to make and to enjoy, with a childlike innocence and sense of fun, there was always a complex set of relations, hidden puns and connections buried within them. Likewise his death by drowning is a work of the greatest simplicity but seems to hide within it mysteries worthy of the Kabbala.

Ray Johnson, artist; born Detroit, October 16, 1927,
died Sag Harbor, January 13, 1995.

REZA ABDOH

RISKY work has special rewards but also its own inherent dangers and thus the death of Reza Abdoh, unshockingly premature at 32, from the callous *déja vu* of AIDS, concludes one of the riskiest theatrical careers of the last decade. Abdoh died in New York exactly a month before he was due to bring his company to Britain for the first time as part of LIFT (London International Festival Theatre), a visit much anticipated by cognoscenti of the louder, violent fringes of the extreme performance avant-garde.

In fact Abdoh had worked in Britain before, as a teenager, moving at the age of 12 from his native Tehran, and two years later joining the National Youth Theatre (NYT) to start directing. His subsequent move to America to study at the University of Southern California seems a smaller distance than that between the very traditionalist NYT and the productions of Dar a Luz, Abdoh's peripatetic company.

Influenced by a roll call of aggressively independent practitioners, from Artaud and Genet to The Living Theater, The Wooster Group and Pina Bausch, Abdoh created multimedia works on a scale closer to the megalomania and adrenalin crush of rock music than traditional theatre, always pushing his performers and audience into increasingly nasty corners and toward frightening choices, punishing all.

Abdoh moved himself and his nomadic tribe from California to New York, and on repeated blitzkriegs across Europe, performing in suitably derelict and physically dangerous venues: the ballroom of the condemned Diplomat Hotel off 42nd Street, the Meatpacking District after dark, an impossibly located loft *sans* fire regulations. Abdoh was a perfectionist, a closet martinet (in both senses) and a prodigiously gifted creator of visual and aural effects, coordinating bombardments of noise, physical energy and outrage. Taking

mythological and classical themes, from the *Egyptian Book of the Dead* to *The Hip-Hop Waltz of Eurydice* (1991), Abdoh fused and subverted them with deliberately shocking topics, mass murderer Jeffrey Dahmer living with Andy Warhol in hell, a grotesque caricature of a Jewish businessman exploiting slaves who were played by White actors in "Blackface" which according to Abdoh was technically illegal in New York, and sexual perversions of the most complex incestuous variety, illness, torture, a plethora of sodomy. Titles such as *Tight Right White* and *A Story of Infamy* only hint at the bravura thrills of Abdoh's productions, which took place amongst and *against* the audience, exploding every taboo with aplomb.

Though Abdoh's aesthetic radically opposed the sensibilities and sentimentalities of liberal humanism, even the Theatre of Cruelty must mourn the passing of one of its own.

Reza Abdoh, performer and director; born Tehran, February 23, 1963, died New York City, May 11, 1995.

GIL J. WOLMAN

THOSE who live by obscurity die by it also, so the minimal response to the disappearance of Gil J. Wolman is hardly surprising. Wolman led a brave, ferociously independent existence at war with the forces of contemporary conformity, the celebrity machine of the mass media being high amongst the accused.

Born Gil Joseph in Paris in 1929, Wolman was an active agent provocateur from an early age. At 24 he published a brief summary of his activities: member of the Young Communists, journalist for the magazine *Combat*, drug trafficker in the Algiers Casbah, long-distance lorry driver from Greenland to Pompeii, merchant marine captain, published poet and accomplished knitter. But Wolman's anti-career really commenced after meeting Isidor Isou in 1950, when together they developed the principles of *Lettrisme*, a radioactively nihilistic form of late Dada in opposition to everything that might be termed Culture (the capital C representing class interests) and status quo.

In February 1952 Wolman was part of a major scandal, mounting a screening of five films, including his *L'anticoncept* (1951), the first of his experiments in "cinematochrone," abolishing images altogether in a violent flurry of black and white strobes projected on a balloon accompanied by a very loud soundtrack of assorted noises. This was nothing compared to the film of his best friend, the agitator Guy Debord, whose *Hurlement en faveur de Sade* (1952) was dedicated to Wolman and resulted in police intervention.

In April of the same year Wolman led a systematic disruption of the Cannes Film Festival and was only saved by a police escort. Most importantly, that May, he founded *L'Internationale lettriste* with Debord in Belgium. At the end of 1952 he was under arrest again, this time for breaking through a police cordon to shower Charlie Chaplin with insulting pamphlets declaring, "Go home Chaplin."

From their Cafe Bonaparte headquarters Wolman planned other *Lettriste* attacks, including a rescue mission to liberate a reform school for young girls. Such attacks extended to André Breton, whose Surrealism they particularly disdained. Wolman's published letter to Breton ended: "You should shut it down and let your daughter look after her old dad. The Surrealist movement is composed of imbeciles or FORGERS."

Wolman's aesthetic innovations, films like *Atochrone* which reversed the cinematic process by breaking up a second into twenty-four parts or *Megapneumie* a sort of organic noise music, and his researches into new forms of painting such as the canvas HHHHHH, were part of a radical change in the arts, which, if dated and tamed by half a century, were vital to the spirit of postwar Europe.

More important were Wolman's collaborations with Debord, including the seminal *dérives* throughout Paris, walks that laid bare the psycho-geographic structure of the city. The *Lettristes* were much concerned with the nature of urban life, especially the detrimental effects of town planning, which they saw as an assault on the erotic and criminal vitality of the metropolis. At a time when progressive artists were supposedly committed to the "modern," Wolman published open attacks on Corbusier and his Unité housing.

Responding to an article on the planned demolition of Limehouse, *The Times* published this manifesto-letter from Wolman and Debord in 1955:

We protest against such moral ideas in town planning, ideas which must obviously make England more boring than it has in recent years already become. We hold that the so-called modern town planning which you recommend is fatuously idealistic and reactionary. The sole end of architecture is to serve the passions of men. If modernisation appears to you to be historically necessary we would counsel you to carry your enthusiasms into areas more urgently in need of it, that is to say, to your political and moral institutions.

Lettristes were ahead of their time in this critique of modernist planning, and their approach to the city as a site of negotiable personal experience with unclassified pockets of resistance has had a permanent influence on architectural theory and teaching. Likewise, the radical ideas of the *Lettristes* and their descendants, the Situationists, came to fruition in May 1968, as well as in the graphics, tactics and f-you aesthetics of punk, not to mention a horde of anarcho-squatter-travellers who live out the ideals of Wolman and his collaborators without having heard of him or his demise.

Gil Joseph Wolman, filmmaker, writer and political activist;
born Paris, September 7, 1929, died Paris, July 3, 1995.

PIERRE SCHAEFFER

IN the world of Pierre Schaeffer, experimentation and entertainment were synonymous; any division between the avant-garde and the everyday simply did not exist. Schaeffer was perhaps best known internationally as the inventor of *musique concrete*, among the most radical innovations of twentieth-century music, but in France he was better loved as the originator of *Les Shadoks*, a cartoon series still adored by every Gallic thirty-something. Born into a musical family in Nancy, Schaeffer mastered a technical understanding of radio early, working as an engineer for Telecom before setting up his own sound studio in 1943, when he began the series of radiophonic experiments that continued all his life. That same year he created a typical early work, *La Coquille a Planetes*, an eight-part series of fantastical sound battles between a voice and various monsters.

After the war he launched *musique concrete* with such masterpieces as *Concert de Bruit* (1948) and *Symphony for a Single Man* (1950), composed of real human noises; the latter became a ballet by Maurice Béjart and something of an international scandal. If this genre of musical innovation, with its emphasis on radio technology and primitive recording equipment now seems painfully dated, its offspring are still very much with us whether in the scratching of DJs or ambient house. The work of those such as Schaeffer in France and David Tudor in America vanished from high culture only to emerge in a rougher, more vital state in a range of popular music.

Whilst working for ORTF (Office de Radiodiffusion-Télévision Française) Schaeffer expanded his experiments with electronic noise in an attempt to create a veritable lexicon of all possible sounds, their sonic frequencies and their physiological effects on the human ear. In 1966 he published the book *Traité Des Objets*

Musicaux, which tried to evaluate a whole range of sonic effects, to reconcile the traditional world of occidental instruments with sounds created in the rest of the world by accident or human design.

In 1960 Schaeffer set up a research centre for ORTF, in which capacity he created the animated characters of *Les Shadoks*. Small birdlike beasts with serrated beaks, the malevolent Shadoks were accompanied by a range of comic, indecipherable noises, from shattering glass to mumbles and shrieks. Despite this enormously successful series and the equally renowned programme *Les Contours*, Schaeffer's research bureau was always under threat. When in 1974 ORTF was broken up into various other television chains, Schaeffer's laboratory was abandoned along with its vital archives, which he rescued at the last moment to create the Institut National de l'Audiovisuel.

Whether the image of his Shadoks hard at work with their mechanical pumps — for some reason they were continually pumping — or a concerto created with just the sound of a creaking door, Schaeffer's imagination and wit were a continual delight.

Pierre Schaeffer, composer and inventor; born Nancy, August 14, 1910, died Aix-en-Provence, August 19, 1995.

PHILIPPE THOMAS

PHILIPPE THOMAS ceased to exist long before he died. For before vanishing physically at age 45, he had already disappeared altogether from the art world, not due to neglect but rather as deliberate strategy. For if Thomas is no longer, works by such diverse figures as Marc Blondeau, Jacques Salomon and Giancarlo Politi are still in circulation throughout contemporary art circuits. These works, whether framed photographs, cinema clapper-boards, paintings of computer bar codes or a simple filing cabinet bear the names of real, living people, as cited above. Any time these objects appear in a museum or gallery the name of such a person is cited as the artist.

In fact all these objects were created by Thomas through a company he established in New York in 1987 called readymades belong to everyone®, a registered organisation which played a complex, clandestine game, pushing conceptual art to its limits. Anyone — collector, patron or museum — who bought a work from readymades belong to everyone® immediately became the "author" of that work. Hence in 1990 when advertising agencies were asked to come up with a campaign to promote readymades belong to everyone®, Leagas Delaney created a poster of a Van Gogh easy chair with the caption, "Become a great artist without the pain, anguish, and poverty."

Thomas himself infiltrated the art scene relatively late. He had studied literature and worked as a teacher before moving to Paris to join with two other artists to create the group IFP (Information Fiction Publicité), which used advertising photography to question the status of an artist's unique signature in today's fluid culture of mass imagery.

Leaving IFP Thomas developed "factionalism," influenced by, amongst others, the multiple-identities of the writer Fernando Pessoa, the invented museums of Marcel Broodthaers and the sly

style of Duchamp. In 1985 he exhibited *Sujet à discrétion*, three identical photographs of the sea's horizon, which changed intention according to the name attached, whether an *Autoportrait* by Philippe Thomas, or the subjective vision of whichever collector's name. In 1987 Daniel Bosser published his *Philippe Thomas décline son identité*, which meant that Bosser had bought the authorial rights of a book written by Thomas himself.

Likewise in 1989 when the Santa Fe collector-dealer Laura Carpenter published her *Insights*, she signed the limited edition but the maxims had been written by Thomas, whose name appeared nowhere. Thomas's most impressive exhibition took place at CAPC Bordeaux in 1990. Called *Feux Pâles* (after Nabokov's detective story told through footnotes) it included sixteenth-century *wunderkammern* and seventeenth-century portraits of collectors with their walls full of paintings, as well as Thomas's own — or rather not his own — creations. His name appeared only once in the exhaustive catalogue, as a tiny footnote.

Though he showed at Kassel's prestigious *documenta IX* and once in Britain at Tyne International, the very nature of ready-mades belong to everyone® ensured its operations were difficult to organise. For the agency to prosper it needed a gallery capable of finding suitable collectors in sufficient numbers, and explaining and disseminating the work without compromising its necessary anonymity. Thus the role of Thomas's gallerist in Paris, Claire Burrus, should not be underestimated in an appreciation of his work, and it was she who reunited a group of his collectors, that is to say his *creators*, his own artists, for the cremation of their alter-ego at Père-Lachaise.

Philippe Thomas, artist and theoretician; born Nice, July 7, 1951, died Paris, September 2, 1995.

GUILLAUME GALLOZZI

I F the best art dealers have a fictitious quality, Guillaume Gallozzi was very good indeed, and despite a precocious demise at 37, he is more worthy of a three-volume novel than 800-word obituary. As a Frenchman in New York, young Gallozzi was already at an unfair advantage when it came to cosmopolitan charisma but it was his social *savoir vivre* that made him altogether novelistic, a character out of an unholy collaboration between Jay McInerney and Henry de Montherlant.

Indeed if Gallozzi was better at being fictional than financially solvent perhaps his genius for good living interfered with any ruthless seller's instinct, not least because he was fascinated by increasingly obscure and overlooked artists. Though the demand for, say, 1940s Brazilian aeronautic drawings or postwar English posters was never extensive, least of all in Manhattan, being a friend and supporter of an expert in such areas was seemingly essential to Gallozzi's gigantic international social network, many from notably noble or wealthy backgrounds.

Born in the shadow of De Sade's Vaucluse chateau, Gallozzi was a flag-carrying anarchist schoolboy in Nantes, hometown to such kindred spirits as Jarry and Jacques Vaché. He moved to America in 1976 and after semi-clandestine activities in California

relocated to Manhattan. Helping set up Pravda, groundbreaking nightclub of the impresario Rudolph, Gallozzi was a central part of the late 1970s "scene," when as anyone of a certain age will admit, New York really was New York.

Paradoxically, as a dealer renowned for arcane twentieth-century European interests, Gallozzi first became famous, and fiscally expansive, with one of the most fashionable art movements of modern times: graffiti. Setting up one of the earliest graffiti spaces, where young Black artists lived and worked *in situ*, Gallozzi rode the crest of the graffiti wave, the energy of street kids and old world elegance making a lethal combination. As a graffiti gallerist he achieved celebrity and wealth, introducing the movement to the Basel Art Fair, creating a hip-hop spectacle for Valentino's 25th anniversary and even taking his "art train" around America. Despite never owning a credit card, Gallozzi maintained a series of anonymous accounts in Austrian banks, traveled in private jets and was long rumoured to be running an art-smuggling ring through the Italian lakes.

Graffiti was infamously short-lived and after building collections for optimistic Belgian and Dutch magnates, Gallozzi jumped as swiftly as everyone else, landing by chance at a magnificent row house on West Houston Street. It had been converted for Barney Rossett, founder of Grove Press, and had the likes of Samuel Beckett as houseguest. By now Gallozzi was dealing in Aeropittura, Futurist plane paintings, and British Neo-Romantics, not automatically lucrative areas. This connoisseur's approach to the byways of art history — the cultivation of neglected footnote figures — led Gallozzi's tastes to be described in *The New Yorker* as "old-fashioned, decidedly recherché."

Seven years ago his inoperable brain tumor made its first appearance. Left for dead at Bellevue hospital, surrounded by criminals, Gallozzi dismissed himself and borrowed enough for a Concorde to Paris whereupon he was immediately arrested for avoiding military service. Released with diplomatic assistance

Gallozzi was, seemingly, miraculously cured by a Parisian specialist to whom he dedicated his comeback show in Manhattan, *Metamorphose*. Later exhibitions ranged from Brion Gysin, cult kif avantgardist, to Steven Sykes, an octogenarian English recluse who had never shown previously, and whose World War II watercolours were subsequently exhibited at the prestigious Redfern Gallery in London as a result.

Under financial pressure from his landlord Gallozzi left his legendary townhouse, where he held a last benefit exhibition with donated work by more than twenty contemporary artists, including several portraits. His playboy features had undergone an interesting redefinition with the tumor, and was somewhat cross-eyed like Whistler's Robert de Montesquieu redone by Picasso. Forced back to France, Gallozzi made one last grand tour of Italy where he stayed every summer, often for months, with an extraordinary variety of collectors, artists, poets and aristocrats in a chain of seemingly inexhaustible generosity.

The flavour of Gallozzi's presence will be left to future social historians to reconstruct, the cork-tipped Craven A cigarettes in the fridge, tailor made Cifonelli suits and monogrammed Turnbull & Asser shirts. That they were other people's monograms adds to the mystique; his extensive wardrobe of handmade hand-me-downs donated by well-meaning and well-to-do friends. Muffled in a fur-collared coat, with bearskin hat and walking stick he was easily mistaken for royalty in exile — Zog, perhaps.

Of the mysterious, rich prose deployed in his catalogues he provided a final example, "Refusing galvanization into the Cemetery of Uniforms and Liveries, Gallozzi is cutting the ropes and going to peer at farther shores, driven by survival instincts, calling / riding the bright wake ahead."

Guillaume Gallozzi, art dealer; born Aix-en-Provence, February 11, 1958,
died Paris, Christmas Day, 1995.

BARBARA MCLEAN

WHETHER due to feminism or the triumph of trivia there has been an increasing fascination with the role of women in Hollywood, from the ideology of physical glamour to the practicalities of the technical work they have been reluctantly allowed to perform there. Barbara McLean, who died at a suitably mythic 92, was not only boyishly beautiful in a manner appropriate to the golden age of Californian cinema, she was, more importantly, a revered editor who perhaps single-handedly established the vital creativity of women in an otherwise unpleasantly patriarchal industry.

McLean was nominated for no less than seven Oscars for her cutting ways, finally winning the award in 1944 for *Wilson*. Without her film editing would never have developed into the female speciality or silo some might say it has become. McLean had an advantage in that she had been chopping and gluing since girlhood in her father's film laboratory in New Jersey, and when she moved to Los Angeles in 1924 she continued this paternalistic pattern by becoming the protégé of Darryl F. Zanuck, the notorious chief of Twentieth Century-Fox. In fact Zanuck relied upon "Bobby," as she was called by those who dared, for almost all his artistic decisions over several decades, and when he pronounced, "Bobby says…" it meant the matter was settled. Thus it was on Bobby's recommendation that Tyrone Power was hired for *Lloyd's of London* (1936) and became a star. Zanuck deferred to her opinion in every area of the business from costumes to composers and composition.

McLean was head of Fox's editing for over twenty years and personally edited all of Zanuck's projects, her dedication being legendary whether watching a film 100 times before making a final cut or spending hours on set noting the director at work. One of her regular collaborators was Henry King and when he was shooting *The Captain from Castille* in 1947 she flew down to Mexico

repeatedly to confer on the cutting, believing that a thorough editor should have seen a film's development all the way through.

Beginning in 1933 with *Gallant Lady* and *The Affairs of Cellini*, McLean went on to edit innumerable films, everything from classics such as *All About Eve* (1950) to the improbably titled *The Magnificent Dope* (1942). Amongst her last films was *Untamed* (1955), but far from being tamed herself, by old age or changes in technology, McLean only officially retired from Fox in 1969.

Whether her exceptional slicer and splicer's eye was inherited from her family or was due to her musical studies as a child which ensured she could cut a musical to the beat, there can be no contradicting Ronald Davis's description in his book, *The Glamour Factory*: "Creative, imaginative, and expert in her art, McLean was also quiet, efficient and cooperative." If that sounds like a patronising male qualification it seems radical by comparison with McLean's own theory on why women make better editors than men: "Because every woman is at heart a mother. A woman uses the scissors on a film like a mother would, with affection and understanding and tolerance."

Barbara McLean, film editor; born Palisades Park, New Jersey, November 16, 1903, died Newport Beach, California, March 28, 1996.

BRYANT HALIDAY

W HEN the black-cloaked figure of Death came for Bryant
Haliday this summer in Paris, he probably greeted him as
an old and profitable friend. For Haliday had made Death a star
across America as the distributor of Ingmar Bergman's *The Seventh
Seal* (1957), the first bona fide European art-house hit in America
and one which, like many other European classics, depended upon
Haliday's Janus Films for general release and target marketing.
Haliday not only created Janus, he also ran the 55th Street
Playhouse in Manhattan as a venue for their films. Without Janus
and its in-house cinema, some of the most important films of the
twentieth century might not have found widespread acceptance
and certainly the cinematic aesthetic of one New Yorker, Woody
Allen, would have been profoundly different.

Janus was created by Haliday with his business partner, Cyrus
Harvey, its name an homage to the differences between them—
Bryant being gay and Catholic and Harvey an Hebraïc heterosexual.
The company was behind the Bergman cult that swept American
campuses and Bohemian enclaves, a situation unimaginable in
today's dumbed-down culture. In the mid-sixties, Janus reported
that Bergman's films made up more than twenty-five percent of
their rental business and *The Seventh Seal* was shown on average
twice a day in the United States. As well as Bergman, Janus distrib-
uted Fellini's work at the height of his glory, from 1957 when he
first travelled to the US to receive his Oscar for *La strada* (1954) and
was stalked by his fan Burt Lancaster, through his third Oscar for
Best Foreign Film for *8 1/2* (1963), up till the party thrown for him
by Jacqueline Kennedy for the New York premiere of *Giulietta Degli
Spiriti* in 1965. But aside from such associative glamour Janus also
distributed a wide range of peerless European fare, from Ermanno
Olmi's *Il posto* (1961) to Antonioni's *L'avventura* (1960).

The seriousness if not existentialist Catholic bent of such films make sense in the context of Haliday's own upbringing at a Benedictine monastery in preparation for the priesthood. However, at 21, he decided to become an actor, taking his place with the legendary Brattle Theatre Company in Cambridge, Massachusetts, and appearing in more than fifty stage productions from the classical repertoire. Less classical in tone and, remarkably, refreshingly different to the quality of the films he distributed were the movies in which Haliday himself played starring roles. Producer Richard Gordon realised Haliday would be perfect for the main part of the insane ventriloquist in his UK horror flick of 1964, *Devil Doll*, definitely not to be confused with Tod Browning's cult classic.

After this role transferring souls into dummy bodies — perhaps a metaphor of his Janus work with American audiences — Haliday went on to play in several more zero-budget British horror films which came back later to haunt him in the graveyard zone of television scheduling. There was the faintly racist *Curse of Simba* (1965), followed by *The Projected Man* (1966), in which a scientist accidentally discovers himself brushing against Death (assuredly not played by Max von Sydow in this case). And best, or worst, of all was *Tower of Evil* (1972), which, in a desperate attempt at marketing — a problem Janus never had — was renamed *Horror on Snape Island* and then *Beyond the Fog*.

Having profitably sold Janus films, Haliday moved permanently to Paris where he continued acting, writing and producing for French television and theatre, albeit signally avoiding all demented doctor roles.

Bryant Haliday, film distributor and actor; born Albany, New York, April 7, 1928, died Paris, July 28, 1996.

KONRAD FISCHER

I F art dealers have always been fascinating—that delicious combination of large sums of money and larger cultural erudition—in the twentieth century they have become increasingly visible, nigh totemic figures. The more hermetic or enigmatic art becomes, the more crucial the gallerist, who not only has to be the first to understand and love the work but then must elucidate others about it, a task the artist may bluntly refuse; not to mention actually shifting the stuff.

Konrad Fischer, who died after a long illness at the depressing figure of 57 (more Heinz than Konrad), was the ideal modern art dealer, absolutely uncompromising in his own rigorous tastes and completely committed to actual artworks rather than anecdotal pseudo-biography or associative glamour. Just as importantly, he was awfully good at selling. With his gallery in Düsseldorf for nearly thirty years, Fischer was amongst the handful of figures who made postwar Germany a universally envied haven for contemporary art, responsible for a generation of enlightened collectors, generous museums and acquisitive local Kunsthalles. There is, of course, a notoriously competitive edge to the art world and though it might seem childish, the question of who-did-what-first looms large, placing Fischer as clear winner with an amazing capacity to understand and support new art as it emerged.

For example, in 1968 he gave Bruce Nauman his fifth ever solo show and his very first outside of America; and he also gave some of the earliest European shows to such artists as Carl Andre, Sol LeWitt and Lawrence Weiner, when such work was being made in illegally occupied industrial lofts and shared as a clandestine activity between a tiny circle of like-minded artists entirely outside mainstream media. Fischer would always be associated with these American artists, just as every important gallerist is always linked

to a specific period and work, but he was also an integral part of Germany's own art history.

Indeed his earlier incarnation as a painter—he studied at his hometown's Kunstakademie and exhibited widely under the name Konrad Lueg—was responsible for his ability to understand the process and intention behind otherwise difficult works, and to deal with the inevitable problems of artists themselves. In fact if he had never done anything else, Fischer's place would already be secure in the annals of German culture as a founder, in 1963, of Capitalist Realism alongside those two most important German artists, Sigmar Polke and Gerhard Richter. Capitalist Realism was a reply to American Pop but it was also very specifically German, mining that dangerous territory between the country's new economic prosperity and recent barbaric history; as if trying to reimagine the Cadillacs and suburban barbecues of 1950s America had it been responsible for the Holocaust just a decade earlier.

Whilst Polke and Richter developed slowly out of the deadpan, often mass-media derived paintings of their own mini-movement, Fischer realised that he was more interested in representing and promoting such works than actually having to make them, saving himself from the fate of a bitter, overlooked third of a trio. A Düsseldorf dealer he had previously exhibited with told Fischer he would make a perfect gallerist and in 1967 he opened a small space with a show by Carl Andre and began his long and consistently ambitious programme of exhibitions and related events, including the first solo shows of such artists as Hanne Darboven, On Kawara and Richard Long, as well as making the Italian Mario Merz a household name, albeit in German curators' houses. As well as his gallery shows Fischer curated some highly influential exhibitions, including *Prospekt* (1970) in Düsseldorf and part of the prestigious *documenta* 5 in Kassel in 1972.

The young artists he looked after slowly expanded their audience from a huddle of SoHo pioneers to an international database of collectors and museum goers. Indeed minimalists like Andre,

despite the reception of his "bricks" at Tate in 1976, now look increasingly like the representative artists of the seventies. Fischer himself is an undisputed classic gallerist of that period, whose devotion to the most rigorous art continued regardless of each artists larger reception or reputation; he would have shown them even if nobody else cared.

To quote Paula Cooper, an equally dedicated Manhattan dealer from the same era, "Konrad made you feel you should stick to your guns and carry on with what you wanted to do, that kind of independence is a dying breed for sure, it wasn't about money it was about art. Konrad was totally independent, totally about the art. He focussed on the art and the artists and couldn't give a rat's ass about the public."

Konrad Fischer, artist and gallerist; born Düsseldorf, April 11, 1939, died Düsseldorf, November 24, 1996.

MICHAEL BRAUN

THE launch of the *Titanic* musical on Broadway has already inspired a flotilla of showbiz folklore which the unexpected death of Michael Braun can only cap. Braun, found dead in his apartment on the first day of rehearsals, was prominently featured on the musical's advertising as one of its two producers, but if his exact role now seems ambiguous, it is nothing compared to the machinations of Braun's own mythic existence.

A Zelig of the counterculture, Braun might have copyrighted the phrase "Been there, done that." Whilst he had lived everywhere and seemingly met, interviewed or cohabited with every famous figure of the late twentieth century, he also had several specific claims to fame: he was The Beatles's actual "Paperback Writer," Roman Polanski's companion and comforter when that call from California confirmed Sharon Tate's murder, and the producer Julia Phillips considered him the most enigmatic, privately wealthy man in Hollywood. But he was also a homeless academic, penniless flâneur, and eclectic expert on everything from international finance to nineteenth-century English literature.

Braun was born in New York City, the son of a lawyer (subsequently never his favoured breed), and may have attended the prestigious Walden School though a Bronx high school seems more

probable. He had an affection for Ivy League education not necessarily dependent on his own attendance; for though he supposedly graduated from Harvard in 1958, that institution's records seem patchy on the point. Interviewing Black Panther Eldridge Cleaver in his African exile, Braun made clear his belief in the Ivy League's redemptive potential, repeatedly exclaiming: "You don't have to do this, you could still get into Harvard." Likewise it is not clear whether Braun's son attended Oxford, or exists.

What can be authenticated is that Braun first travelled the world as a cabin boy and found himself in London in the early sixties as assistant to Stanley Kubrick, who had moved there to make *Lolita* (1962) and *Dr. Strangelove* (1964). He then started to work as a journalist for *The Sunday Times* and *The Observer* at the height of their reputations, and in this capacity followed a new band called The Beatles on their first British tour. Braun became friendly with them and published the earliest Beatles book, the tour diary *Love Me Do!* (1964).

Remaining part of the British music scene and attendant Swinging London phenomena, Braun started working for Roman Polanski, though as always his precise office remained undefined. As a globetrotting writer Braun covered all the quintessential trouble spots of the era, from Vietnam to South Africa, Russia to Cuba, but hardly limited himself to war and revolution, becoming friendly with Borges and Nabokov as well as countless stars in the entertainment firmament. This led to his relocation to 1970s Los Angeles, a dangerous time and place for anyone genetically inclined to recreational narcotics. During that legendary cocaine decade Braun was busy, or not, with a quintessential project of the period, producing the film *The Secret Life of Plants* (1979). Stevie Wonder's score was described as "the most curious album in Wonder's career, ostensibly a soundtrack for a film few people saw, if indeed it was ever released."

Seventies Hollywood may now be the stuff of glamorous nostalgia but it was less constructive for those living there, and Braun's

health — not to mention reputation — was probably permanently dented by this epoch. Braun returned to New York, living by all accounts in a homeless shelter whilst fraternising with some of the wealthiest American heirs and pursuing his endless intellectual interests, Proust reading groups, political activism, or the structure and history of confidence tricks.

Braun had a strong attraction to those whose personal mythology was not limited by prosaic biographical fact. Jerzy Kosinski was a favourite, and some of his friends were, technically, blatant criminals. Leaving behind a tangled *tagliatelle* of contractual mysteries, including whether he was 55 or 60, Braun was buried in his ubiquitous sweat clothes surrounded by chanting Buddhist monks from his sister's ashram. Appropriately enough, several fistfights broke out round the body of this arch manipulator, masterful provocateur and "unknown legend in his time."

Michael Braun, journalist and producer; born New York City, April 28, 1936,
died New York City, January 27, 1997.

MARTIN KIPPENBERGER

THE contemporary art world no longer requires one to be talented, in old fashioned terms of skill, technique or sensibility, in order to be considered great and much of the blame or praise for this situation might be thrown at Martin Kippenberger who died at the aggressive age of 43 after a long, terminal battle with disco dancing, indiscriminate fornication and above all, drinking.

Kippenberger or "Kippi," took the notion of the bohemian painter and exaggerated it to ironic excess, pastiching, promoting not only Montmartre-style self-destructive hedonism but more importantly, his whole native German culture. Amongst post-war German artists angst was, not surprisingly, obligatory along with the haunting question of what constitutes Germanness after Nazidom. Whilst Beuys or Kiefer turned such issues into operatic, metaphysical themes, Kippenberger was the only one to honestly face the kitsch and commercial crassness of the New Germany.

Kiefer painted burning fields and imperial eagles; Kippenberger celebrated *würst* TV advertising, Heidi boutique mannequins, badly printed beer mats, Berlin kebab shops and lurid cartoon hangovers. His career can be traced from 1979 when he lived in Cold War Berlin and mounted such events as *Pisscrutch Action* or *Spying on Your Neighbour* followed by museum shows in Darmstadt in 1986 and seemingly everywhere else, simultaneously, thereafter.

His trademark sculpture was ye olde bent gas lamppost as seen in comic postcards of the fall-down drunk and in essence that was the core of Kippenberger's modus operandi, a man who made Gully Jimson seem teetotal. He boasted that he would rather be known as a drinker than artist and this wish was granted. Yet he was only trying to demonstrate a crucial element in German life overlooked amongst his country's puritanical economic miracle; indeed Kippenberger's oeuvre was an attempt to prove a whole set

of stereotypes, Teutonic or male, completely true. In this he was an important influence on countless young artists, not least celebrated younger British stars, stressing the importance of massive alcohol intake, all-night sociability and sundry bar outrages, along with aforementioned unimportance of the actual art.

That said, some of his work could be surprisingly fine, a series of watercolour sketches done on the paper of those expensive hotels he passed through, or trashed, expressionistic paintings hung as colour photocopies whilst the originals lay shredded in skips, a self-portrait in bronze standing in disgrace in the corner. That much of this work was produced by others, young artists he patronised and promoted by whim, or in collaboration with colleagues, only added to the ambiguity; as did his creation of a whole set of heteronyms, pseudonyms, imaginary artists and art groups. Thus he was founding member of The Lord Jim Lodge whose motto is "Nobody Helps Anybody" and even invented his own jive talk with which he would berate uncomprehending indigenous peoples the world over, usually as a prelude to a vicious fistfight.

Kippi, like all Germans of his generation, was obsessed with American rock'n'roll and had as many bands, stage names, record labels and limited edition 45s as painterly alibis. Anyone who saw him in action, ranting and raging, swinging his mike on stage at 5 a.m., could see his genuine, abiding star quality, a charisma which happened to have been diverted into art. In 1986 he bought a petrol stop in Brazil and christened it "The Martin Bormann Gas Station." In Venice, California he bought an Italian restaurant with express intention of serving the lousy pizzas he could find back in Germany, firing several chefs till finding one talentless enough. For a large show at the Museum Boijmans in Rotterdam he organised a performance in which he forced women to dress up and perform as American cheerleaders. None of their rara skirts or tops quite fit, emphasising the erotics of the pseudo-teenage display.

Kippenberger was consistently, gleefully, sexist, pugilistic, loud, obnoxious, cruel, autocratic, drunk or hungover. He was also,

thanks to the power of the German art world, often impressively rich and fat, but the more money he had the more willingly he spent it on parties, exotic travel, whores or yet another punk band. In terms of massive output, endless exhibitions, piggishness, drunkenness and Germanness, he was comparable to that other dangerous genius, Fassbinder, a comparison he would have hated, Werner being a "faggot."

If the list of Kippi's exhibitions is daunting—from 1993 at the Pompidou Centre to the recently opened retrospective at the Museum of Modern art in Geneva spanning 1976–1997, not to mention shows in private galleries all over the world—equally impressive was the resistance of the official German art world to this figure. Ironically, this summer he will finally be included in *documenta X*, the international show held in Kassel that he became obsessed with penetrating.

Kippenberger truly loved art and collected, accumulated and accepted as gifts or through osmosis the work of many contemporaries, not least organising the art on display at Berlin's pre-eminent hangout, The Paris Bar, yet he never pretended his own massive production was anything other than high-volume braggadocio. And that is precisely why he will be remembered as one of the most influential artists of the end of the twentieth century, for knowing instinctively that life, myth, publicity, will from now on be more important than any occasional elegant canvas.

Martin Kippenberger, artist-provocateur;
born Dortmund, February 25, 1953, died Vienna, March 7, 1997.

ABE FEDER

WHEN Abe Feder was "embraced by the light" last week he was probably highly critical of its effects, and future spectators of the afterlife's reputed glow may well find this ultimate special effect has been entirely re-designed by Feder in the interim. If anyone could give God advice on his celestial lighting it would be Feder, who from the age of 14 to his death had dedicated himself exclusively, obsessively, to the topic of illumination, artificial and otherwise, in so vast a range of applications that it could as well have been a different subject.

For Feder was not only America's first modern lighting designer for the legitimate theatre, both experimental and Broadway, he also became the country's most respected architectural and urban lighting consultant. Thus Feder's resume runs in two distinct columns: the hundreds of plays, musicals, dances and films he lit; and the buildings, stores, restaurants and public spaces he did likewise; both reveal not only an impressively long chronology, but also equal grandeur. Thus *My Fair Lady* can be matched by the RCA Building at Rockefeller Center, or *The Cradle Will Rock* with the Wadsworth Athenaeum Museum in Hartford, a parallel history of the most important theatre productions and buildings in mid-twentieth-century America.

Feder was born in Milwaukee and "blew his first fuse" on a school production, having been greatly inspired by a visiting magician, The Great Thurston, and his ingenious use of lights. Feder attended the Carnegie Institute in Pittsburgh, where he studied architecture, which in practical effect was what he practiced professionally, albeit using electricity and candlepower rather than brick or concrete. His sensibility and metaphysical intelligence were always closer to that of sophisticated architect than stage hack. Indeed considering the range of buildings he worked with, on, or in, and

the integrity of his solutions—respected by everyone from Gropius to Morris Lapidus—Feder could be seen as forerunner of those theoretical architects today investigating cyber-technology, electronics and other forms of "building" without traditional materials.

Still an undergraduate, Feder won praise from Paul Claudel himself for the novel lighting of one of his plays and was soon working professionally at the Goodman Theater in Chicago. Moving to Manhattan in 1930 he was almost immediately hailed as a precocious star, at the age of 20, the only independent lighting designer in America and in fact the first professional so-termed in the country. His avant-garde credentials were swiftly established with Gertrude Stein's "Negro Opera" *Four Saints in Three Acts* (1934), for which he consulted skin specialists on how Black pigmentation differs from White, resulting in his using more intense light to get a luminous quality to the faces. These specialised techniques would prove useful when he started his collaboration with Orson Welles at the Federal Theater, including the famous Black Macbeth for which he developed new gels and filters for Black skin. As part of the Living Newspaper Productions, Feder utilised radical techniques of projecting colour slides and film footage in lieu of painted sets, ideas adjacent to *Citizen Kane* (1941).

His most important production with Welles was *Dr. Faustus* (1937), where light first shaped the stage without benefit of sets, a job of such magnitude Feder moved into the theatre to live and was hospitalized for a breakdown afterwards. Some of this may have been occasioned by his ferociously antagonistic relationship with Welles and Feder's own notoriously short temper. By now known as "The Houdini of the Switchboard" or "genius of light," Feder became lighting director and technical director of all Federal Theater productions, some 200, including landmarks such as *The Cradle Will Rock* and Nazimova's *Hedda Gabler*.

In the war Sgt. Feder toured with *Winged Victory* and subsequently lit every major Broadway show from *Camelot* and *The Boyfriend* to *My Fair Lady*. The latter also resulted in a

groundbreaking court case that awarded him $500 in damages for the British version of his lighting plan, establishing a precedent for the importance of theatrical lighting design, and in the process revealing Feder was paid almost twice Cecil Beaton's set design fee.

"Theatre is the most wonderful training possible for this profession, but how can you get excited about a 50-foot stage after you've lit a 50-storey building?" Feder commented of his increasing architectural commissions, spearheading the postwar discovery of public lighting. The United Nations, the altar of St. Patrick's Cathedral, a JFK terminal, the Bronx Zoo, even Buckminster Fuller's first geodesic dome, Feder was always ready to "Push back the darkness!" For the Rockefeller he used 50 million lumens from 342 tightly focused lamps hidden on nine buildings to cast no shadow; these lamps had been built to order by General Electric, his instructions even including which chemicals he wanted in the vapors. For the Pan Am building he deployed 206 incandescent bulbs with pencil-like beams mounted on the surrounding rooftops, proving his motto: "Lighting is the only design material that can fill space without blocking it."

In everything from the 1949 corset department of Gimbels to luxury Transatlantic liners, Otto Preminger's Manhattan residence, the gigantic Lincoln Mall in Miami, or the deployment of brass mesh and fluorescents to simulate sunlight in his own kitchen, Feder was both technical, practical expert and abstract metaphysician. He was directly responsible for ten different new types of light bulbs, not to mention a column in *Women's Wear Daily* on how to encourage retail trade through lighting techniques. At the same time he always emphasized, "thinking in light is something essentially independent from the physical means of carrying out those ideas." This was a man who had to turn down the San Marco piazza in Venice and Jerusalem's Wailing Wall for lack of local resources and could not eat under ugly restaurant lighting; his passion and expertise knew no boundaries of scale or curiosity. "Lighting by Feder," the famous trademark name of his company,

may be no more—but how appropriate that his death should have been honoured by the early extinction of the lights at Rockefeller Center and the Empire State Building.

Abraham H. Feder, lighting designer; born Milwaukee, July 27, 1908, died New York City, April 24, 1997.

JAMES LEE BYARS

T HIS *is a Call from the Ghost of James Lee Byars* was title of a 1969 performance by the eponymous artist but considering the variety of mediums he employed, this obituary too might well be a posthumous "last call" from a maestro of occult implication, who had also declared, "publicity is the content of this exhibition." Byars had been anticipating, celebrating, forestalling and forewarning his recent demise at age 65 throughout his career, death being one magnetic pole of his oeuvre, the other beauty or perfection. After all, Byars set up a "death lottery" in the seventies, he tried to mark his own death in advance, invited Dalí to Hollywood to film his death and many of his works used death in their titles, if not ghosts and spirits.

Byars's other most favoured term was "the perfect," and in 1984 he performed *The Perfect Death*, walking in a large circle outside the Philadelphia Museum of Art whilst a Tibetan monk sounded his long, traditional horn. But Byars's own real death was in its way just as perfect; he expired in the Anglo-American hospital in Cairo, a well-chosen venue to convey the exotic, slightly old-fashioned and inherently romantic flavour of his existence and work, the two having been long inseparable. Suitably enough it also has a synchronistic frisson: in 1989 he went to Cairo to collaborate with two other artists under the pseudonym "Johnny" and created the text *Egyptian Secrets, or Johnny Investigates the Afterlife* which was published by *Artforum* in May of that year, the very month he died.

It would be hard to encapsulate the meanings and methods of Byars's art, which involved the simplest of objects with profound metaphysical implications often reliant upon context—the neutral, reverential spaces of the art world—to convey their full potential for meaning. Like many postwar artists Byars used

fragile, or weak, materials for his art; the deliberately ephemeral and transient including thoughts, questions and kisses, refusing to limit art to the production of objects for display. However, like surprisingly many such artists, as he grew older the concepts and quests seemed to become embodied by increasingly solid, three-dimensional and elegant physical forms until they ended up looking suspiciously like traditional *objets d'art*. Thus Byars was latterly known for his signature blocks of polished white marble, which though they might have names such as *The White Step* or *The Figure of Question* looked indubitably like sculpture, as did the series "The Path of Luck" carved from blue African granite. This is a familiar journey, from conceptual purity and anti-materiality to large scale, formal art objects, a trajectory often subconsciously driven by market forces, but Byars had been lucky enough to have sufficient patrons to hold out against the necessary creation of "things" for a surprisingly long time. These patrons were another typically anachronistic, aristocratic element in his life, lived halfway between that of Buddhist beggar-poet and eighteenth-century court artist, lingering in others' villas, sleeping months in a friend's hallway, a chain of hosts across the globe rewarded with enigmatic traces: a folded pile of blank paper, a word on a petal, as evidence of his stay.

Byars's style was apparent early: trading toy guns for silk socks with classmates; removing the windows, doors and furniture of his parents home to display large spherical stones for just one day; showing sculptures at midnight under a full moon in the snow, whilst pulling the invited guests in sleds. His first patron was a Detroit Greek called Mr. Softi, for whom he created a two-week garden including tons of white sand and a goat with golden chain. The neighbours were so impressed they offered the 25-year-old Byars a one-year travel grant to go wherever he wished. Thus it was that from 1958 until 1967 Byars lived in Japan, studying traditional arts and crafts, and creating his first performances involving out-of-scale folded papers; some of which he installed

in the emergency stairwell of MoMA in New York, only for a few
hours. Zen and Noh were obvious influences, as much as the bur-
geoning performance and Conceptual practices of the sixties, his
trademark appearance in gold or black suits with top hat and full
veil or blindfold, silent or repeating a single word, was part hippy
fantasia part Oriental ceremony.

His sense of the theatrical, the photo-op, was paramount
whether having a Catholic nun in full habit unfold *A 1,000-Foot
Chinese Paper* (1965) or being ferried by gondola across the Grand
Canal in gold suit and black blindfold. His early actions were as
varied as his costumed persona— courtesy of his Asian tailor Mr.
North South— was consistent, but they were always a blend of
poetic and dramatic: closing a stretch of Fifth Avenue to be driven
past the Guggenheim in a taxi at one hundred miles-per-hour,
ringing Alain Robbe-Grillet to exchange a prearranged thirty-sec-
ond silence, getting members of the Metropolitan Museum to gild
the curb in front of the museum or creating his famous "dresses"
for two to five hundred people, the latter worn round 65th Street
with Shere Hite leading the procession.

Byars was always interested in philosophy and specifically in the whole idea of questions; scattering tiny scraps of white paper imprinted "O?" from a rooftop, traveling to Oxford to discover what questions persisted in the Faculty of Philosophy, and setting up the World Question Center, broadcast live on Belgian TV in 1969, for which students telephoned famous intellectuals to state what questions they were asking themselves. He was even granted residency by the Theory Department of the European Organisation for Nuclear Research in Geneva.

Byars moved to Europe in 1972 and made it a primary abode for much of his career despite difficulties aroused by his earlier attempt to become "Artist of the Pentagon" which led to accusations that he was sponsored by the CIA, probably due to his always mysterious means of financial support, patrons, friends and anonymous benefactors. In Germany and later Venice his aesthetic met its ideal context and he realised some of his most potent works: standing on the pediment of the Fridericianum at *documenta 5*; whispering to Josef Beuys through his veil; or displaying *The Holy Ghost* (1975), a gigantic cotton sheet in Piazza San Marco. Particularly notable was the 1976 *Play of Death* where Byars reserved all the first-floor rooms of the Dom-Hotel in Cologne. At midnight the shutters were simultaneously thrown open by Byars and twelve doctors or others who worked directly with death, all dressed in black, a performance that much later influenced the famous Chanel Égoïste advert by Jean-Paul Goude.

Thus Byars lived art, whether in his Venice pensione rented by the year, or residences in Bern, Los Angeles, Florida and Santa Fe, starting the day writing letters on his collection of handmade papers or dried leaves, gold and black calligraphy on black-edged funeral cards, occasionally creating actions such as one at a villa where he simply appeared briefly on the distant horizon of the garden. In 1982 he visited the Furka Pass in Switzerland, open only 100 days a year and in gold suit and top hat placed a drop of black perfume in a small depression on a boulder, returning there

the next year to greet Beuys, seen in silhouette on the mountain peaks before vanishing in mist.

Titles of Byars exhibitions such as *The Elegant Show*, *Beauty Goes Avantgarde*, *It's Gotta Be Beautiful*, or *Stealing Diamonds* make clear his interest in beauty, long unfashionable in contemporary art and now back in favour. But clearly Byars was outside the local concerns of contemporary art, his clandestine, fleeting appearances in full costume, his rich patrons and enigmatic, expensive objects making him so highly improbable as to be obligatory. In 1978 he exhibited a huge marble slab engraved with the minuscule text, "I Am Imaginary." Whether he was or wasn't, James Lee Byars created a resonant lifelong masterpiece from just such ambiguity.

James Lee Byars, artist; born Detroit, April 10, 1932, died Cairo, May 23, 1997.

SARAH ANN HORSEY KLEIN

SARAH ANN HORSEY KLEIN was the quintessential English romantic, her history representative of a whole generation of Anglo-Saxon women caught between bohemia and good breeding, exotic fantasy and reality, the life of culture and necessity of commerce, and sadly her early death from cancer was equally typical of too many gentlewomen of her age. Klein seemed to have emerged from some distilled essence of English fiction, a mélange of A. S. Byatt and George Eliot magi-mixed with *The Golden Notebook*. As artist, writer, hostess, mother and Zionist she embodied the ideals and disappointments of liberated postwar women whose attempts at true independence were hampered by domesticity.

The Horsey family appear in *Tess of the D'Urbevilles* as impoverished Cornish aristocrats, already ruined back in 1873, and a certain elegant hauteur, or grand disdain for the banalities of reality came with such heritage. Born in Hertfordshire to a mother who was both professional pianist and swimmer, Klein's peripatetic childhood was due partly to the Blitz and partly family circumstance. Suffice to say she ran away at 16, was a student at St. Martin's School of Art by 18, and as rapidly married. Her husband was eighteen years older and already married twice. Peter Otto Klein was a Czech Jew from Most, smuggled out with his first wife and son by the Quakers in 1938. He had tried to open a kibbutz farm in the West Country, been wounded by mortar fire during the Normandy invasion, divorced, remarried an Hungarian Princess and became an art student once again. Soon after this third marriage in 1957 he gave up painting and burnt his entire oeuvre, the only works surviving some prints made back in Prague during the 1930s with his cousin, the writer and politician Dr. Karl Fleischmann.

The Kleins had four children and such obligations indubitably compromised the creative desires of both parents. To support

the family he took a job selling Honeywell Bull CII computers in Eastern Europe, whilst she took full advantage of their Vienna residence, being invited to study with legendary Surrealist Ernst Fuchs, from whom she learnt the egg tempera *mische* technique. Klein used *mische* for the rest of her career, for self-portraits, professional commissions and a string of exhibitions including at the prestigious Salon de Mai, Artexpo in New York, Art Contemporain in Quebec and for various manifestations of the British Inscape Group.

Vienna perfectly suited Klein's old-fashioned, Pre-Raphaelite sensibility and she was on her way to local legend-hood when everything collapsed, as it did for many people in that *annus horribilus*, 1972. When her husband lost his job they were forced to return to Britain for a year before moving again, this time to France where he found other work with Honeywell. Living in a beautiful three-storey house in the still rural Parisian suburb of Pontoise, Klein came into her own as mother, cook, entertainer and party queen, ruling over a sprawling household and loud, pan-international boho set where nobody went to bed before midnight. "*Où sont les Anglais?*" became the local rallying cry.

When not painting, her time was spent in the Bibliotheque Nationale researching Nicolas Fouquet, Louis XIV's Superintendent de Finance whom she was convinced had been falsely imprisoned. This obsessional academic quest resulted in over forty notebooks filled with hand-copied documents, though as with all her writings she consistently refused publication. Indeed Klein was convinced she had a love affair with the ghost of Fouquet and created several striking portraits in his honour.

Her husband unexpectedly died in 1989 but a year later she had taken up with the other great love of her life, an Israeli the same age as her youngest son, a difference of some 25 years. With Amir she eloped to Amsterdam, then the extreme north of Canada, before moving to Tel Aviv and opening a business designing medieval capes and raincoats, not necessarily the most practical garments for that climate. Dogged by melodramatic, virtually nineteenth

century personal tragedy—Amir died of a sudden epileptic attack at 33—Klein's grief segued into her own illness. She returned to the family house outside Paris where she died surrounded by her four children and her creative legacy; her son Paul Pagk, the well known New York painter, another artist son in London, an ex-model graphic designer daughter in Israel, and the other daughter a teacher in France.

Sarah Ann Horsey Klein, writer and painter;
born Harpenden, Hertfordshire, November 14, 1937, died Arville, August 23, 1997.

ROBERT STANLEY

ROBERT STANLEY died on the last day of his New York solo show, a perfect artist's exit only marred by the fact it was his first exhibition for ten years in the city where he had worked and lived, and that the gallery was one tiny room specialising in forgotten artists. Stanley was abundantly so. "Of course marginalised figures get lost: that is what it means," the renowned critic Robert Pincus-Witten wrote of Stanley in a 1989 catalogue already ominously entitled *Twenty-Five Years Later*. Indeed Stanley was always labelled a sixties Pop artist despite the length and variety of his career and his later concentration on the classical female nude. Dubbed "pirate of the Pop Art movement" by another influential critic, Mario Amaya, Stanley may latterly have seemed more shipwrecked survivor on his own desert island but he was sufficiently aware of his place in art history not to worry if the public remained ignorant. Indeed Stanley's work was studied and written about by some of the most significant names in modern art history and criticism, one of those few cases in which the art critic was not left behind, fuming in low-paid tenure or hackery, whilst those once promoted become blasé millionaires.

If Stanley was signally edited out of many chronologies of American art, his blatant talents as a draughtsman, sure sense of graphic design and sheer boldness of content suggest that his work will eventually find its just level of appreciation. In the early sixties Stanley established himself with photo-derived flat renditions of singers, sports events and pornography, a dangerous area for any male artist unless lucky enough to be homosexual. Though Pop was eponymously about popular culture there was perhaps something a little too commercial in Stanley's chosen subjects, an attraction too overt, not sufficiently aestheticised for the era. Stanley was destined to always be at odds with prevailing taste. If his 1960s images of

Christine Keeler, Jagger, or fellatio then appeared aggressively thin, his next paintings of branch shadows seemed romantically whimsical amongst the shallowness that he had helped spawn, and more recent drawings and paintings of attractive naked women were read as bourgeois corn rather than subversive stabs at desire itself. When he died the name "Stanley" was plastered all over America, a bitter coincidence announcing the show based on the life of another misunderstood painter obsessed with the naked female form, but the example of how Stanley Spencer can be mythologised into glamorous bohemianism whilst an artist like Stanley struggles with the everyday reality of neglect is paradigmatic of a culture that markets cultural biography as sexy entertainment whilst ostracising actual creative figures. And Stanley himself was hardly lacking the raw anecdotage required to create a vendible local legend who slowly matures into cult figure and thence Broadway star.

After all he was born poor in Yonkers, studied at numerous schools including the mythological Art Students League of the fifties and Columbia University, endured menial labouring jobs, found fame and fortune with his first show at age 25, had his sexually explicit work denounced and even censored, appeared in mass market teen magazines such as *Cheetah* and on the cover of *Sports Illustrated*, showed with museums around the world, knew famous people from baseball as well as art, then seemingly dropped out.

Reviewing Stanley's resume it would be hard to think of another artist who showed so much and in the most important venues only to be subsequently ignored. After all, his dealer in the sixties was the legendary Ivan Karp, whose gallery O.K. Harris invented SoHo and minted stars including Stanley's stablemate Richard Artschwager, who even wrote a text for his old friend with the title "Parade In the Face of Death." Likewise Stanley remained a friend of the minimalist Robert Ryman, whose presence at Stanley's last opening was an incongruous reminder of the social integrity of that generation of artists. For pleasingly, an artist of Ryman's seriousness would hardly be conscious of the difference

in status between himself and his old colleague; they came from a small creative community where being a painter and having a show was sufficient in itself regardless of the name of the gallery or price of the work. But it is nonetheless strange that Ryman's glorious career was built on the repetition of the starkest white blanks whilst Stanley's accessible and entertaining figuration failed to sell. If, in crudest terms, you had been asked to put your money down in 1964 between white monochromes or sexy naked girls, few may have predicted the ensuing result. But it would be simplistic to see Stanley as a Pop artist superceded by Minimalism just as those Pop artists themselves had knocked countless late Abstract Expressionists out of the race; rather Stanley was just an artist of wide talents, not least graphic and compositional, whose work sometimes dealt with images drawn from popular culture and nearly always addressed issues of pleasure, sensual gratification and arousal itself— beauty's dare.

Stanley had a dealer in Paris, galleries in Italy, and shows everywhere including *The Obsessive Image* at London's ICA in 1968, *4. documenta* that same year, and he appeared at the Whitney Annual in 1967, 1969 and 1972 as well as the very first Whitney Biennial in 1973. It was not even as if such major shows had entirely ended, he had a retrospective in Winnipeg in 1980 and showed at Le Consortium in Dijon in 1986. Stanley is also in every important collection including that of Ludwig, Arman and the British John G. Powers, as well as all the necessary museums such as MoMA, The Metropolitan, the Corcoran, the Whitney or Fort Worth's MoMA.

But perhaps Stanley was simply more committed to art itself than such career trophies, whether his massive painting *Louisiana Sweet* which covered 99 × 7 feet of PS1 in 1977 or his nudes. "I put together this technique from looking at Poussin's drawings," was how he described the series. He was unrivalled at life drawing, teaching at New York's School of Visual Arts for sixteen years, though his own works remained derived from snapshots, true to his motto: "I see photographs as drawings."

Yet whatever one's integrity or confidence the wind of history can be undeniably cold. A Stanley Beatles print recently came to auction in a job lot of junk and sold for $50. Stanley's funeral was attended by not only his art star friends but also famed critics and curators, including musicologist Robert Christgau, who had worked with him as a night supervisor at DuPont, where Stanley secretly ran off his porn xeroxes. The reception afterwards was held in the notably grand townhouse of another Pop artist, Roy Lichtenstein, who died only seven weeks previously, his widow being the sister of Stanley's own wife. The contrasts in their parallel careers might serve as bittersweet finale, but should not obscure the import of Stanley's own singular oeuvre.

Robert Stanley, artist; born Yonkers, New York, January 3, 1932, died New York City, November 15, 1997.

ALFRED BINGHAM

"**G**UCCI Socialist" would not have been the term for Alfred Mitchell Bingham, who not only believed in stronger political medicine but also would have despised the Nouveau Riche associations of such footwear, his own brand of New England WASP radicalism perhaps casting him as a "Brooks Brothers Bolshevik." As a writer, editor, activist and lawyer Bingham was involved with an impressively wide swathe of twentieth-century American political issues from the 1930s New Deal to the 1960s New Left, a paradoxical journey from youthful Republican to elderly Democrat. Bingham's life also had the perfect curve of a classic tragedy, his own personal wealth and radical agitation eventually producing a son whose costly defence against terrorist charges would deplete the family fortune. This political and financial heritage canceling each other with an inexorable logic, as if deemed by the Furies. "My mother's maternal grandfather Charles Tiffany founded the jewellery and silverware company and became a millionaire. My father's paternal grandfather led a famed mission to Hawaii, which gave the islands a written language and a Bible. These two great-grandfathers seemed to typify the rival influences that had shaped me...."

If the lineage was impeccable on the Bingham side, a row of Protestant missionaries called Hiram stretching back to the Mayflower, the Tiffany genealogy may have been rather more recent but had distinct financial compensations. Indeed that one store on Fifth Avenue guaranteed intellectual and social independence for generations afterwards, providing not just breakfast *off* Tiffany's, but lunch, dinner and champagne too.

Born one of seven brothers in 1905 in Cambridge, Massachusetts, Alfred Mitchell had exactly the education expected of his class and period, Groton followed of course by Yale and then Yale Law School. Whilst his father was a star of Connecticut

Republican politics and notoriously conservative as Senator, the young Bingham's Republican beliefs were shaken by the liberal intellectual atmosphere of Yale and like so many independently wealthy American idealists, he abandoned his degree and humbled himself with various dead-end menial tasks, perfect revenge on any father as later perfected by those sixties drop-outs.

Also like any proto-hippy he then traveled the world for a couple of years, inspecting Stalin's Five Year Plan first hand in Russia, and being apparently impressed, as well as interviewing everyone from Gandhi to Mussolini on his Grand Tour of global politics. He returned to Manhattan in 1932 and began a liberal monthly called *Common Sense* which he edited for ten years, turning it into a key forum for all the activists of the era, a quintessential intellectual-radical journal with contributors such as John Dos Passos, James Agee, Theodore Dreiser, Upton Sinclair and Edmund Wilson. Whilst his father had won success as a political journalist, especially for his 1913 article "The Monroe Doctrine: An Obsolete Shibboleth," young Bingham's stance was altogether more fiery and physical.

Indeed in 1934 he was even physically thrown out of the restaurant at the Waldorf Astoria after addressing his fellow dinner guests in support of the hotel's striking kitchen staff, and that same year was arrested picketing alongside striking workers in Jersey City. The motto of *Common Sense* was, "production for use not for profit" and Bingham hoped to turn it into the spearhead of a broad new cooperative social movement, a third party that would replace the outworn bipartisan politics of the time. In 1934 he published his first book, *Challenge to the New Deal*, followed the next year by *Insurgent America* in which he "sought to show the fallacy of the Marxist expectation that the proletariat would become the dominant class and ventured the conclusion that the technical and managerial middle-classes are slated to be next in the sequence of ruling classes." This became a central theme in Bingham's thought, that the Dictatorship of the Proletariat had become the

Dictatorship of the New Bourgeoisie throughout America. Even in 1970 he wrote, "If the New Left in this country is to be realistic it must consider the class character of revolution: it must be able to say what class is now in power, and what class could take power. Those who would organize class interests for social revolution can no longer overlook that it is the new middle classes which are now dominant. The Marxists had failed to apply their own social analysis to these new middle classes."

Indeed throughout his books, *Man's Estate* (1939), *The United States of Europe* (1940), *The Techniques of Democracy* (1942), Bingham proved prescient on a range of issues. His understanding of America's new managerial classes was linked to the future power of multinational companies: "General Motors or J.P. Morgan will perform an essential integrating task in the absence of a responsible authority." He also wrote of those "millions of Negroes who could not vote in America," that the "maintenance of full employment seems to be the major task of overall economic management," and placed a very contemporary emphasis on the sociology of technology: "The revolution which has gripped the whole world since 1914 is, clearly enough, a phase of the technological revolution which began with the application of the scientific method to industry."

Bingham's view of America's emergent middle class was naturally tempered by a somewhat sensitive appreciation of the role of class and wealth within that country's social structure: "The wealthy are always a legitimate target, and there is plenty of careful social analysis, as well as invective, concerned with the rich and the very rich. Radicalism has always used 'malefactors of great wealth' as targets, yet it is less able to pinpoint them as individuals and identify them by name today...."

In 1970 he published *Violence and Democracy*, twenty-six years after his previous book. Bingham was one of those lucky writers whose works become increasingly engaging and entertaining as they age, and whilst his first six books are unreadable today, *Violence and Democracy* remains a fascinating analysis of the revolutionary

chaos of that period from the perspective of a 65-year-old activist from an entirely different tradition. The flavour of his tone can be sensed in such chapter headings as, "When is violence legitimate?"

Four years later Bingham was able to again ask himself that question in earnest when his son Stephen was accused of having smuggled a gun into the high-security San Quentin State Prison where it was used by George Jackson in a botched and fatal escape attempt. Stephen Bingham was a lawyer himself and highly involved in revolutionary politics, and like many law-breaking idealists of the era he went underground for eleven years before finally giving himself up to the authorities. Considering his own past and the surprisingly militant tone of his last book it was hardly surprising that Alfred should come to the defence of his son, nor considering legal costs in contemporary America that he should have almost bankrupted himself by the time Stephen was finally acquitted by a jury.

If Bingham did not exactly mellow with age he did switch his authorial interests from political policy to family history, a welcome improvement for his readers. On retiring from the law he began a mammoth twin-family history provisionally entitled *God and Mammon*, before breaking it down into more realistic sections. In 1975, a long article on his missionary grandfather was published by The Hawaiian Historical Society and he published an essay in the *Connecticut Historical Society Bulletin* about slavery in New England: "I had discovered, to my astonishment, that Black slaves had cleared the land of the ancestral Connecticut farm near where I now live."

His 1989 biography on his father was followed by *The Tiffany Fortune and Other Chronicles of a Connecticut Family*, the only one of his books to remain in print. Bingham's commitment to democratic ideals and egalitarianism despite the pressures of world war, McCarthyism or gun-toting students made him an exemplary American liberal, and one well-served by his own words from *Violence and Democracy*, "The absence of sharp class distinctions, in contrast to the rigidities of the old world, was always part of

the American dream. Even a wealthy or powerful man might be described as democratic if he behaved as if other people were his equals."

Alfred Mitchell Bingham, writer, politician and lawyer;
born Cambridge, Massachusetts, February 20, 1905,
died Clinton, New York, November 2, 1998.

NORMAN BLUHM

THOSE who despise the establishment need not be surprised to later find themselves unestablished, this is as true in the art world as in that of politics or economics. That Norman Bluhm had little time for games of fame and fortune, and no time for the machinations of the commercial art world, goes without saying — it is indicative enough they had just as little time for him. Thus despite being a major painter, Bluhm's obituary requires explanations, historic context, and anecdotage rather than the lavish reproductions and litany of public honours that most such artists expect. The importance of Bluhm's oeuvre is an openly acknowledged secret amongst several successive generations of American critics, poets, curators, and writers but such clandestine acclaim does not necessarily lead to larger recognition. But if Bluhm cannot be memorialized here as a genuinely important painter — because that would require each reader to slowly tour a full-scale retrospective of his work — he can at least be honoured as a paradigmatic figure of one of the major cultural shifts of the twentieth century, from the School of Paris to the New York Abstract Expressionists.

Bluhm was born in Chicago but spent six years of childhood with his mother's family in Lucca, Italy. On returning to Chicago he became, at age 16, the youngest student of Mies van der Rohe, this architectural training later evident in the gigantic scale and complex, almost Gothic forms of his paintings: "It reminds me of the architect I never became."

During the war he flew a dangerously high number of B-26 bombing missions in North Africa and Europe whilst even acting as personal aerial chauffeur to Marlene Deitrich for her troop performances. As a legendary raconteur, some of his friends in New York were not convinced by this story, and to embarrass him invited

him to a reception for the actress. As he entered, Deitrich rose to her feet and cried, "Oh Norman, so good to see you...."

After his distinguished war service Bluhm went back to Mies briefly in Chicago and then, supported by the GI Bill, went to study in Florence where he analysed fresco painting, later a major influence, before moving to Paris in 1947. There Bluhm studied at the École des Beaux-Arts and became a friend of everyone from Giacometti to Antonin Artaud, Éluard to René Char, and found his first serious collectors in the daughter of Matisse and her husband, the then-revered critic Georges Duthuit. He was asked by Cocteau to appear in his 1949 classic film *Orphée*, where he can be seen, a handsome bohemian with dark goatee, sitting in a cafe reading *Portrait of the Artist as a Young Man*.

Bluhm came to New York in 1956 – the year that Pollock died – and was soon acknowledged as a central figure in what became known, not happily, as the second-generation of Abstract Expressionists, already criticized for being unduly influenced by their immediate predecessors. Bluhm was very much part of the hard-drinking and hard-fighting crowd around the notorious Cedar Tavern, where he was suitably revered for his alcohol intake and Parisian tales. Bluhm began collaborations with the poet and curator Frank O'Hara, with whom he produced a series of twenty-six poem-paintings which now belong to New York University. In the poem *Three Airs*, dedicated to Bluhm, O'Hara perfectly captures the artist's work in his first stanza: "So many things in the air! soot./ elephant balls, a Chinese cloud/ which is entirely collapsed, a cat/ swung by its tail/ and the senses/ of the dead which are banging about/ inside my tired red eyes."

A year after arriving in the city, Bluhm had his first show with the recently opened Leo Castelli gallery, where he continued to

show for several years including in group shows with contemporaries such as Rauschenberg and Jasper Johns, who would soon be construed to have supplanted Bluhm's own aesthetic. In fact Bluhm popped in unannounced to check on his 1960 solo show only to discover paintings by the two aforementioned artists propped up against his own works, entirely obscuring them. Castelli apologized by saying, "But Norman, what can I say, they're selling!" Bluhm no doubt offered physical violence and stormed out, henceforth calling Castelli "Mighty Mouse."

Indeed the eclipse of Ab Ex by Pop was almost as genuinely total and overnight as most arts journalism makes it sound, and the notion of changing "movements" every few years became established. Bluhm suffered, as a whole lost generation of painters suffered, and his combative stance probably did not help: "By accepting the rules of the dealer the artist destroys himself, better than anyone else could. New York now means this destructive merchandising of art." Bluhm returned to Paris in 1964 for a year and then moved to East Hampton and finally remote Vermont. When he returned to Manhattan it was to visit the Metropolitan and the Cloisters, whose fifteenth-century Unicorn tapestries were as influential as the works of Tiepolo, Rubens, Matisse, Baroque architecture and stained glass.

If Bluhm was far from being fashionable in recent decades he had become one of America's best known little-known major artists, and his supposed neglect should not be exaggerated. He was in the collection of every major museum in America, honoured with various touring retrospectives, and even showed in 1994 in successful commercial galleries such as Ace. Indeed a forty-year retrospective is scheduled at the Butler Institute of American Art in Ohio, along with the first full-length monograph to be published by Galleria Peccolo in Livorno.

Bluhm's style continued to evolve regardless of fashion, following its own internal obligations, and the paintings seemed to get larger every year as if in deliberate defiance of the art world's

relative disinterest. Bluhm made clear the only thing that mattered was the work and its successful resolution; everything else was publicity and marketing. Thus by his own strict standards, Bluhm was one of the most successful American artists of the century.

Norman Bluhm, painter; born Chicago, March 28, 1921,
died East Wallingford, Vermont, February 3, 1999.

WINTHROP K. EDEY

WEALTHY eccentrics are as rare in America as they are commonplace in Europe, a Puritan culture ensuring even the best endowed remain workers rather than playboys. Winthrop K. Edey however was an ideal exemplar of the Manhattan eccentric who, like many so-labeled, was actually a vastly learned and respected expert. Edey's expertise was in antique clocks and watches, and he was both a nonpareil scholar and collector. The family funds which bankrolled his exceptional collection also removed Edey from the obligations of academic tenure, museum directorship, or auction house employment, any of which could have been his for the asking. Though these might have given him a measure of official recognition, Edey preferred to linger in his own deliciously minted chiaroscuro, a collector's collector, an horological expert's expert, a figure often consulted and rarely, at his wishes, quoted.

The "K" in his name was special indeed, for it stood for Kellogg and honored his grandfather Morris Kellogg, who had won gargantuan sums of money designing oil refineries and America's atomic-bomb plants. Edey was usually known as Kelly, a diminutive of the very Kellogg which had made his life of leisure and connoisseurship possible. For Edey was equally knowledgeable about ancient Egypt, eighteenth-century literature, and the history and practice of photography. His social set included as many louche avant-gardists as elderly timepiece dealers, queens of the New York night along with antiquarians. He knew both the notorious Robert Mapplethorpe and Andy Warhol, who included Edey in his forty-minute black and white silent film, *The Thirteen Most Beautiful Boys*, along with such figures of the period as Gerard Malanga and Freddike Herko. This was in 1964, the same year Warhol's mural, *Thirteen Most Wanted Men*, was removed from the New York World's Fair.

Edey was a man of habit, not just that of collecting. He maintained an impeccable townhouse on the Upper West Side exactly as it had stood in the late nineteenth century, including working gas jets. He awoke at precisely five in the afternoon. Such an hour was justified, as if justification were needed, by a habit of working throughout the night on his clocks and his diary, an obsessive task which had occupied him since age 6.

Edey's mother had set up the first outpatient vasectomy clinic as a mainstay of the Association for Voluntary Surgical Contraception. He grew up in the expected luxury on Long Island, attended Amherst College and the Institute of Fine Arts in New York. But throughout this he never failed his journal. This massive, many volumed work covering more than fifty years promises to be a revelatory document and even potential bestseller, including everything from downtown 1960s bohemia to leisured travel worthy of the previous century. On such journeys Edey carried a large turn-of-the-century camera; his interest in photography included taking his own old-fashioned images as well as collecting Man Ray. However, a good number of people may well have to clutter these same obituary pages before Edey's diaries can ever see publication.

A hint of his impeccably recherché prose can be gained from the two books published in his lifetime. In 1967, Walker & Co. of New York put out his guide to collecting French clocks, the first book in English on the subject, "A knowledge of French clockmaking involves the study of many different subjects: cabinetmaking, bronze-casting, the manufacture of machinery, the evolution of theories of time, sculpture, even porcelain, the composition of metals and some astronomy." This slim book also carried several plates of clocks from his own collection, including such rarities as a Green Horn wall-bracket by Gille Lainé from 1745, a *Tête de poupée* by Balthazar Martinot from 1680, and a *Pendule religieuse* by Gosselin of Rennes from 1660. And Edey's wit remained firmly deadpan, "To English eyes, the gaudiness and extravagant ornamentation of

French clocks must have looked like efforts to compensate for their inferior timekeeping."

In 1982 the Frick Collection mounted the first major exhibition of French clocks in the US. Edey was the guest curator and nine of the finest works were from his collection though his name was, typically, modestly omitted. As curator Edgar Munhall put it, "The Frick is fortunate to be able to engage Edey as Guest Curator. An internationally renowned horological specialist, it was he who first opened my eyes to the wonders and beauties of clocks. The choice of items included in the exhibition, the catalog and the installation were his work...."

And it is to the Frick that Edey has left thirty-nine works from his collection of around sixty clocks and watches, a donation of incomparable magnitude. In the book for the Frick show, *French Clocks in American Collections*, Edey demonstrated his taste in prose as well as timepieces, "After the Revolution, clock cases were less often worthy of the best movements, and less often the carefree sumptuous objects that they had been. They gradually lost the fabled sweetness of the *ancien régime*, taking on in its place a harsh chill." Elsewhere in this essay his words could serve as his own epitaph: "Thus the market was much reduced, and a certain spirit of taste was killed, a taste that had taken centuries of increasingly refined living to develop."

Winthrop K. Edey, clock collector and diarist;
born Upper Brookville, New York, June 18, 1937,
died New York City, February 22, 1999.

FELICIA GIZYCKA MAGRUDER

T HE exceptional existence of ex-Countess Felicia Gizycka Magruder can hardly be outlined or understood without mention of an even more exceptional individual who shaped her life in every sense, namely her mother, Eleanor Medill Patterson. If Felicia Gizycka is eminently worthy of at least an obituary, her mother was the subject of two full-scale biographies published within ten years of each other. Furthermore, this formidable mother-daughter act and the dynamic of their mutual loathing are entwined with modern American history.

Eleanor Patterson, known as "Cissy" was granddaughter of Joseph Medill, founder of *The Chicago Tribune*, and came from influential wealthy dynasties on both sides. Her brother founded the *New York Daily News* and journalism was so much in her blood that she not only was a longtime columnist, news reporter and gossip-jockey, but later became editor of a Washington newspaper and "the most powerful woman in America." She grew up in a massive Washington mansion by Stanford White on Du Pont Circle, a house of such magnitude it even served as the White House for three months. As was the fairy-tale custom of the time, she went to Europe as a debutante and was presented to Emperor Franz Joseph in Vienna. It was also a custom of the era to view American

heiresses as the easiest method to restore European aristocratic fortunes, and Cissy was pursued by a classic impoverished nobleman. This was Count Josef Gizycki, a hard-riding, hard-drinking ladies man with a bankrupt estate in distant Russian-Poland. A great rider herself, Cissy fell for dashing Count "Gigi," and despite pleas from her family married him. No sooner did she reach his dilapidated, freezing "castle" in Narvosielica than she realized her mistake. The Count also informed her, quite bluntly, that he only had sex with her in order to make a child and gain her $30,000 annual income. In 1905 that child, Felicia, was born in extremely primitive conditions whilst the Count was away whoring. Determined to escape the remote wasteland with neither telephone nor telegraph, Cissy enlisted her serfs and fled by sleigh over the icy slopes to the Russian border. The Count pursued them to London in a large touring car and, disguised in motoring goggles and fur coat, kidnapped Felicia from a Camden Hill park. Felicia was hidden in an Austrian convent, and as divorce was not recognized in Europe, an order from the Tzar would be required to release her. Eventually family-friend President William Taft sent a personal letter to the Tzar and when the Count returned to his estate he was arrested. Amongst rumours the family had paid $500,000 in ransom, little Felicia finally toddled into her mother's hotel suite in Vienna. Felicia never saw her father again and a divorce was finally granted in America in 1917.

Felicia grew up amongst her mother's many properties including a ranch in Wyoming, a Long Island estate, and houses in California and Virginia. Not yet five, she spoke German, Russian and some French learnt in the convent, but little English. Wherever she played she was accompanied by a private detective. Yet despite the melodramatic custody battle, Cissy seemed overwhelmingly uninterested in her daughter, who was brought up by servants. In her novel, *The House of Violence* (Scribner's, 1932), Felicia wrote, "She'd have a lot of money some day, and that she was a pretty lucky girl." Felicia went to Foxcroft in Virginia in spite of the Count's

wishes, "I do not want Felicia to have the sort of education of which you are the victim." Difficulties between mother and daughter were apparent early, Felicia being just as independent as her mother. Cissy described her as, "about as easy to drive as a team of young bull moose. I've got to remember every minute that Felicia is half-Polish." Felicia refused a formal debutante coming-out but did have a Washington ball in her honour, with fifty invited for dinner and a hundred afterwards.

Wanderlust was strong in both mother and daughter. Running away as a teenager from their Jackson Hole ranch, Felicia rode bareback down a canyon, removed money from her bank account, took a stagecoach and then a train bound for Salt Lake City. She was pursued by her suitor, the young journalist Drew Pearson, whom she rebuffed as a bore. Arriving alone in San Diego she moved into a rooming house for girls claiming to be married to a sailor and became a waitress in a waterfront bar where the owner stated, "You're running away from something. If it's a man I don't want you." She kept her whereabouts hidden for four months. Pearson was more anxious to find her than her mother, who claimed not to care. He was determined to marry her and persuaded Felicia that she could try it for three years and then leave. In 1925 they married at Long Beach, California, the *Chicago Herald-American* calling her, "an international figure ever since she had been the most kidnapped child in the world."

In 1927 Felicia gave birth to her only child, Ellen, a daughter with whom she had an identically strained relationship. They bought a house in Washington's not yet fashionable Georgetown and she reviewed movies for the *Washington Post*, then moved to Manhattan. After exactly three years she divorced Pearson who was fast becoming an American journalistic legend. As befitted an independently wealthy young American beauty Felicia led a life of international frivolity as a classic "flapper." She lived between Biarritz, London, Paris, New York, Washington, Deauville and the Virginian hunting counties, getting drunk and married.

"Felicia is going abroad this month — I guess I will have to join her later and pick her out of any new love affair she has fallen into," wrote her mother. In 1934 she married Dudley de Lavigne in London, an impoverished insurance broker and part of the Prince of Wales social set. His sister was married to Viscount Castleross who, writing as Cholly Knickerbocker in his *Sunday Express* gossip column, described Lavigne as "tall, slim and not very energetic." Her mother was surprised by a cable announcing the marriage, "I have never heard this gentleman's name before." However she sent her own lawyer to London to handle the divorce case that same year. Felicia even had her own penniless Polish count, Alfred Potocki, who was turned down after demanding a million-dollar dowry from Cissy. All this time Felicia was also writing, often for the same publications as her mother, including reviewing Paris restaurants for *Harper's Bazaar*, a job her mother secretly arranged for her. Felicia's first fiction was published in *Liberty* (run by her uncle) and often anthologized subsequently. Just like her mother she published two novels, the difference being that they are surprisingly good, and suitable candidates for resurrection.

The House of Violence is jazz age aristocratic experimentalism awash in alcohol and unhappy rich kids, "We might as well get lit, we'll be dead any minute now." Drink, divorce, a distant mother and violent father are the themes along with constant travel with playboys in pursuit, "No air and the terrible noise, and the drinking, and the women squashed against the men all the time. Here it was again, men with their episodes all like beads and no string through them, and women with their strings desperately trying to string on beads."

Her second novel, "contemplated" whilst living in Sicily, *Flower of Smoke* (Scribner's, 1939) was more autobiographical and infuriated Cissy with its portrait of a heartless socialite mother. Their relationship was so bad that in 1945 Felicia announced she had divorced her mother, "I'm tired of being Cissy's daughter." Though she kept a house in Manhattan and one upstate, she refused Cissy's offer of a floor to herself in the Washington mansion and resolved

to live by her writing and $3,500 per year from a grandmother's trust fund. As she put it, "I think my mother thinks more of her poodles than she does of me. She loved me but she couldn't show it. She hated me because she hated herself, and took it out on me." Before Cissy died in 1948 she changed her will several times, remarking to her chauffeur, "They'll have a damned good fight when I'm gone. I've fixed that!" Indeed whereas in 1924 her "beloved daughter" was sole heir, she was finally only left (that "only" is relative) the Long Island estate, North Dakota properties, household furnishings, wardrobe, jewellery and paintings along with a lifetime tax-free allowance of $25,000 a year, "to keep her off the streets." Felicia filed a formal notice of contest claiming the whole estate, which was conservatively calculated at over $16 million. Drew Pearson financed this fight because their daughter Ellen had been disinherited. After protracted legal skirmishing, which naturally made the front page of every tabloid, Felicia settled for a lump sum of $400,000, tax free.

"Do I have to wait till I'm the richest girl in the world?" she'd written in her first novel, and now at 44 she was wealthy and free of her mother. She lived in New Canaan and Wyoming and in 1958 married John Magruder, a landscape architect who ran the Alcoholics Anonymous Men's Home in Alexandria, Virginia. Though both she and Cissy were the very opposite of anonymous they were, however, committed alcoholics, and she had even taken her mother to an AA meeting, but Cissy considered herself too old to join. This last marriage also ended in divorce after a few years and Felicia ended her life alone in a Wyoming retirement community. As she once asked, "I spent so much time hating my mother. How could I ever really love anyone else?"

Felicia Gizycka Magruder, socialite and writer;
born Narvosielica, September 3, 1905,
died Laramie, Wyoming, February 26, 1999.

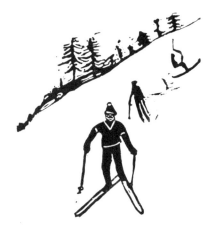

PIETRO NARDUCCI

WHEN William Boyd published his book on Nat Tate, a mysterious Abstract Expressionist painter, it was a disguised work of fiction, and Boyd surely had no idea that exactly such a figure actually existed. That the novelist did not know of Pietro Narducci, who recently died aged 84, is hardly surprising. Nobody had heard of him, despite his being a founding member of the Ab Ex movement who had done nothing but dedicatedly make art for more than sixty years.

Whatever the reasons for his obscurity, Narducci is undeniably unique. A highly trained painter who was an integral part of the most important movement of twentieth-century American art Narducci only had one formal exhibition and subsequently refused to show his work; this was the career profile of an eccentric outsider artist, a hermit and recluse, the difference being that he spent years at art school, teaching and working on government commissions, and both knew and was respected by the most famous artists of his era.

The culmination of all these creative labours is "The PAN Art Museum & Institute" (an acronym of his initials Pietro Antonio Narducci) in the small New Jersey town of Denville. Located on Main Street above a row of suburban shops, PAN is a warren of small rooms where Narducci lived and worked for the last

thirty-five years, singularly obsessed with his painting. It was here that Narducci painted all day, every day, conducted optical experiments and gave occasional lessons to local students. Every evening he put on a small show of his recent paintings for the townspeople, hung and spotlit in the windows of his museum, the only venue he could trust to show his work in exactly the way he wanted. The PAN Museum now houses the entire posthumous Narducci archive, at a rough estimate containing over two thousand works in a variety of media, from massive astral abstractions to smaller sculptures and drawings. Despite having rented these rooms for so many decades, and his status as bona fide local celebrity, next month's rent is due on the PAN Museum and its fate is less than certain.

Narducci was born in a small Italian mountain town in the Gran Sasso, where he could ski into the front room of his parents' house. He was largely raised by priests at the Catholic church next door. His father had already left for America and when Narducci was 15 he sent for him, to escape Mussolini's Fascist recruitment of Italian youth. He joined his father in Denville and soon enrolled at the Leonardo da Vinci Art School in Manhattan, a renowned academy of the period which the actor and collector Edward G. Robinson was known to patronise. Having studied fresco restoration at the Metropolitan Museum, Narducci began working as a painter for the Federal Arts Project, in the WPA Mural Division, and he won the Prix de Rome for one of his gigantic frescoes. This work was shown at the Grand Central Art Galleries along with work by Isamu Noguchi and other luminaries. The classical fresco of wild stallions was painted on a concrete wall so heavy it had to be delivered to the uptown gallery by horse-drawn wagon. When the show ended the gallery did not know what to do with such a monumental work and let loose jealous students with sledgehammers. This wanton destruction confirmed Narducci's loathing for the commercial art system and it was the last time he would show in public.

However by this time he had been introduced to the Cedar Tavern and its roster of nascent stars including Pollock, de Kooning,

Sam Francis and Franz Kline, the latter becoming his closest friend in the group and indeed outside of it. He would often stay with Kline, who once offered him various works as gifts. Narducci refused them, shocked any artist could give away his creations. Narducci was known as Peter rather than Pietro and his Cedar Tavern nickname was The Lizard, or New Jersey Lizard from the Swamps, as he commuted to the bar from Denville. He was also known as The Prince because of his aristocratic airs, a quintessential Italian peasant-aristocrat with his strong accent and handsome bearing.

The two catalysts for Narducci's discovery of Abstract Expressionism, and Modernism in general, were being led into the dark smoke of the Cedar Tavern and being introduced to Stravinsky's *The Rite of Spring* by an opera-singer girlfriend. But the great love of his life was his wife, who went by the stage name of Muriel Reed, an Irish-Catholic-Russian-Jewish ballerina from a circus family who he met in Manhattan's fabled Russian Tea Room. It was only after marriage, his best man the then curator of the Guggenheim Museum, that he discovered she could speak English at all. The marriage did not work out and in 1951 he was crushed by the simultaneous blow of divorce and the accidental death of his 5 year-old only son.

In many ways this was a turning point. Several of his old artist friends were already dead; the last time he'd seen De Kooning was just after they had heard of Pollock's death. The two of them sat on a New York sidewalk sharing a pastrami sandwich, then De Kooning drove back to the Hamptons and Narducci to New Jersey, neither of them ever to return to the city. In a letter to Narducci's daughter, Elaine de Kooning described both artists' situation, "Bill, too, is a recluse and never visits the city if he can help it. He just wants to stay in his studio and paint." That too was all Narducci wanted to do, but for a while he was forced to support his family with various jobs such as bartending and antique dealing. Planning to join the American Air Force he discovered he had signed up for American Airlines instead, where employed as a graphic designer he created

the company logo of an eagle—yet another of his unsung contributions to postwar American culture.

But Narducci slowly retreated into self-imposed exile in his self-created museum, taking students but otherwise entirely refusing the outside world. Increasing agoraphobia and sensitivity to cold ensured he rarely left his quarters and would take a taxi just to visit his dentist a few streets away. Thus, sadly, his aesthetic experimentations and steady creative evolution were for his eyes only. If his painting style had already changed from neoclassical to Ab Ex, such as the "Nebula" series of 1954 and cast-concrete sculpture like *Apollonian*, it then shifted dramatically again. Using an oscilloscope wired to a camera he kept on his fire escape, pointing into the sun, Narducci began painting with light and sound waves, the first ever paintings done with the energy of the sun, abstract images captured on film and transformed into cybernetic paintings and huge sculptures such as *Cosmic Woman*, which was even wired for sound.

Narducci never ceased to try new techniques and considered his personal breakthrough into purest creativity in 1985, when he began using acrylics mixed with rainwater and ammonia, elements from the universe taken directly from nature. This series of "Quintessential Aesthetics" occupied him until his death, a secret shared only with his children and occasional chosen students. As one of these, Lisa Tideman-Meyer wrote in the local paper, "Like a hidden treasure, with his teaching and his work, he brought a little bit of culture and art history into Denville for more than forty years. Perhaps some day the world of art will mourn this significant loss. For now, the few who knew Narducci and his work will mourn alone."

Pietro Antonio Narducci, artist; born Pietracamela, Italy, February 1, 1915, died Denville, New Jersey, March 1, 1999.

BOB CATO

IN our self-conscious era of artifact fetish, the art director has moved from anonymity to creative celebrity and it is proof of one's worldliness to know the name of whomever designed the Lucky Strike packet or Braun clock. Bob Cato is very much part of this pantheon, not only because he designed many cult record sleeves, but also because he embodied the hip Manhattan art director in his golden era, a world of "Silver Bullet" martini lunches, sharp suits, chain-smoking soirées, and a cultural savvy which today's designers look back on with nostalgia. Cato was the ultimate sophisticate, with the emphasis on "cat," an expert on modern jazz and James Joyce, fabled cook, sculptor, photographer and collagist whose awards and museum shows were incidental to a vibrant *savoir* and *joie de vivre*.

Born in New Orleans to a Cuban émigré mother and business executive father, at 15 his family moved to Mexico City where Cato began to study art with José Clemente Orozco and Pablo O'Higgins. During the Second World War Cato was imprisoned as a conscientious objector and then moved to Chicago to study with László Moholy-Nagy. In 1947 he went to work for Alexey Brodovitch, one of the most influential and revered figures in twentieth-century design. As well as helping him at *Harper's Bazaar*, Cato assisted the famous classes Brodovitch gave at The New School. As Cato wrote for the catalogue of the 1972 show *Brodovitch and His Influence* at The Smithsonian, "I became Alexey's 'Man Friday' and all-round assistant in New York. I drove his car, worked at *Junior Bazaar* and 'Big' Bazaar, cooked for him, kept the attendance books at school, did the shopping and generally kept things together for him and Mrs. B. I had been involved with the jazz scene for many years and it gave Alexey a great deal of pleasure to play host to my many musician friends, who would drop by to talk and drink Scotch with us."

Brodovitch was a strong influence on the young Cato as with most designers of the period. Like his mentor, Cato took numerous photographs of dancers including a renowned series of Paul Taylor used as the cover for *Dance Observer* in 1960. Two of Cato's record covers were included in the Smithsonian Brodovitch show, the offset poster for Simon & Garfunkel and the colour photograph of Miles Davis used for *Miles*. In 1960 Cato joined CBS-Columbia Records as art director and vice president of creative services, a job he held for a decade.

It was here that he created record covers ranging from Leonard Bernstein to Dylan's *Basement Tapes*, *Moondog Matinee* by The Band and *From Every Stage* by Joan Baez and jazzer Charles Lloyd. Cato was willing to experiment in any direction, as recounted in Al Kooper's memoir *Backstage Passes*. For a 1967 Blood, Sweat & Tears record Cato photographed the band with little children in their laps, each child's face replaced by the face of the person whose lap they occupied and entitled it *Child is Father to the Man*. For the 1968 double-set *The Adventures of Mike Bloomfield & Al Kooper*, "I called Bob Cato the CBS art director at home to ask if Norman Rockwell could do the cover." Cato contacted Rockwell and the cover was thus created.

One of Cato's most infamous choices was of Robert Crumb illustrations for Janis Joplin's *Cheap Thrills*. The Joplin bio by Alice Echols explains this had not been the original conception: "Columbia's art director had planned a different cover, a photo of the group in bed in a hippie crash pad. The band arrived and discovered a bedroom done up in pink frills—like no hippie pad they'd been in. 'Let's trash it, boys,' Janis declared and they did. The shot of them in bed naked, the bed covers pulled up only to their waists was junked in favor of Crumb's caricatures." Cato worked with artists such as Robert Rauschenberg and Warhol as well as cartoonists and psychedelic illustrators, though he also often shot the cover work himself, as with *Miles*.

Cato won Grammy awards for two cover designs, Barbara Streisand's *People* (1964) and *Bob Dylan's Greatest Hits* (1967) as

well as the President's Merit Award in 1997. Cato's importance in turning record cover design into an established art form cannot be underestimated. Philip Meggs's definitive *History of Graphic Design* (Wiley, 1998) has this to say: "The design staff of CBS Records operated at the forefront of the graphic interpretation of music. Conceptual image making emerged as a significant direction in album design during the early 1960s, after Bob Cato became head of the Creative Services department… photographs of musicians performing and portraits of composers yielded to more symbolic and conceptual images."

Having set up his own design company, Squadra Gallileo Inc., Cato also designed books on everyone from Garbo, Gloria Swanson, Dietrich and Corbusier to the painter Oscar de Mejo, the *Collected Poetry of Aimé Césaire*, as well as a series on *Life* photographers. Cato was often featured on the front page in billing as large as the author or illustrator, one of his most sumptuous works being *Celebrating the Negative*, a collection of photo negatives published by Arcade. In 1975 Macmillan published *The Great Garlic Cookbook* by Cato and Barbara Friedlander. As the latter was vegetarian Cato created and tested all the meat, fish and poultry dishes, their titles revealing his range of friends: "Spiedini for Leo Lionni" (the famed children's book illustrator), "A Hot Shot for Bob Dylan," "Topolski's Garlic & Paprika Pork Loin" and "Shrimp & Mushroom Appetizer for Joel Grey." Cato's love of modern literature culminated in one of his finest achievements: *Joyce Images*, drawings and photographs complied by Cato and Greg Vitiello with an introduction by Anthony Burgess (Norton, 1994). This book featured a striking jacket design and illustrations of Joyce by Cato as well as an acknowledgment thanking his mother, "who read to him from *Ulysses* when he was just 8 years old and who gave him a 1926 edition of the book which he still has."

Bob Cato, art director, photographer and artist;
born New Orleans, January 26, 1923, died New York City, March 19, 1999.

PIERRE ANDRÉ-MAY

THE large role of the little magazine in twentieth-century literature is exemplified by the French journal *Intentions* whose founder, editor and owner Pierre André-May recently died aged 98. *Intentions* only existed for three years, between 1922 and 1924, but in thirty issues published an extraordinary range of major talent whilst encouraging a whole generation of younger writers. This was all the more remarkable as André-May was then in his early 20s, had never before been involved in publishing, and created and sustained *Intentions* entirely by himself without even a secretary; soliciting, selecting, editing and printing everything that appeared in its pages.

Publishing was, however, in his blood. Born in Paris in 1901, André-May's maternal grandfather was editor of *Le Moniteur de la mode* and his father, a doctor, was director of the *Journal de Médecine*. André-May grew up between his parental apartment in the Rue de Phalsbourg, in the seventeenth arrondisment, and their *petit* Château de Blanchefort in Nièvre. At this chateau, André-May, a single child reading in rural seclusion, developed his obsession with literature and theatre. As he later wrote, "I spent the time of my adolescence in too large a solitude." After Lycée Carnot he began law studies to please his father, and having done well in exams the latter offered him the chance to start his own publication as a reward. His father put his own printer at André-May's disposal, and gave him financial backing for the entire undertaking. He was already an habitué of the famous bookshop Maison des Amis des Livres run by Adrienne Monnier in the Rue de l'Odéon. Monnier and her shop were central to André-May's enterprise, and it was thanks to her recommendation that he secured contributions from many major writers.

In December 1921 André-May published a press release for his new journal in several newspapers, and as promised the first issue of *Intentions* was distributed on January 2, 1922. With its elegant

gray covers and deep black typeface, *Intentions* was noted for its design as well as its editorial statement. Acknowledging that many new literary journals rubbish their predecessors and claim most contemporary writers without value, by contrast André-May wanted to reestablish the cult of veneration and pay humble homage to many living masters. This was an intelligent position in keeping with the journal's taste for *Classicisme moderne* rather than radical avant-gardism, and though only a modest thirty-two pages, selling for two francs, the first issue garnered attention and praise. André-May ran the entire business from his parents' apartment, where he was "at home" every Saturday between four and six to receive potential collaborators. He continued to live at Rue Phalsbourg for much of his life.

Marcel Proust was one master, who André-May visited on his deathbed, after having published two rare texts at a time when it was still a risky choice. Indeed, one reviewer called the extract, "a heavy slice of the new 'pudding-psychologique' of Monsieur Proust." Paul Claudel, who never published his work in journals, sent *Intentions* a suite of twelve poems from Tokyo where he was then ambassador. André-May also managed to persuade another writer-diplomat, Saint-John Perse, to contribute, as well as Jules Supervielle, who divided his time between Paris and Montevideo. André-May's persuasive powers resulted in a long roll call of distinguished contributors: poems by Pierre Reverdy and the very young Michel Leiris, texts by Philippe Soupault and André Breton, works by François Mauriac and Raymond Radiguet, and topical reviews by everyone from Paul Éluard to Robert Desnos.

The format of *Intentions* was to introduce a writer's work followed by a critical essay on the author, and thus some figures appeared both as contributors and critics. Max Jacob, for example, wrote an essay on the notorious Marcel Jouhandeau (whose novel *Monsieur Godeau* was published in long sections in five consecutive issues, to as much protest as praise, and was even sent by Gide to Arnold Bennett) as well as his own poetry. At the nightclub Le

Boeuf sur le Toit, André-May met the composer Darius Milhaud, whom he persuaded to write essays on contemporary music including an early appreciation of American jazz. *Intentions* also published special issues, the first of which was dedicated to Valery Larbaud, for whom André-May also hosted a celebratory dinner after his Légion d'honneur. Larbaud, still enjoyed today in France, is perhaps best remembered elsewhere for his championship of Joyce, on whom a special number was planned for January 1924. In the end this did not appear, nor did an issue on Gide, but Joyce's short story, "The Sisters," was published in translation in 1922. Larbaud was also behind a special Spanish issue which introduced the "Ultraïste" movement to France, and such writers as García Lorca and Ramón Gómez de la Serna.

Distribution was always a problem, as it remains for any small literary journal, and though *Intentions* was placed in bookshops from Japan to Chile by its contributors, no issue probably sold more than three hundred copies. Thus despite strong letters of appreciation and support from Max Jacob, Proust, Gide and Cocteau, *Intentions* was forced to close when André-May's father decided he could no longer cover costs. The last issue, a triple number (28–30), came out in December 1924 and still owing money to the printer, André-May was forced to sell some of his rare books via Monnier. André-May was then only 23, and after working in his father's office he began dealing antiques, later opening a shop on Rue de St. Père where he bought and sold beautiful objects for the rest of his life.

This impeccably discrete retirement from literary life was only interrupted by the publication of his novel *Le Matin* in May 1945, a bad year to issue a book, not least because as an aesthete André-May must have been horrified by the cheap paper Éditions du Pavois were obliged to use, which by now is as brown and brittle as toast. *Le Matin* is not without its charms, a very French coming-of-age romance heavily indebted to Proust. André-May kills off his father as a doctor at the Front and details his adoration for his

mother, stealing into her bedroom to watch her sleep and falling asleep himself with her letter pressed to his heart. The atmosphere of adolescence at a small chateau is charmingly caught, creating his own marionette theatre complete with candles, spying on a beautiful local servant boy with blonde curls in the enchanted domain of the *jardin d'hiver*.

Despite relative poverty, André-May always lived in a beautiful apartment, which cost almost nothing having been rented from before the war, surrounded by exceptional pieces saved from his shop and portraits of his many adored dogs. His only luxury was a full-time butler, a difficult man only a few decades younger than himself, who would often forbid guests due to his reluctance to cook. This life of elegant obscurity was mitigated through his rediscovery by the young literary scholar Béatrice Mousli, who dedicated her thesis to André-May, the oral defence of which the great man himself attended with his even more elderly female coterie. Mousli published a fascinating book, *Intentions, histoire d'une revue littéraire des années vingt* (Ent'revues, 1995), without which no appreciation of André-May — including this obituary — would be possible. Thanks to Mousli, André-May's place in literary history has been replotted, as the French diplomat and critic Henri Hoppenot foresaw: "It is something for you to be able to say that one could never now write the history of three major years in French literature without citing *Intentions*."

Pierre André-May, literary editor and antique dealer;
born Paris, January 15, 1901, died Paris, April 1, 1999.

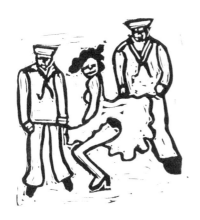

SAM SHAW

MASCULINE cool may now be used to market everything from magazines to alcohol, but its true heroes all belong to an age before such self-conscious narcissism. Sam Shaw was a perfect exemplar of that mythic era. Shaw personally created two key iconic images of the late twentieth century: Marlon Brando in a sweaty T-shirt for *Streetcar Named Desire* and Marilyn Monroe with her white dress ablow for *The Seven Year Itch*. Shaw not only took these photographs, he came up with the original ideas, persuaded the actors to agree and styled them with his own hands, at least four professional jobs by today's industry standards. But just when Shaw starts to sound like a Hollywood hack, one must recall he was also the producer of John Cassavetes films. Shaw may have been a fixer, a go-between and publicist, but he was also a well-read, sophisticated and charming cultural omnivore with an awesome range of contacts and interests.

Shaw grew up tough and poor in New York's Little Italy, where his creative energy was already evident, creating sculptures out of mud to support himself. Offered a scholarship to Pratt to continue painting, or a studio in which to work, he took the studio, along with the artist Romare Bearden. Finding work as a courtroom artist, and

then a political and sports cartoonist at *The Brooklyn Eagle*, Shaw became a full-time photojournalist with covers for *Life* magazine and *Look*. Shaw moved into movies as a stills photographer, and had an ability to integrate the biggest stars with ideas for publicity campaigns, script changes, plots.

In 1951 Shaw persuaded Brando, who "thought it was vulgar" to be photographed in his undergarment for *Streetcar*. On *Viva Zapata!* (1952) Shaw was the only mutual friend of Brando and Anthony Quinn, even judging a peeing contest between them and diplomatically declaring it a draw. In 1958 he covered *One-Eyed Jacks* (1961) for *Life* whilst also acting as a "fat checker" for Brando: "I'd point to my chin, telling him to keep his head up so there wouldn't be a double chin." In 1979 Shaw published his photographs and reminiscences in *Brando In The Camera Eye* (Exeter Books).

Shaw first met Monroe on the set of *Viva Zapata!* where she worked as his driver. When Shaw read the script of *Seven Year Itch* he recalled photographs he'd taken for *Friday* magazine of sailors at Coney Island, their girlfriend's skirts blowing in the wind. Shaw devised the publicity stunt with Monroe's skirt, and the event gathered fifteen thousand fans, almost as many journalists, blocked Manhattan traffic and ended her marriage to Joe DiMaggio. Shaw himself took the official photographs of the scene in the film, shot in the seclusion of a studio lot. These impossibly famous images later led to a $100 million lawsuit Shaw brought against his son for illegally reproducing Marilyn pictures. Shaw published three books on the actress: *Marilyn Monroe as The Girl* a 1955 paperback original (Ballantine), *The Joy of Marilyn* (Exeter Books, 1979) and *Marilyn Among Friends* (Holt, 1987).

The first film Shaw produced was *Paris Blues* in 1961, under the auspices of Brando's production company, Pennebaker. A romantic tale of jazz musicians in France, starring Paul Newman and Sidney Poitier, it was very much of Shaw's aesthetic, including a moody score by Louis Armstrong. The link between this movie and Cassavetes films is obvious, a poetic vision of bruised male

grace and nocturnal camaraderie. Shaw introduced Cassavetes to burlesque houses in 1950s New York and remained one of his most devoted creative collaborators. Indeed a section of *Husbands* (1970), in which the men are surprised to discover themselves transported in a drunken fugue to London, was inspired by Shaw's experiences during *Viva Zapata!* Leaving Brando drunk on set in Texas, the very next day he was spotted strolling in Manhattan.

Shaw was also the production designer for *The Killing of a Chinese Bookie* (1976), storyboard artist for several films and producer of *A Woman Under the Influence* (1974; also winning several international awards for his advertising campaign), *Opening Night* (1977) and *Gloria* (1980). Many of Shaw's best photographs of Cassavetes were published in the German book *Cassavetes: DirActor* (PVS Verlager, 1993) and shown both at MoMA and the Venice Biennale.

Sam Shaw (Samuel Joseph Warshawsky), photographer and producer; born New York City, January 15, 1912, died Westwood, New Jersey, April 5, 1999.

DAVID SEIDNER

OSTENTATIOUSLY young deaths amongst overly talented American males already seem of another era, and the loss of David Seidner at 42 feels somehow very mid-eighties. Seidner had indeed been living with AIDS since 1984 and his relative longevity may be proof of his energy and stamina as well as medical advances, but it also marked him as a courageous fighter against the stereotypes of the illness and its attendant culture. If Seidner's death appears oddly historic already—albeit a history that only goes back fifteen years—that would be appropriate. Unlike most fashion photographers, Seidner was keenly interested in the past and the history of both photography and fine art, passions that informed his aesthetic, whether ancient Greek sculpture, nineteenth-century salon portraiture or the vanished world of prewar haute couture. Despite the inherent pretentiousness of the term Seidner really was an artist-photographer, whose large body of commercial work for magazines and advertising campaigns was just as inventive and creative as his more personal projects.

The precocity of Seidner's career, leaving behind as many museum shows as books, catalogues, editorial or advertising awards, started early, as precocity will. Born in Los Angeles in 1957, he had his first magazine cover at 19. This was in Paris, where he loved to work and live, shuttling between America and Europe all his working life. His first solo show was also in Paris at La Remise de Parc in 1978 and the next year he exhibited in *Artists by Artists* at the Whitney Downtown, followed by a string of shows including at the avant-garde Clocktower Gallery in Lower Manhattan in 1981. Such venues only require mention because the subsequent glamour and richness of Seidner's career obscure his genuine involvement in contemporary art at its most experimental as well as modish. Seidner studied art history and literature, and his signature technique of

taking portraits from above using a telephoto lens to equalise the distortion was developed on a shoot with his philosophic mentor John Cage. Interviewing Cage for the *Los Angeles Times*, Seidner only had a telephoto lens, so rather than a full-length portrait he took five different shots which he combined later.

Fragmentation, superimposition and multiple exposure became Seidner's style; a love of plaster, of glass plates painted black, scratched away to reveal fractions of an image, models surrounded by darkness, caught off-guard within some ultimate shadow, fragmented thus into installments. This very specific aesthetic was first seen in Britain in *Harper's & Queen* in 1986, where models and dresses were shown only as reflected in broken shards of mirror. "Smuggling art onto the printed page" was Seidner's aim though he was perfectly aware of the philistine milieu; "*Vogue* reduces old masters to 'Elegance in Art.' People don't go to the bathroom, they don't have nervous breakdowns, there is no alcoholism, it is a hermetically sealed world...." Seidner worked continually for magazines, including every country's edition of *Vogue*, *The New York Times Magazine*, *Harper's Bazaar* and *Vanity Fair*, where he recently shot descendants of Sargent portraits, made-up and photographed as if by Sargent—a quintessentially Seidner story. He also created advertising campaigns for Bill Blass, Bergdorf Goodman, Revlon, L'Oreal and Yves Saint Laurent, where he was under contract in the eighties.

Closer to his own interests was his work as a contributing editor to the small New York publication *BOMB*. He interviewed the legendary model Lisa Fonssagrives for them in 1984, when she was 72 and he 27. This reflected his fascination with the world of pre-1960s fashion, an era he eloquently mourned: "Gone the days of a finely crafted gown, of an entire day to do one photograph, of the woman who can best do her own makeup. Gone the notion of a well-turned ankle." Seidner was fascinated by the great models of earlier eras and as an enthusiastic historian and lecturer predated current studies of fashion microhistory. His last book

was *Lisa Fonssagrives: Three Decades of Classic Fashion Photography* (Thames & Hudson, 1996) which he personally originated, edited and designed. "Over an eight year period, I was blessed with having this miraculous spirit grace my life, our connection often seemed telepathic. She called it a special deep friendship and I thought it more like a platonic love affair." This statement comes from Seidner's introductory essay, "Still Dancing," which is also notable for revealing something of his moody nature: "My serious and sometimes depressive character... born with an old soul." Indeed a key to his cultivation of past legends and his romantic pessimism is nicely revealed by his writing in his journal that "the romantic was constantly endowing others with the qualities that I needed most, and as a result, I was constantly disappointed."

Seidner had a long list of publications, beginning in Paris with *Les Cahiers de L'Energumène* (Gerard Julien Salvy, 1983) and including *Moments de Mode* (Editions Herscher, 1986), *Eiko & Coppola on Dracula* (Collins Publishers, 1992) and a volume of studio shots of artist friends, *The Face of Contemporary Art* (Gina Kehayoff, 1998). The best retrospective volume is *David Seidner* (Schirmer/Mosel, 1989), which he conceived and designed, and includes an exemplary essay by Patrick Mauriès, "Fragments on Fragments": "The mechanics of fetishism might well serve as a basis for a first reading, however simplistic, of these images." This text also explains Seidner's modus operandi of long exposures "allowing the body to show itself, to unfold in its own time, to fall into its own elegance," what Mauriès terms "a certain langour in suddenness." The book features many Seidner portraits of such luminaries as Richard Serra, Lucinda Childs, Brice Marden, Christopher Isherwood, Alberto Moravia, Philip Glass, Christian Boltanski, Annette Messager and Cindy Sherman. There is also a suitably homoerotic image of Robert Mapplethorpe from 1978, when Seidner was just 20.

Mauriès writes accurately that, "Seidner's photography belongs from every point of view to the tradition of the grand formal portrait

which can be traced back, long before the golden age of fashion photography, to the society painting of the turn of the [twentieth] century." He also makes a crucial point about Seidner's neoclassicism: "What might be regarded as Seidner's formalism – the extreme refinement of his compositions, his fondness for a linear, calligraphic definition of the body." This is evident in Seidner's nudes, which he exhibited at the Robert Miller gallery in New York and later published as a book (Gina Kehayoff, 1995): "The right moment. What the Greeks called Kairos, an abstracted reality. I do not attempt to express anything."

Perhaps Seidner's most charming book was his photographs of historic maquettes, *Le Theatre de la Mode* (Du May, 1990) which he photographed at night – just as Paris couture was once photographed – when silence and isolation accentuated their theatricality. He spent a month with the dolls in their 1946 outfits, by which point they started to come alive for him. The colour provided by his favoured Paris laboratory, Central Color, was particularly evocative and indeed Schneider's colour-work as opposed to his self-consciously avant-garde black and white portraits may finally prove to be his finest. As Susan Train writes in her *Avant-Propos*, *"il a souffert et lutté pour capter sur son film la vie sècrete de ces créatures inanimées"*. Seidner's French was sufficiently expert that he wrote as well as photographed for *Vogue Paris*, and his essay "La Répétition" later published in *Le Theatre de la Mode*, was at that time the only text by a foreigner that was not translated.

Seidner was, of course, as active a socialite as a photographer with the proviso that his snobbery was of that preferable genre that pursues the artistically and intellectually gifted rather than merely rich or titled. Tales of his sitting at Café Flore after the opening of the Picasso Museum and greeting Paloma Picasso: "Oh Paloma, we've just been at your daddy's museum" should not be easily dismissed. Seidner ended up friends with all his cultural obsessions simply by dint of wanting it enough. His friend, the artist Ross Bleckner, recalled Seidner as "The Energizer-Bunny" thus:

125

I always saw him around for a long time, with such style and his taste, he really knew his stuff and also had incredible courage. He had such amazing energy, he never complained and he really fought hard. He was always fascinated with art and artists, he loved contemporary work but was a formalist, a classicist. He was collecting art from an early age, trading, buying when he could. The fact that he had to make his living as a commercial photographer, well, perhaps he wasn't always thrilled by that. Perhaps he always wanted to be taken more seriously as the artist he was.

As an AIDS activist Seidner was a member of the board of the Community Research Initiative and his portraits of celebrities with the disease were used in advertising for AIDS research. But he also was scathing about "red-ribbon" platitudes, notably in an essay he wrote for the *New Yorker* in 1993. He was honoured with the Eisenstaedt Award for Portrait Photography by Columbia University in 1998 and by a retrospective at La Maison Européene de la Photographie in Paris planned for 2000. Perhaps the best description of Seidner's work comes from himself: "Little about photography is true of course, except that it serves up artifice and fantasy as truth. In these half-truths, we can only hope to ascertain glimpses of reality, reflections of a troubled or ideal world."

David Seidner, photographer and writer; born Los Angeles, February 18, 1957, died Miami Beach, June 6, 1999.

JULIUS TOBIAS

ALTHOUGH Julius Tobias was an artist of wide inspiration who worked over decades in as many media as styles, he is perhaps best remembered as one of the boldest and most innovative of those American sculptors who became known as minimalist. His sculptures were often of such scale as to become walk-in rooms in their own right, but their immensity made them impossible to preserve other than as architectural drawings and scale models.

Tobias was also representative of a generation of American artists who studied under the GI Bill, often abroad, and then revitalised downtown Manhattan with their illegal lofts and studios. These urban pioneers were a hardy lot, as good at building furniture and repairing roofs as stretching a canvas, and it is indicative of Tobias's physical stamina that his death — due to medical malpractice during a routine operation — should seem premature even at 83.

Julius Tobias was born in 1915 at the Harlem Hospital, the only White child in the ward. His grandfather was a rabbi in Ukraine and his father immigrated to New York at the turn of the twentieth century, peddling lace for a living despite a great love of music. His father died when Tobias was 17, just when he had been inspired to become an artist by a reproduction of Gainsborough's *Blue Boy*. Though he studied in the evenings at the American Art School, he was obliged to work, first as an elevator boy, for $7 a week, and then in the post office for five years. He became a Communist sympathiser and though never joining the party officially, he remained a lifelong Marxist.

At the age of 27, he signed up for the US Army Air Forces. Stationed with the Eighth Air Force in England, he flew B16 bombing raids over Germany, seated under the pilot in a curved, transparent space, watching the beautiful flak below. This strongly influenced his later sculptural themes of negative space and spatial

relationships. Pursued by ten German planes on his twenty-sixth mission, he managed to shoot down all but one before crash-landing in a Swiss potato field. He was sent to Adelboden, where officers of every nation were gathered, in great comfort, and where he became friends with the widow of Ernst Ludwig Kirchner and was greatly inspired by her collection of paintings. After six months Tobias escaped from Switzerland by night taxi to Lake Lausanne and thence by rowboat to France, where he was met by a member of the French Resistance, then spirited via Lyon back to London. He was awarded the DFC (Distinguished Flying Cross) with Four Clusters and a Presidential Unit Citation then sent back to Fort Dix, Texas. This was at the height of segregation and Tobias fought on the micropolitical level of everyday acts against the apartheid of the era. Back in New York, he met his wife and soon after marrying in 1948 they moved to Paris on the GI Bill. Tobias studied with Fernand Léger, whose political convictions and socially driven aesthetic were close to his own beliefs. He and his wife remained in Paris for four years before returning to New York.

Tobias was in an early group show in 1957 at the legendary Brata Gallery in New York, but in 1946 he had already shown with the Provincetown Art Association, a centre of Abstract Expressionism on a par with the Brata. His first one-man show was in 1959 at the Esther Stuttman gallery and he later showed at the Museum of Modern Art in Tokyo and Gallery Creuze in Paris. Having moved from neo-plastic abstracts to white, wall-sized paintings Tobias began making large-scale sculptures and rooms within rooms. These clean, well-lit, austere spaces were at the forefront of the new minimalism. A *New York Times* review of 1968 describes them thus: "The size of small rooms, white-walled, they enclose precise, sparse arrangements of large beams. Disciplined abstract exercises on the one hand, they are also imaginative, even poetic, conceptions on the other."

Tobias used masonite, wood, cement and concrete to create environments, including for a notably strong series of shows

from 1970 onwards at the Max Hutchinson Gallery. At his own loft nearby he simultaneously showed a full-scale room environment, *TATHATA*, within which the fashion model Peggy Moffitt was photographed for an ultra-modernist shoot. Tobias had one of the original lofts of NoHo (north of Houston Street, as opposed to SoHo), on Great Jones Street, an area that remained notoriously rough. He was continually robbed, as were neighbours Meredith Monk and Robert Rauschenberg, in an era well-captured by Don DeLillo's 1973 novel, *Great Jones Street*. Tobias's sculptures—such as *The High and the Low*, variously sized slabs of poured concrete weighing in total some 10,000 pounds, or the sequence of slab units, *Slab City*, or the concrete walls of *Half and Half* (all 1971)— now look like precursors of everything from the work of Richard Serra to Peter Eisenman's Holocaust memorial in Berlin. Their elegant aggression culminated in a series of barrier installations, for which Tobias blocked the entrances and circulation of his gallery shows, reflecting his view that "art, to be vital, should somehow go against the grain." Such abrasive anti-commercialism was typical of the time.

Tobias showed an *Interior Space* installation at the Whitney Annual in 1967, and his work belongs to numerous collections such as the Brooklyn Museum and the Albright-Knox Gallery, Buffalo, but the sheer list of grants he received suggests not only his worth but also his constant commercial struggle. His sculpture had been growing larger and larger, turning into outdoor public art installations such as *Homage to the Cows of the Sioux Falls Stockyard* (1981), when he slowly returned to painting. Around 1983 he devoted himself increasingly to canvases of stacked bodies in piles, clearly making reference both to the Holocaust and to other arenas of twentieth-century butchery. These were his first overtly figurative series, curiously returning to Léger's own socially and politically engaged figuration which he had studied thirty years earlier. Tobias's ominous paintings culminated in a series of all-black canvases, suggesting a return to classical monochrome modernism.

They were shown at the Pardo Sheehan Gallery in New York in May, his first exhibition of paintings in the city in forty years, indeed practically since his first solo show – also of all-black canvases. Asked the most memorable thing he had learnt from Léger, Tobias repeated a single phrase which serves well as his own epitaph: *"Ca doit être monumentale!"*

Julius Tobias, artist; born New York City, August 27, 1915,
died New York City, June 16, 1999.

ALBERTO GIRONELLA

MEXICO, as mirror and motor of so many "-isms," from Surreal to modern, naturally guards its own chart of cultural heroes – and if Alberto Gironella never achieved the global repute of fellow legends like Rivera, José Clemente Orozco or Kahlo, that probably suited him fine. As a Mexican nationalist it was doubtless sufficient to be revered at home in a manner that would seem exaggerated in any other context. For Gironella was extremely, overtly famous in Mexico, and as with his fellow twentieth-century Mexican art stars, it was as much for his political and social involvement as his painting, not to mention an appropriately juicy home life. Gironella may have been Mexico's greatest living painter (the sort of thing few countries currently even aspire to) and portraitist of Emiliano Zapata, but he was also the founder of one of its most important newspapers and an unofficial ambassador-at-large for that mélange of machismo and militancy which is so Mexican.

Proof of his extreme Mexicanness was a recent commission to paint the portrait of the singer Madonna, a collector of Kahlo and connoisseur of Mexican modernism who was deliberately seeking the last link to that entire generation of artists and intellectuals. Though Gironella had exhibited with Rivera and Tamayo in 1953, at the tender age of 24, he soon became notorious for representing a younger generation challenging the dogma of ruling muralists like Rivera, by proposing a more personal, subversive aesthetic instead of the Communist Party-led social realism of their elders. This approach has been labeled Surrealist, but Gironella's affiliations and influences were with a whole range of art practices including Cobra, Nouveau Réalisme and Tachisme.

Gironella was born in Mexico City in 1929 to a mother from Yucatán who spoke Maya and an immigrant father from Catalonia who took him regularly to bullfights, the family root of one of his

later obsessions. His other lifelong passion, for literature, was well served by his studies in that subject at the National Autonomous University where, after graduating in 1949, he founded a small literary magazine, *Clavileno*, and created another equally fleeting journal, *Segrel*, two years later. Writing poetry and even a full-length novel *Tiburcio Esquila*, none of which found publication, Gironella's creative frustration led to his becoming an artist, at which he was instantly successful.

He spent four years in Montmartre, like so many Mexican painters before him, and continued to be a serious Francophile all his life. Gironella was a regular at the famous lithography workshop Atelier Clot in Paris and his prints were especially well-regarded, illustrating a range of books such as Carlos Fuentes's *Terra Nostra*, Lowry's *Under the Volcano* and works by Miguel de Cervantes, Julio Cortázar, Flaubert and Nietzsche. One of his major influences was the Vélazquez retrospective in Madrid which he had seen during his European travels of 1961–64. Gironella later did his own, almost equally revered interpretations of *Las Meninas* and of famous works by Goya.

Following a tumultuous 1958 exhibition at the Unión Panamerica in Washington, DC, he won a prize at the 1960 Biennale des Jeunes in Paris where he also had a successful solo show presented by Edouard Jaguer entitled, "Mort et transfiguration de la Reine Mariana." Gironella was always more than just a painter, he was a social and cultural catalyst, becoming the close friend and collaborator of everyone from Fernando Arrabal and Octavio Paz to Surrealist mainstays such as André Breton and poetess Joyce Mansour. His best, lifelong friend was probably Luis Buñuel, even though Gironella admitted a singular dislike for any form of cinema and only spoke of poetry with his compadre.

In 1963 he organized a large exhibition on José Guadalupe Posada in Paris, the first serious critical retrospective on the popular artist, for Gironella was as committed to promoting culture in general as his own work. Indeed he dedicated a series of his

exhibitions to other figures, like Buñuel or the matador Manolo Martínez. He was also involved in several collaborations, notably with Pierre Alechinsky, with whom he exhibited at *L'écart absolu*, the last official exhibition of the Surrealist movement, held in Paris in 1966. The previous year they had engaged in a pictorial duel, producing etchings in competition with each other. In 1980 Alechinsky came to stay with Gironella and they embarked on a large series of collaborative works about bullfighting, resulting in an exhibition which toured everywhere from the *Centre culturel mexicain* in Paris to Madrid and Jutland, before it was jointly gifted to the Musée Réattu in Arles in 1996. This work also resulted in a combative book, *Deux pinceaux dans le sable* (Actes Sud, 1996).

In 1980 the two artists also appeared, along with Octavio Paz, on one of Mexico's most popular TV programmes, *14.15* on Canal 2, to discuss "*Pintura, Poesia y toros.*" In his obsession with bullfighting Gironella often dressed in full matador costume and there is an impressive photograph of the white-bearded patriarch in full regalia, a woman slung in his arms, which appears in another deluxe book entitled *Noche Fantastica - Tauromaquia* (Galería Sloane Racotta, 1980). Indeed Gironella boasted that his bullfighting pictures, which always featured the number 8 (another of his fetishes), completed the trilogy started by Goya and Picasso.

Gironella may have been an avant-garde rebel in his youth but he soon received official approvals such as a Guggenheim grant in 1968, and an even larger one from the *Fundación cultural televisa* in 1977, making his permanent home back in Mexico at the mountainous lake resort of Valle del Bravo. He also bravely demonstrated his active interest in his country's public life when, during the press crackdown of 1984, he donated several of his paintings and took an active role in founding the left-wing newspaper *La Jornada* which soon became one of Mexico's leading dailies. *La Jornada* itself reported Gironella's death with an elegant full-page cover photograph but no accompanying story, in keeping with his ferociously reclusive, if not testy legend. Though it is known he died after a

long battle against bone cancer and that his body was immediately cremated, any details concerning his demise or the number of his wives, girlfriends and children, legitimate or otherwise, are still suitably oblique.

By his own description, "The spectator remakes the painting that he sees. Each recreates in his own way. Sometimes the secret remains as complete for him as for me. For there is a secret in that anomalous relationship which is a painting; I do not know why I put this next to that. There is something irrational within this...."

Alberto Gironella, artist; born Mexico City, September 26, 1929, died Mexico City, August 2, 1999.

SHARI PEACOCK

SHARI PEACOCK's death was as mysterious and frenetic as the rest of her short life. She had recently enrolled at a professional dance school in Hamburg and having been losing weight and repeatedly coughing, went to a local hospital where she stayed for tests and died in her sleep. The cause was lung cancer. Peacock, who loathed smokers and whose obsession with fitness had come to dominate her life, was not aware she was ill. That she should be able to die so suddenly, casually, from what is considered a long, inherently self-conscious disease was typical of her talent for paradox.

She was a dancer and athlete but also a writer, calligrapher and illustrator, and, by training, an architect. She was an Iranian, but an Iranian born in Sofia, Bulgaria with the name Sharareh Pouladvand – confusingly the name Peacock came later from her English husband. Thus she spoke Farsi but also Bulgarian, English and Russian, from the Soviet school she attended as a Young Communist. Her mother and father were Iranian exiles. Both were committed Communists who had escaped Iran when the Shah took power. They made their way overland along the ancient trading routes to Bulgaria, happily coming to rest in a genuine Communist state. When, years later, the Shah's regime became more tolerant of Communists, the Pouladvands returned to Iran. No sooner had they arrived than the Ayatollah took power and they had to escape once more, back to Bulgaria.

By this time Peacock had already moved to Britain. With the sponsorship of a generous uncle, she was able to enroll at the Architectural Association in Bedford Square, London in 1975, at the very height of its international pan-theoretical reputation, Zaha Hadid being a slightly older fellow student. She married the architect Jeremy Peacock and became a central character in a now celebrated social and creative milieu between Glam decadence

and the bosky foothills of punk. She had an instinctive genius for friendship; her range of admirers, acquaintances and acolytes included Anita Pallenberg and Rostropovich (who improbably lived downstairs from her on the Holloway Road), writer Geoff Dyer, the architect Liza Fior, cancer specialist Professor Jonathan Waxman and an eighties art group, the Grey Organisation. Whether teaching at St. Martin's School of Art or training at the YMCA, Peacock was always looking for new recruits to her ever expanding army – people with some sense of "style," either academic or physical. This was just before style became a microindustry of its own, and it was an infectious, central element of the zeitgeist, in a London of New Romantic exhilaration. Having grown up in Soviet Bulgaria, Peacock had a hunger for Western, especially American, style. This meant not just fashion but a whole attitude toward existence, an active aesthetic akin to dandyism. This fascination led her to become an artist and she forced herself to draw every day, perfect her technique, refusing to relax until she had turned herself into a well-know fashion illustrator.

She won the Cecil Beaton Award organised by *Vogue* magazine, was profiled in the women's pages of the *Guardian* and worked for a wide variety of publications, from the glossies to music journals, book covers and even *Girl About Town*, which she had earlier distributed outside tube stations to support herself as a student. Peacock's line was unique, simultaneously sensual and sinister, as if Egon Schiele had downed some opium and crawled out along the catwalk. Ironically, Peacock also designed the cover of *The Molecular Biology of Cancer* (1989), a subject her work suited weirdly well. She also created the cover and numerous illustrations for *Sexual Exercises for Women* by Anthony Harris (1985), a subject in which both her drawings and life were well versed. After finally travelling by Greyhound Bus around her mythic America, writing about Donald Judd in Texas for *Tatler*, and doing live sketches of jazz musicians for *The Wire*, Peacock had somewhat exhausted her interest in fashion style.

Instead she became increasingly obsessed with literary style. Driven by a desire to emulate everyone from Nabokov and Joseph Conrad to the traditional Russian greats, Peacock devoted herself to the laborious creation of a novel. This was laborious not only because it had to be absolutely faultless, a text of which not a single word could be changed, but because she hand-wrote every letter, whitening out mistakes to write over them. The final manuscript resembled one of the masterworks of her great-grandfather, a Persian calligrapher. Supporting herself by teaching drawing, Peacock laboured for years over this novel whilst slowly developing a new passion for gymnastic exercise, dance and ballet. It was as though she had finally found a discipline suitably punishing, one which demanded the perfection she always sought, a masochistic perfection all the more impossible for her relatively advanced age.

Finally Peacock moved back to Bulgaria where she could devote herself full time to dance training. And it was in Sofia that her novel was finally put out by an English language press, Vessela Lyutskanova, in 1998. Entitled, suitably enough, *English as a Foreign Language*, the book turned out to be a vivid roman à clef about her years in London which did not automatically find favour with its thinly disguised cast of characters. Peacock then enrolled with the dance school in Hamburg, telling them she was 34, for 43 is as ludicrously old to be dancing as it is young to be dying. Satisfied that she was by now without a jot of surplus weight, Peacock continued to push herself physically even when dangerously weak, her love of Simone Weil—the Catholic mystic who starved herself to death—perhaps setting a dangerous precedent. Her longterm attraction to occultism and spiritual purity had led inevitably to a conversion to the Bulgarian Orthodox Church, and there was indeed all the intensity of the martyr in her end, not to mention subsequent rumours that she might even be nominated as a potential Orthodox saint. A certain complex exoticism even accompanied Peacock's burial in the mountains of Bulgaria, as a delegation of young Iranian muslim zealots fought to claim her soul for Islam,

trying to drown out her favourite Beethoven with Muslim chants, until her father drove them all away by opening a bottle of the finest wine to drink a final toast in her memory.

Shari Peacock (Sharareh Pouladvand), artist, writer and dancer, born Sofia, May 30, 1956, died Hamburg, September 27, 1999.

STEPHEN GREENE

T HE artist Stephen Greene, handsome and natty as ever at 82, was sitting at home in the country north of New York awaiting a driver to take him into the city to deliver a lecture on Ingres portraiture when he died. That Greene, known as an abstract painter, should have been expert on Ingres hints at both his working knowledge of art history and continued dedication to education, for Greene still believed in the transformative and redemptive possibilities of art above all else. In this same spirit he was due to give a lecture at the Art Students League on his entire life's work.

Greene may have been a committed abstractionist for some forty years, but he had trained, worked and was well known as a figurative painter long before his exemplary conversion to abstraction. This happened after a lecture by Clement Greenberg on Barnett Newman in 1957: "I had chills running down my spine. It was like a bad movie." After that, Greene reportedly "couldn't draw the figure like I used to." His last show in New York, *Five Decades*, held at David Beitzel Gallery in 1998, spanned his whole career in fifteen representative oil paintings, including his earliest Renaissance-related religious works as well as his succulent, spontaneous last canvases.

Greene was born in New York in 1917 and attended the National Academy School of Fine Arts and then the Art Students League, both in his hometown. He followed these with a BFA and a MA from the University of Iowa in Iowa City. He was taught by Philip Guston, who remained a close friend but also something of an unshakeable namecheck, always mentioned in any article on Greene. After seven years in Iowa and Indiana, he came back to Manhattan and had his first solo show in 1947 at Durlacher Brothers, with whom he continued to show until 1952. That year he won the Prix de Rome and the four years he spent at the American Academy proved a major transformation, not only for his exposure

to the wide vistas of southern Italy and sixteenth-century Mannerist painting, but also for meeting his wife, Sigrid de Lima.

Greene had been forewarned of her arrival by a fellow Rome scholar, William Styron, who had previously been her boyfriend. De Lima, a highly respected American novelist, married Greene on Christmas Eve 1953. "It's the one day I'm not teaching," she said, "I'll be home." Their honeymoon in Tunisia had a significant influence on Greene's later work, not least in his use of a searingly Mediterranean blue. De Lima and Greene were a devoted couple who lived and worked together for over forty-five years, much of it spent at their historic home in Valley Cottage, a suburb near Nyack, where Edward Hopper had lived. After her fifth novel was published in 1968, de Lima concentrated on raising their daughter, Alison de Lima Greene, now, appropriately, a curator at the Museum of Fine Art in Houston, which holds work by Greene in its collection. Indeed, Greene is represented in all the principal American museum collections, from *The Burial* (1947), an early neo-Renaissance painting belonging to the Whitney, through to late abstract works in the Guggenheim, the Carnegie, MoMA and the Brooklyn Museum.

Altogether, Greene's work appears in some sixty public and corporate collections including the Tate in London, which included him in two round-up shows of twentieth-century American painting. In terms of gallery and museum shows (quite apart from their collections), Greene had an enviable track record, participating in over twenty-five group exhibitions at the Whitney Museum, the first in 1947 and the last in 1997. In 1963, in his mid-40s, Greene received a full retrospective at the Corcoran Gallery in Washington, DC.

Despite all the evidence of a successful career, Greene was thought of as a painter's painter with a relatively private reputation limited to art-world aficionados. His death may have been announced on National Public Radio, but as he once admitted, "Out of the forty-nine years I have shown, there may have been two in which I could live off my work." Instead Greene supported

himself as a teacher, a role for which he may be best remembered by decades of students whom he inspired with his enthusiasm and generosity. Greene had an absolute openness to helping younger artists and is recalled as a dynamic catalyst even by students who were only briefly taught by him years previously. His most famous pupil was Frank Stella, who admits his debt to Greene and who remained a close friend, even providing lodging for Greene on his visits to the city.

Greene was also close to such luminaries as the playwright Lillian Hellman, the gallerist Betty Parsons, the art historian Dore Ashton and Fred Licht, curator of the Peggy Guggenheim Collection in Venice, but he remained equally in touch with successive generations of students regardless of their professional status. For unlike most, those taught by Greene often remained practising artists for the rest of their lives.

If Greene's main inspirations remained Piero, Ingres and Arshile Gorky, regardless of the art movements and terminologies he saw come and go over the decades, the work that he produced so steadily, surely and modestly remains entirely his own. As he wrote, "What remains vital is the sense of your own statement. It is not a reissuance of what you already have. A sense of yearning persists and what you work and pray for is a vision that is uniquely yours."

Stephen Greene, painter and teacher; born New York City, September 19, 1917, died Valley Cottage, New York, November 18, 1999.

ROBERT BINGHAM

ROBERT BINGHAM had an overtly enviable existence and, though his accidental death at 33 is self-evidently tragic, his own sophisticated, subversive view of the world might not have seen it so. That is to say, though he would have happily lived to 90, Bingham's wry sensibility was sufficiently bold, cold, caustic and audacious that it could easily encompass such an early death as yet another cliché.

The circumstances of his death—he was found on the bathroom floor of his Tribeca loft after what was probably a heroin overdose—have provided cheap copy for the media and are easily misrepresented as either the tale of a rich junkie or of an American dynastic curse. The reality is far more subtle and more rewarding. For if it must be admitted that Bingham was a lover of women, alcohol and drugs, it must be added that he was equally a lover of literature, music, political policy, modern first editions, hockey and economics, both micro and macro. Much of this was in his blood, both the interests and the attraction to certain recreations.

He was from a well-known, extremely wealthy Southern family that had created a newspaper empire in Louisville, Kentucky. His great-grandfather, Judge Robert Worth Bingham, had been ambassador to Britain from 1933 to 1937, and his grandfather, Barry Bingham Sr., was reigning power of the clan. Robert Bingham Jr.'s father, Worth, was accidentally killed in July 1966, at the age of 34, when "Robbie" was only 3 months old. There are three hefty books on the Bingham family: *Passion and Prejudice*, by Bingham's aunt, Sallie Bingham (1989); *House of Dreams*, by Marie Brenner (Random House, 1988) and the Pulitzer prizewinning *Patriarch*, by Alex S. Jones and Susan Tiffet (Summit Books, 1991). Consulting their indexes, you might think young Robbie hardly stood a fighting chance. Next to the entry for the original "Bingham, Robert"

you find "as alcoholic"; while "Bingham, Worth," is followed by a suggestive litany: "death of, drinking of, drugs taken by, gambling by, girlfriends of."

Growing up in such a family had its own ritual atmosphere. One Christmas, aged 7, Bingham recited "Casey at the Bat" to his family; his grandmother disapproved of the chosen poem but at the next year's recitation contest he won $350 with "Once more unto the breach...." Later it became a tradition for him to recite from memory the entirety of Dylan Thomas's "A Child's Christmas in Wales" every Christmas Eve for his family.

Bingham was educated at Groton School and at Brown, an Ivy League university known for its ferociously high entry standards and very wealthy families. He graduated in 1988, followed by an MFA in creative writing from Columbia University in 1994. But perhaps the central event in his youth was the decision of his grandfather to sell the family business. Bingham was in Hong Kong when his grandfather called at five o'clock in the morning local time. "It was very eerie. I cried a little bit. It was like the end of a dream." From Brown he sent a long, heartfelt letter to his grandfather asking him not to sell to friends, who might not pay the full price. The grandfather wrote back a three-page response and distributed copies of both to the family. In the end the media empire was sold to Gannett for $435 million in 1986.

Bingham was thus worth a considerable sum, but much of this was also due to his own skill at playing a variety of financial markets. Although he was often riotously drunk or entertainingly blitzed on one of his cocktails of unusual chemicals, he was at the same time a diligent, smart investor who followed the markets closely and cannily. Bingham was also generous with his money. Most notably he supported the New York literary and arts journal *Open City*. His title there may have been "publisher," but he was just as involved in the selection of poems, rejection of art projects and consideration of potential covers. This interest in literary administration, even reading random unsolicited manuscripts after a long lunch at

the Racquet Club on Park Avenue, was an example of the diligent, hardworking and perfectionist side of his persona. This was all the more evident in the long hours and hard labour he put into his own fiction, not least his posthumously published novel, which he rewrote and refined through numerous drafts.

Bingham spent much time travelling, and formed a particular attachment to Cambodia, where he worked for two years on the English-language *Cambodia Daily* and was involved in the country's politics at many levels, even lingering with Prince Sihanouk in Parisian exile. Bingham continued to visit Cambodia on a regular basis, blessed as he was with the ability and temperament to travel as he wished, whisking someone he'd just met, say, from Chicago to Europe, or following his favourite band, Pavement, on tour. Bingham was passionate about Pavement, and spent much time with the band, including attending their most recent recording sessions in London, where he featured in several press interviews as a mysterious Southern gentleman with hip flask.

Pavement played at Bingham's wedding in Princeton. His beautiful bride was Vanessa Chase, a Harvard graduate art and architecture historian. Chase provided all the support and domestic stability Bingham lacked, as well as an intellectual and moral core for an otherwise haphazard lifestyle. He visited Venice frequently with Chase, where he bought and maintained a boat just for the sake of it, and had been looking forward to ushering in the Millennium with his new wife on the beaches of Cambodia.

Bingham had his own unique style of social action and anecdotes are abundant, often set in go-go bars, strip joints or country club marquees. He made the papers often, boldly hectoring Caspar Weinberger at the celebrity restaurant Nobu, or almost landing his grandmother in gaol in 1990. Bingham was working on the US Senate campaign for Louisville's mayor when he revealed, during a martini-drinking marathon, that his grandmother had made a secret contribution to the Democratic National Committee. In the end no legal action was taken, but it made a perfect Bingham

anecdote, involving his family's dynastic mystique, shady money and journalistic subterfuge, not to mention Martinis.

Somehow Bingham always maintained a redeeming charm. Even at his most murderously cruel, if not physically violent, one sensed a childlike innocence below it all. He wrote in a story, "That malicious bastard I can be flowered in my heart," and also, "But we are none of us the great murderers of our mind, just simple fools stumbling toward what is expected of us."

For someone who was so clearly, albeit unselfconsciously, a fictional character, Bingham's fiction appropriately stands as most fitting memorial to his manifold talents. His short stories were published in the *New Yorker*, the first when he was 26, and then as the collection *Pure Slaughter Value* (Doubleday, 1997). With triggering titles like "This Is How a Woman Gets Hit" and "Marriage is Murder," they are unique precisely because so genuinely shocking in their raw honesty and brutal realism.

Compared to John Cheever's, Bingham's characters are considerably more upperclass and considerably wilder, resembling some freak breeding of Hunter S. Thompson and Louis Auchincloss. However the comparison to Cheever stands with respect to the quality of the prose, for Bingham wrote with that magical excellence which sometimes finds one running a finger under the words in disbelief at how the author brought it off. There is also a noticeable subtext of early death: "A lot of his friends were doing it. They were dying or getting married. A few were doing neither, but the margin was narrowing. Max did not want to die, but he viewed marriage as a kind of death. He was twenty-nine...." One character pops his girlfriend's birth control pills when he can't find any Valium, then assuages his hangover by renting a porno, ordering out Indian food and falling asleep to his favourite war film, *The Guns of Navarone*.

Pure Slaughter Value will without doubt slowly establish itself as a minor classic of American literature; it is more revelatory than any autobiography, and phrases can be found that suggest Bingham's long love of the edge: "He still wanted to alter his life,

145

see what would happen to it if he tried to throw it away." Or: "that thrilling corner of his heart that still wanted to destroy himself, to make himself an early grave." Yet these ideas are also universal, for who has not felt, "He wished not for death but to be absent from his life"?

By all accounts Bingham's first novel, *Lightning on the Sun* (Doubleday, 2000), is even more impressive. A Graham Greene-style entertainment set in Cambodia, it establishes Bingham as a major writer, one whose career perhaps gained as much in media mythology as it lost in potential production. As his agent Jennifer Rudolph Walsh remarked, "We thought we were at the beginning of something so palpable and tremendous. And how did we know we were at the end as well?"

Robert Worth Bingham, writer, publisher, journalist and philanthropist; born Louisville, March 14, 1966, died New York City, November 28, 1999.

PAUL CADMUS

P AUL CADMUS became an overnight celebrity at the age of 29. He was a figurative painter all his working life, but scorned labels such as "realist" or "traditional," much as he disdained acclaim as one of the first openly homosexual artists. It was such sexuality that first made him famous, when his painting, *The Fleet's In* (1934), commissioned by the Public Works of Art Project and hung at the Corcoran Gallery in Washington, DC, was removed by the US Navy in a storm of official protest. Admiral Hugh Rodman denounced the painting as "a disreputable drunken brawl," by an artist with a "sordid, depraved imagination." Colonel Henry Roosevelt, Assistant Secretary of the Navy and cousin of the president, declared that the painting "will for ever be out of sight" and took it home, although he subsequently bequeathed it to a private club in Washington, the Alibi Club. Tracked down by an art scholar and restored to the Navy Museum, *The Fleet's In* has become a favourite exhibit, with its depiction of sprawling sailors, vulgar hussies and an evidently homosexual admirer. Cadmus created a print from the painting as soon as it was confiscated: "I'm going to do the picture as an etching. They can tear up the canvas, but they'll have a sweet time eating copper." Other Cadmus canvases such as *Sailors and Floosies* (1938), *Coney Island* (1935), and *Herrin Massacre* (1940; commissioned by *Life* magazine but rejected as too violent and political), all likewise caused controversy and protest.

Cadmus was born on 103rd Street in Manhattan in 1904, and went through a rigorously formal art training, both of his parents being artists. At 10 his first published sketch appeared in the *Herald Tribune*, in a children's drawing contest. In 1933 he travelled to Europe for the first time, buying art reproductions in Florence and being influenced by Luca Signorelli's frescoes in Orvieto. With fellow artist Jared French, Cadmus cycled all over the Continent and

together they settled in a Mallorcan fishing village. After Cadmus was sent clippings about the American Scene movement, he painted the seminal *YMCA Locker Room* (1933) from memories of his home city. Returning to New York, Cadmus established himself as a highly successful young painter. His first one-man show at Midtown Galleries in 1937 broke all attendance records, with 7,000 visitors, and he sold twenty-six works over its five-week duration. Cadmus was involved in the foundation of the American Ballet through Lincoln Kirstein, a lover whom he smartly married off to his sister, Fidelma. The two of them became major collectors of his work, owning the grotesque series *Seven Deadly Sins* (1947).

It was Kirstein who came up with Symbolic Realism, the only term Cadmus approved to describe his work, although he was also part of the Fire Island School. He commented, with typical tartness, "I really do not consider myself part of the avant-garde, and I have continually done what I wanted without worrying about the latest trends in the art pages of the Sunday papers." In 1950 his work appeared at the Institute of Contemporary Arts in London in a show called *American Symbolic Realism*. An important influence on Cadmus was his intellectual mentor, E. M. Forster, to whom he sent food packages during the Second World War and who came to stay unexpectedly in Cadmus's studio when he visited Harvard University as a speaker. The two had a long correspondence and Cadmus drew Forster's portrait at Cambridge — Forster read from his then unpublished *Maurice* during the sitting. This watercolour became the cover of the first British edition of *Two Cheers for Democracy* in 1951.

The single major shift in Cadmus's work came in 1940 when he adopted the laborious, ancient technique of egg tempera, and his production dropped drastically. As he stated, "I consider overproduction to be the characteristic vice of the modern artist," and created only sixty-six paintings in the next forty years. However, these included masterpieces such as *Bar Italia* (1953–55), *Le Ruban Denoue: hommage a Reynaldo Hahn* (1963) and probably his single

finest work, *Night in Bologna*, painted in 1957. A 1981 retrospective at the Miami University Art Museum was followed by a catalogue raisonné of Cadmus's prints, a book of his drawings (Rizzoli, 1989) and a limited edition selection of photographs, *Collaboration* (Twelvetrees, 1992). He was in the collection of every leading American museum, was elected to the National Academy and was a member of both the American Academy and the Institute of Arts and Letters. He found further much-deserved fame in the documentary *Paul Cadmus: Enfant Terrible at 80* (1984), in which he admitted, "I'm slow and lazy, but how much does one have to say anyway?"

Paul Cadmus, artist; born New York City, December 17, 1904,
died Weston, Connecticut, December 19, 1999.

MARK LOMBARDI

THOSE who live by conspiracy theories die by them also, and it is hardly surprising that the suicide of the artist Mark Lombardi at his home in New York should have launched a wave of paranoid rumour. For Lombardi's art was specifically based on scandal, crime, dubious dealings and contemporary financial and political conspiracies. Lombardi obsessively researched these cases, then turned the gathered information into detailed, strangely beautiful drawings, elegant diagrams linking participants and plotting arcs of influence. Considering that these drawings outlined events such as the Whitewater and Vatican Bank scandals, several of which involved suspicious suicides – specifically by hanging – Lombardi's death naturally evokes a certain doubt.

Very recently his career was going better than ever, achieving at last precisely what he had long desired; strong critical response to his work, several solo shows and inclusion in the major exhibition, *Greater New York*, which opened at MoMA PS1 just a month before he died. Lombardi had been warned not to continue with a planned drawing tracing connections between New York mob families, and had abandoned it for the safer topic of a microhistory of the Neo-Geo movement. Lombardi was influential in the New York art world, and specifically in the community of younger artists who live in Williamsburg, Brooklyn, not only because of the resonance of his drawings, but also as an older artist who had been out in the world and settled down to make work relatively late in life.

Born in Syracuse, New York State, in 1951, Lombardi received a bachelor's degree in art history at Syracuse University and then moved down to Texas where he lived for some twenty-five years. He became a curator at the Contemporary Art Museum in Houston and ran his own small gallery, Square One, whilst working as an abstract painter. In 1993 he started his first drawings, inspired by

doodles he had made on the phone while discussing the Savings & Loan scandal with a banker friend. Paul Schimmel, curator of the Museum of Contemporary Art, Los Angeles, saw these drawings in 1996 and awarded him a prize, including a solo show, at the Lawndale Art Center. Lombardi began showing with the Robert McClaine gallery in Texas before realising that, having spent most of his life as an art administrator, it was time he took the plunge and moved to New York as an artist.

Lombardi was quite open in his ambitions; he had moved to the city to become famous. He was socially gregarious, a smoker, drinker and committed art world fixture always distinguished by his blatant intelligence, amusing anecdotage and certain personal elegance; a connoisseur of Parmigiano-Reggiano who considered socks unsophisticated, who might abruptly leave the city to go skiing for the day. With his clear spectacles and crewcut, Lombardi sometimes resembled a CIA systems analyst, a fast-talking fact cruncher whose uncanny energy could result in his staying up several nights in his studio.

Lombardi rapidly gained attention in Manhattan, from a group show at the Drawing Center to his first solo exhibition in 1998, *Silent Partners*, at the alternative space Pierogi 2000 in Brooklyn, to *Vicious Circles* at Devon Golden Gallery in Chelsea in 1999. Lombardi considered the core of his work to be research and sketching; he would read at least two newspapers per day, Xerox endless articles and had a fat library of books covering conspiracy theories. Lombardi would read every available book on his chosen scandal and, taking copious notes, would distill the essential ingredients of the story on colour-coded index cards, a handwritten database of more than twelve thousand three-by-five inch cards. From sketches he would create a maquette, then start on the larger diagram, in which, for example, a black dot could symbolise a two billion dollar loss, black lines traced actual events and red lines showed criminal charges.

His favourite work, the massive piece on show at PS1, had been destroyed when a sprinkler went off in his studio, so he

stayed up for eighteen hours nonstop recreating it for the exhibition. The end result was even better. Lombardi had priced this work very high, because he never wished to sell it, yet collectors were increasingly reserving the relatively few works he produced, some of which could take six months. As well as doing several versions of the same drawing, Lombardi made digital copies on an architectural blueprint machine when one was sold. Lombardi's drawings seemed an extension of conceptual art—he claimed Herbert Marcuse as an intellectual mentor—if not directly derived from Hans Haacke's research into financial and political skulduggery. In fact there is a whole sub-genre of such flow diagrams and plans in contemporary art, whether Simon Patterson or Nicholas Rule, Matthew Ritchie or Jimmy Raskin, but few others have dealt so directly with current events.

Perhaps somewhat overwhelmed by all the recent attention he had been receiving, including direct calls from collectors and curators, Lombardi had deposited his entire oeuvre, some sixty drawings, with Pierogi 2000 the day before his death. He was found hanged one day short of his 49th birthday. Circumstantial evidence suggests that Lombardi did indeed hang himself, his loft bolted from the inside with no other means of exit, but the congruity between his manner of death and his art cannot be denied. It seems almost a part of it, a culminating statement directly linked to his lifelong creative project.

Mark Lombardi, artist; born Syracuse, New York, March 23, 1951, died New York City, March 22, 2000.

JACQUES GUÉRIN

AN elegant, discreet and impossibly sophisticated gentleman of the old school, a figure of infinite learning, impeccable taste and only incidentally, a certain wealth: the last thing Jacques Guérin wished was for his name to be known to the public, let alone appear in a vulgar newspaper obituary (or hardback collection) such as this. His well-guarded life covered much of the last century as well as its most revered artists, writers and cultural figures. He is often referred to as a collector — of paintings, drawings, furniture, and above all books and literary manuscripts — but more than anything he was a collector of people, a friend, confidant and patron to everyone from Jean Genet to Chaim Soutine; a man who recognised talent (literary, artistic or merely social) sufficiently early to ensure he was always a part of history rather than mere observer or hoarder.

In fact Guérin was the sort of figure young, penniless artists dream of; a book collector who actually read the works he bought, an aesthete and connoisseur who truly understood the art he sought, a man of conservative demeanour who could recognise the brilliance of the most avant-garde figures of his day and help them on their way. Guérin was born in Paris in 1902 and his brother Jean in 1903, into true Parisian haute bohème. Their mother, Jeanne

Louise Guérin, was a great beauty, dressed by Paul Poiret, who lived with her two sons in an enormous apartment overlooking the Parc Monceau and maintained an occasional salon that included Erik Satie, who wrote *Tendrement* for her. Brother Jean became a quintessential flâneur and dilettante of the era, a dandy and *fumeur de toufaine* (opium) who ran with an international fast set involving Nancy Cunard, Georges Auric, Djuna Barnes, and Harry and Caresse Crosby. Jean's influence on his elder brother was considerable, even though he moved to California in 1930, becoming an American citizen and a painter with several exhibitions at the Georgette Passedoit Gallery. The slightly decadent tone of Jean's essentially abstract oeuvre might be guessed by titles such as *Strictly Watery* and *Femininity in Bathing*. When the Chartres Museum held an exhibition of his works in 1991, *Jean Guérin, 1903–1966*, his brother wrote one of his very few personal texts for the catalogue.

Jacques Guérin remained in France all his life and soon began to cultivate his own contacts in the creative milieu, dedicating himself to figures rather more substantial than his brother's glamorous socialites. One of the artists whom he supported from an early stage was Soutine, and he assembled a large, perfectly representative collection of his works, many of which the artist willingly gave him, and would have given more were he not so poor. Guérin befriended and collected Modigliani and other figures of the École de Paris, but he was also friends with a twentieth-century pantheon of painters including Vuillard, Bonnard and, of course, Picasso.

Aside from his art collection, Guérin was an obsessive bibliophile, whose collection of manuscripts, ephemera, association items and utterly rare editions stemmed from a deep love of literature, a true reading mania and close connection to many key writers, whom he supported with a selfless but never fawning respect. Guérin collected French literature from the late fifteenth century, say Pierre de Ronsard, right up until his own epoch, and visited on a regular basis all the leading dealers throughout the 1940s, 1950s and 1960s. He was not only unusually well read, but also one of

the first people to understand the historic importance of original manuscripts. Guérin owned important manuscripts of Verlaine, Blaise Cendrars, and the Comte de Lautreamont, Racine's copy of *Plutarch's Lives*, and why not the manuscript of *A Season in Hell* just for the ditto of it. Thus Guérin became mildly famous as Proust became all the more so, for he had carefully assembled a wondrous range of his documents and papers long before the author had been fully vindicated by André Gide, let alone the Académie.

When Edmund White wrote his definitive biography of Genet, Guérin proved to be a key source and White devoted suitable space to the relationship between the writer and his main patron. Through a recommendation at the Librairie Gallimard Guérin bought and read *Our Lady of the Flowers* and despite being warned off Genet by the bookshop staff he instantly understood the importance of the book and in March 1947 arranged a lunch with Genet in one of the few good restaurants of that period. The next month Guérin bought the manuscript of *Querelle* for fifty thousand francs – the first time Genet had made any serious money from his writing. Genet erased the dedication to Cocteau and wrote instead to Guérin: "You are the first, Sir, to love *Tonnerre de Brest*. You are the only one to own it in its first draft." The actual book was dedicated straightforwardly to "Jacques G."

Guérin became one of Genet's closest friends and thus assembled an unrivalled archive of presentation photographs, manuscripts and editions. At the time he met Genet, Guérin was producing his own perfume, *Le Chevalier d'Orsay*, running an olfactory factory and employing talents like Marie Laurencin, Cocteau and Colette to come up with publicity ideas. Guérin gave the writer several bottles of his latest perfume when they met and later named one "Divine" in homage to Genet. The two Gs loved to talk for hours together and Jean would stay for long periods at Jacques's beautiful house in Luzarches, north of Paris.

The house had been designed by François Joseph Belanger in the 1780s on the site of an old monastery, and Guérin restored

and maintained it in all its glory until he died. Here Genet would sometimes burst into Guérin's boudoir in the morning to read the passages he had written so feverishly the night before. Naturally enough, considering Genet's volatile and proudly criminal character, this friendship slowly turned sour. Not least because Genet introduced his friend to a fellow writer, Violette Leduc, and her first book, *L'asphyxie* after which she became a far closer confidante of Guérin. The first time Leduc was invited to dine with Genet at Guérin's apartment at 8 Rue Murillo, she was overwhelmed by his butlers and servants, his black and white floor and the Soutine portrait of a splayed rabbit, but Guerin rapidly offered to bring out a luxurious limited edition of her book about de Beauvoir, *L'Affamée*, and personally arranged all the details of its publication. Thereafter Leduc came to dinner chez Guérin every Wednesday for the next seventeen years.

Genet continued to associate with Guérin, not least for the possibility of increasingly preposterous loans, yet Guérin was never easily fooled. When asked for an unusually steep sum he offered the ultimatum of cash or his friendship and Genet wisely realised the latter was more important. Genet even made a short silent movie on the grounds of Guérin's house in 1950, in which his brother Jean played a *curé*. Genet subsequently sold his patron the only extant print of his literally seminal film, *Un Chant d'amour*, of which there turned out to be several, all sold as if unique.

In the end jealousies with Leduc and general Genet-ness ensured that Genet wrote Guérin, "I think that in order to maintain the high quality of our relationship it's better if we see each other less." Once in 1952 they did nearly meet but Genet crossed to the other side of the street, though he greeted him warmly in the Brasserie Lipp later and even sent New Year greetings, adding that he had never loved him so much as when "I know we'll never see each other again." By this time Guérin's collection of letters, presentation copies and limited editions of Genet was nonpareil, including his poems *Secret Songs* (1944) dedicated to Sartre and

de Beauvoir, a handwritten first draft of *The Thief's Journal* (1949) and his rarest item, Genet's first publication, the 1942 booklet *Le Condamne a mort* (The Man Condemned to Death) with a flamboyant inscription to Guérin.

As well as Genet and Leduc, Guérin personally cared for a large stable of writers such as René Behaine, Maurice Sachs and the infamously handsome Glenway Wescott, all of whose current neglect seems just punishment for their once modish notoriety. By the time Guérin died, at the age of 98, he had donated much of his collection to several major French institutes and museums, and sold his carefully researched and personally inscribed library through the auction houses, including a series of beautifully catalogued sales at Drouot beginning in 1983. Such selfless dedication to art and literature has made Genet's words to his greatest supporter ring violently cruel and true, "*Votre générosité est impardonable.*"

Jacques Guérin, collector and patron; born Paris, June 23, 1902, died Luzarches, France, August 6, 2000.

PETER PINCHBECK

PETER PINCHBECK was an abstract painter who worked and lived in a loft in the heart of Manhattan's SoHo. As such, he was both a bohemian anachronism and the potentially regenerative symbol of an aesthetic rooted in utopian formalism and personal integrity. Pinchbeck had no shortage of the latter and this made him a contented man, one who wished to devote himself entirely to his art and found the time and energy to do so for forty years.

The location of Pinchbeck's Greene Street loft was of more than anecdotal interest; it represented an entire generation of artists and their ambitions, ambitions which had nothing to do with the art market and everything to do with the scale and resolution of their canvases. The only thing more regularly declared dead than abstract painting is the old artistic community of SoHo and, if amused by the Vivienne Westwood and Helmut Lang boutiques that mushroomed around his apartment, Pinchbeck knew that his art and where he chose to make it were closely related. Perhaps this was because Pinchbeck was in a way self-created, a transplanted Englishman whose accent was as languidly American as his bearing and clothing remained those of a distinguished Anglo-Saxon academic.

Pinchbeck is an ancient English name and, as Rita Shenton explains in her 1976 book *Christopher Pinchbeck and his Family*, generations of Pinchbecks through the seventeeth and eighteenth centuries were famous for their expertise in clockmaking and horology – a manual, practical skill surely related to Peter Pinchbeck's own artisanal concerns. Pinchbeck grew up in hard circumstances in the suburbs of wartime London, his parents having left to live in

Brighton but returning to the city at an inopportune moment. Pinchbeck's father was a retired policeman who ran a tobacco shop in Teddington and who never saw eye to eye with his son on anything, whether national service or art school. Despite parental opposition, Pinchbeck attended both Twickenham Art College (1953–55) and the Polytechnic in London (1955–57), and like many British students of that era was deeply fascinated by the energy coming out of New York.

He emigrated to the United States in 1960, and thus witnessed the final days of the Cedar Tavern and the Abstract Expressionist legacy. But aside from the facile mythology of that period, Pinchbeck's work was altogether different, and to see his work as part of their project would be to underestimate the range of his concerns. For Pinchbeck was a continually questing and questioning intellectual, acutely aware of the issues of abstraction and their larger cultural and philosophical context. His daily practical experiments went hand in hand with his reading and discussions. Pinchbeck was part of a loose group of abstract practitioners who used to meet to debate the issues of contemporary art in the SoHo bar Fanelli and later at Caffè Dante. In recent years, Pinchbeck had become involved with the American Abstract Artists, founded in 1936, and helped write and edit the group's publications out of his loft.

In prose and speech Pinchbeck was lucid, logical and highly informed, perhaps a result of teaching for nearly thirty years at a Manhattan community college, and if his discourse ranged easily from Merleau-Ponty through Bachelard to Deleuze, he was equally expert at explaining changes in his own work. For Pinchbeck had moved from a concern with the picture plane to the issue of volume, the central theme of his mature work: "The problem for abstraction has become how to regain volume without verging on the literal. Volume is important because it creates a tangible space." Indeed, in his last works Pinchbeck proposed a volumetric abstraction that would attempt to depict consciousness itself, "mirrors of the mind."

He had his first success, however, with large-scale installations that played with the issues of painting as a three-dimensional object in space, creating brightly painted, simple wooden structures influenced by early Constructivism. These were exhibited in 1971 and in the fabled *Primary Structures* show of 1965, held at the Jewish Museum in New York – the first exhibition of what was later termed Minimalism. Pinchbeck's *Space Jump* in this show was a particular favourite of the influential critic, and then wife of Frank Stella, Barbara Rose, and she tried to buy it, only to discover he had dumped it on the street the day before. However, Rose did include Pinchbeck in another major show that she herself curated, *American Painting: The Eighties*, which opened at the Grey Art Gallery in New York in 1979. In the now rare catalogue for the show, Pinchbeck explained his intentions: "The shapes I use, squares and rectangles, function both as coloured volumes and as visual signs.… The shapes I use are not metaphors for anything outside the painting. The geometry of shape, size and placement creates an image which has no counterpart in the real world but exists as an autonomous object."

Pinchbeck was in other important group shows such as *The Shaped Canvas* at Von Bovenkamp in 1965 and *Sculpture from All Directions* at World House the same year, not to mention *Painting Up Front* at the Johnson Museum in Ithaca, New York, in 1981. But he also continued to show commercially with New York galleries such as Paley & Lowe, Gallery 84, Cayman, Art Works and June Kelly. Pinchbeck only exhibited in his native Britain once, contributing two drawings to *New Work, New York*, part of the 1983 festival "Newcastle Salutes New York." At the time of his death, Pinchbeck was preparing works on paper for a tribute exhibition to Mondrian, to be shown at the Mondriaanhuis in Holland.

Despite his total commitment to his art Pinchbeck was also a well-known, always boyish figure on the streets of New York, whether in his heyday at the legendary Max's Kansas City or simply strolling for lunch in one of his neighbourhood spots such

as Jerry's or Buffa's, where they had even hung some of his work. Pinchbeck was married to the writer Joyce Johnson, best known for her 1983 memoir of life with Jack Kerouac, *Minor Characters*. Their son Daniel was a cofounder and editor of the art and literature journal *Open City* and subsequetly the groundbreaking author of a book on psychedelics and late twentieth-century culture, an echo perhaps of his own father's "mind mirrors."

Peter Gerald Pinchbeck, artist; born Brighton, England, December 9, 1931, died New York City, September 3, 2000.

161

GIAN LUIGI POLIDORO

IN any retrospective rating of the best twentieth-century jobs, being a postwar Italian film director would clearly come close to the top. Gian Luigi Polidoro was a classic of the genre: the many wives, the children, the politics and meals, studies at the famous Centro Sperimentale, stints at Cinecittà and even a perfect death, crashing his Maserati into a tree outside Venice – almost a replay of Godard's 1963 film about filmmaking, *Le Mépris*. But unlike his older and perhaps more famous colleagues, Polidoro was less limited to Italy as a topic, inspiration or location for his work; indeed he was a deliberate internationalist, a playboy globetrotter whose films took him around the world, veering from Europe to America to Asia just as they shifted between high comedy, documentary realism and sombre drama.

Polidoro was born in 1928 at Bassano del Grappa in the foothills of the Dolomites in a family palazzo complete with original Bassano paintings. After studies in Rome at the Centro Sperimentale di Cinematografia, Polidoro began, like so many neorealists, working on almost ethnographic documentaries about his native land. His first success was the short *La Corsa delle rocche* (1956), produced by Astra Cinematografica, which won the Prix du Documentaire at Cannes. Three years later, Polidoro was back at Cannes winning a Silver Ribbon for best short film with *Paese d'America* (1959), which he not only directed but also wrote the script for and edited. In fact, Polidoro was such a regular on the Croisette that he is included in the greatest hits listing "500 Names that Made Cannes." Other Polidoro documentaries included *Oeuverture* (1958), which received an Academy Award nomination, and *Power Among Men* (1959), which won the prestigious Flaherty Award.

In 1958, aged 30, Polidoro went to New York to work for the United Nations, headhunted to start their ethnographic

documentary unit. He travelled with them to Haiti and subsequently shot footage all around the world, making some sixty short films, with a wanderlust that was to continue long after he had left the UN. The first feature Polidoro made after this semi-bureaucratic employment was *Hong Kong, un addio* (1963), a Dino De Laurentiis production starring Gary Merrill, which he subsequently considered a far too serious and depressing study of the breakup of his first marriage.

Polidoro was never quite sure if he should commit to serious drama or farce: his real strength, claimed Antonioni, was in the creation of lyrical dramas and he should never have started making bitter comedies instead. But he had an enormous hit with *Il Diavolo* (released in England as *To Bed or Not to Bed*, 1963), starring the inimitable Alberto Sordi as Amedeo Ferretti, an Italian fur dealer in Sweden. This provided an early role for Britt Ekland, with whom Polidoro naturally commenced a complex affair. A cruel comedy, again produced by De Laurentiis, *Il Diavolo* won the Golden Bear at the Berlin International Film Festival. This was Polidoro's most lasting work (and the only one of his eighty films still easily found) which remains hugely enjoyable.

In a similar vein was the comedy *Una moglie americana* (*Run for Your Wife*, 1966), a Rizzoli films production with Ugo Tognazzi, Rhonda Fleming and Juliet Prowse. In 1965, Polidoro was one of three directors to create the portmanteau film *Thrilling*, the other two being Carlo Lizzani and Ettore Scola. The film also starred Sordi and had the added bonus of an early score by Ennio Morricone. Though Polidoro was friends with all the usual suspects, he did not enjoy good relations with Federico Fellini. Partly this was because they had both made a film of *The Satyricon*. Polidoro's lesser-known version came out in 1968 and featured a script by his best friend Rodolfo Sonego, who had neglected to mention he had just written practically the same thing for Fellini.

One of Polidoro's great seventies Italian films was *Permette signora che ami vostra figlia?* (released in America as *Claretta and*

Ben in 1983), a Carlo Ponti production starring Bernadette Lafont and Ugo Tognazzi as the head of an acting troupe who slowly comes to believe he is Mussolini. Between 1977 and 1985 Polidoro was mostly living in Manhattan, where he maintained a glamorous apartment in the Olympic Tower, an infamous Eurotrash hotbed on Fifth Avenue and 50th Street. He directed several films in America including the comedy *Rent Control* (1981), Brent Spiner of Star Trek fame's first film, which was based on the marital adventures of the notorious rare book dealer and film producer Joel N. Block. *Variety* called this "a gem, a first rate comedy that defies its threadbare production budget" and indeed it displayed Polidoro's genius at revealing the comedy inherent in the lives of everyday people.

Polidoro also made an American comedy starring the improbable talents of Rita Tushingham and Aldo Maccione, about an awkward girl who asks a computer to find her perfect mate — a film released by Westernworld Video under various names such as *Loose in New York* and *Instant Coffee*. Hopping between countries, Polidoro made films such as *Sottozero* (1987) when back in Italy and a 1993 television feature in Paris called *C'est quoi ce petit boulot?* (What are these little jobs?) which was then turned into a successful miniseries. At the time of his death Polidoro had happily just finished *Hitler's Strawberries* (1998), a vitriolic comedy about a Jewish boy who dresses as the Führer at his Orthodox wedding.

Gian Luigi Polidoro, film director;
born Bassano del Grappa, Italy, February 4, 1928,
died Rome, September 4, 2000.

JANICE BIALA

I N addition to being an accomplished and acclaimed painter, Janice Biala was a perfect representative of American bohemia in France. She was also a fine example of the Eastern European Jewish diaspora, its assimilation into New York and subsequent role in the rise of modernism. Biala's older brother was the acclaimed Abstract Expressionist painter Jack Tworkov, once rated up there with de Kooning and Pollock, and both siblings had an ambiguous relationship to their Polish Jewish origins. Biala was an adopted name, just as Jack Tworkov was actually Jacob Tworkovsky.

They were both born in Biala Podlaska, a village in southern Galicia from which Jews were expelled in 1765, then allowed back in the mid-nineteenth century. The Jewish population in 1929 was 2,600, and those who did not escape to America or elsewhere were all deported to Auschwitz. Their father was a tailor and emigrated to New York's Lower East Side, his wife and two children following in 1913. Biala briefly attended the National Academy of Design, then at 18 studied with the painter Edwin Dickinson in Provincetown. Biala survived by routine work while living the Greenwich Village scene, and somehow became briefly married to a fellow painter, Lee Gatch.

It was then that a mysterious couple of benefactors gave her the money for a boat to Paris, which was to be her home—spiritual if not actual—for the rest of her life. In Paris she met the writer Ford Madox Ford and lived with him from the late 1920s until his death in Deauville in 1939. Biala was his literary executor and at her own death was still renewing books such as *A Man Could Stand Up* (1926) and *No More Parades* (1925) in the US Catalog of Copyright Entries. Biala painted *Portrait of a Critic* (1932) of Ford at his heftiest, reclined in his deckchair, and provided drawings and artworks for several Ford titles. These included *Provence* (1935) and *Great Trade*

Route (1937) as well as *Buckshee* (1966), with an introduction by Robert Lowell and Kenneth Rexroth. Her paintings and original pen and ink sketches for *Provence* were exhibited in New York at the Georgette Passedoit Gallery, her first solo exhibition in America. In 1937 she had a show of paintings and the original drawings for Ford's *Great Trade Route* including *Short History of America to Civil War* (1936), which had been the book's frontispiece. The catalogue to the show included a foreword by Theodore Dreiser, and notes by Ossip Zadkine and Reid Anderson of *The Glasgow Herald*, who wrote, "Biala seems to draw with some acid pigment of magic invention." Zadkine remarked on the "enlightening, intuitive quality" of Biala's painting while Dreiser, waxing lyrical, revealed that "this woman has a revolving, camera eye. Nothing escapes. It's like rubber-necking the whole thing yourself. I still think she could do Manhattan on a penny, an intensely alive, resourceful temperament which obviously desires to record itself in and through painting."

Biala constantly travelled between Europe and America and sketched and drew as she did so, having regular shows in Paris such as at Galerie Jeanne Bucher in 1951 and back in New York, as in the exhibition at Carstairs Gallery in 1950. For many years Biala's main New York representative was the Bignou Gallery, where she contributed to their *Exhibition of Modern Paintings* in 1945; her *Red Tray* was shown amongst eighteen artists such as Dalí, Derain, Picasso, Rouault, Soutine, Utrillo and even Vuillard. Biala was very much part of the second generation School of Paris and never tired of inherently French subjects, as evidenced in her titles, such as *Bathers at Juan les Pins*, *Provençal Interior* and *Au Clair de la Lune Cap Brun*. This may not have qualified as red-hot avant-gardism, but she continued to show in Manhattan, whether at Gruenebaum in 1981 with a text by Hilton Kramer, or with Kouros Gallery where she had her last show in her lifetime in 1999.

Reviewing one of these later shows at Livingstone-Learmonth Gallery in 1977, *The New York Times* caught the right elegiac tone: "For those of us who fondly remember Biala's paintings from

the Stable Gallery shows in the fifties the paintings she has now brought over from Paris are full of delightful reminders of everything we once loved in French painting." This same show featured a catalogue essay by Henri Cartier-Bresson, who met her first in 1947. "I like Biala's attitude," he writes, "her sense of color, of form, her aesthetic rigor, her perpetual disquiet. Her painting has nothing to do with fashions, with literature or graphism. It has a gravity and exaltation, whether it is a landscape, a studio interior, a cat, the sea or the face of a girl."

Forced back to New York by the Second World War in 1943, Biala married the French cartoonist-painter Daniel "Alain" Brustlein and they lived between Paris and Manhattan for fifteen years, before settling in France in 1958. As a couple the Brustleins knew an appropriately large range of Bohemian celebrities on both sides of the Atlantic, including de Kooning, Saul Steinberg and Harold Rosenberg, whilst their Paris house was a near-salon. If Biala is regularly compared to Utrillo or Marquet, in retrospect her most lyrical and free paintings are not unlike the currently fashionable naive style of, say, Luc Tuymans or Peter Doig. But perhaps Carl Van Doren put it best in his catalogue essay for the Bignou show of 1944: "Biala's paintings are not relaxed like a memory, but immediate like an experience. I desire acutely to climb her green hill to that pink village in Provence, to see more of her exciting Toulon, to sit down and look long at her musical Paris, to stand up facing her magnificent New York, to breathe the wind on her Fire Island beaches... I can only say how fresh and bright and swift I find her total magic."

Janice Biala (Schenehaia Tworkovsky), artist;
born Biala, Poland, September 11, 1903, died Paris, September 24, 2000.

ZOGDAN PALASHI

ANYONE living in Bucharest in the late thirties would be more than aware of the Palashi family, the various members of which spanned social and artistic life, to say nothing of the economic world, where the senior member of the clan, Mersto (or "Rasto" to his friends) had the controlling interest in the trading and manufacturing giant (by Roumanian standards), Balko Company.

It was in this culturally diverse climate that young Zogdan cut his poetic teeth. From his early to late teens he produced an outstanding range of highly evocative and prescient poems, all illustrated and lithographed by himself and printed on to the rare "Obsidian" paper of the Roumanian National Paper Manufactory.

Unfortunately the very able translations of these by V. Vashtek (Monopol Press, 1942) caused such a furor at the time of publication that the whole edition was withdrawn and destroyed. There is one copy in the Rare Books section of the San Francisco Public Library which this writer has been privileged to see and peruse its elite strophes. But it is his later years that are of more than passing interest.

Born in 1915, his twin Zemeny survived only a few weeks, which is not surprising considering the state of the notorious lying-in hospital Bethany, which features in several novels of the Roumanian "real life" genre. Zogdan was of stronger physique, which stood him in good stead throughout his life at the extreme edges. Interestingly his mother, Hilaire, had been a ballet dancer and had eloped with a renegade Italian priest who had joined the Orthodox Church.

However the Palashi family network had returned her to the fold and no more was heard of the priest. Zogdan and Zemeny wore born some two years after that event and rumours as to parentage were quite unfounded. The father, third son of Rasta, married Hilaire (his second cousin), took little interest in his eventually considerable family (seven daughters), and as such Zogdan had to survive in a rather oppressive female establishment memoralised in his line "city of women, where are your banished princelings?"

Zogdan had a conventional and undistinguished education but in his fourteenth year he met the priest-poet Magirda Maudran, who recognized the boy's talent at versification and showed him the possibilities of *terza rima* and the early romance poets of the region. Apart from his poetic success, until 1939 Zogdan kept a low profile, but with war clouds looming, he took a leading part in several politico-artistic movements, including the manifesto "100 Days" of which he virtually wrote the whole and oversaw through a clandestine press called Tomorrow. From then on he was a hunted or a hated man both by the government and extreme parties of the left and right.

His fortunate meeting with a young English diplomat who had an abiding passion for Roumanian folklore led to a hasty departure from his home and family, and after a circuitous and very tough journey, he reached the United Kingdom by rowing across the Channel. His Foreign Office friend having secured for him a UK visa, he was let through at the Folkestone Harbour when he arrived there in 1938. He proceeded to London through the good offices of the Friends Relief Service, who also housed him for a brief while until he found his feet in the Crimpsall advertising agency, where he was responsible for several successful campaigns, writing the copy and doing the artwork himself. Older readers will remember the cod liver oil advertisements of that time—entirely his invention—especially the slogan "By Cod, I'm well!"

During this period he was also involved in Dartington Hall, where he often participated in musical events (he was a considerable

performer on the flute); he met up with the Kurt Joos Ballet and is believed to have taken an important part in the Green Table Ballet, which thrilled thousands through its antipolitician storyline.

Come the war he was interned like many émegrés, shipped to Canada and narrowly escaped death when the ship was torpedoed only a few miles from the North American coast. He saved many lives when he manned one of the lifeboats, and his rowing prowess secured an easy landfall exactly on the line separating the US from the then Canadian Dominion. This demarcation can be seen as a metaphor of his later life, characterized by his uncertainty as to which side of the line he belonged, culturally and sexually. He somehow got to New York and briefly was in the Auden-Britten ménage. Auden's line, "Balkan keeper of the silent bolts secure these too," is thought to be a reference to Zogdan's role as a sort of doorkeeper/butler in that establishment.

For a period of about twenty years Zogdan's work was virtually unknown, but in '75 and onwards a series of articles and reviews in various national and local journals established his reputation as the leading intra-existential writer of our time. His major work, "History of the Next World"—just completed before his untimely death following an injury when his rowing boat was cut in two by a cargo ship (ironically the ship's name was "Excalibur" and registered in Split)—has yet to find a publisher.

He will be sorely missed at the Romanian Émigré Club on Bleecker where he was mostly to be found, holding forth to a group of admirers, overcome by the rodomontade of his epistemology.

Zogdan Palashi, philosopher-poet; born Bucharest, July 24, 1914,
married Countess Helena Zawlinski 1947, marriage dissolved 1948,
died New York City, April 1, 2001.

STANI NITKOWSKI

I N a contemporary art world dominated by slick surfaces, conceptual gloss and a sort of ultra-flat interior decoration whose practitioners are supposed to be as smart as their patrons, the truly angry outsider is left all the more outside and angry. Stani Nitkowski was the ultimate rebel artist, a self-taught expressionist whose themes were degradation, violence, abuse and extreme despair, all born out of his experience of the world. Nitkowski embodied the bitter end of the line of an entire French tradition of *poètes maudits*. As worthy successor to this heritage of Rimbaud, René Crevel and Artaud, Stani Nitkowski ended his life in the approved manner of any such serious nihilist. It took him until the age of 51 finally to do so but his entire existence had been in some ways a slow, spectacular suicide.

He was born in La Pouëze in the Maine-et-Loire to a miner father of Polish origins. His father was a brutal alcoholic who once bit a chunk out of his wife's arm. They both ended up in hospital. This set a pattern for Nitkowski himself, who would regularly be hospitalised for alcoholism over the years. At the age of 23 Nitkowski was confined to a wheelchair because of myopathy and in reaction tried to kill himself for the first time, by slitting his wrists. Inspired by Van Gogh, Nitkowski taught himself how to paint by long and painful

experimentation. Art Brut was very important to his development, not least through his correspondence with Jean Dubuffet and his friendship with Robert Tatin, who had created his own strange world in the French countryside. But Nitkowski's art had a rage and range not usually found at any generic "Outsider" art fair. A typical drawing such as the cruelly titled *L'hymne à la vie* of 1994 features a splayed, crucified figure exploding from every orifice in a scatological attack upon all polite ideals of society. This extremity was implicit in all his work, including ink drawings such as *L'atelier du jouir* (The orgasm studio, 1995) or *Treblinka* (1984). The savagery is not merely in the image but also the expression, a vicious, hacking ink line which spared nobody's feelings, let alone his own. Nitkowski also did various illustrations for underground publications, such as a searing cover for the magazine *Face B* in 1985. As he scrawled on one drawing, *"L'empreinte de mes pas vierges dans la neige m'emportait vers des pays d'instinct. Je m'imaginais grattepapier chiffonnier bourlingueur…"* (The imprint of my virgin steps in the snow carried me to the lands of instinct. I imagined myself a hack scribbler ragman voyager).

In 1981 Nitkowski first wrote to Dubuffet, then the world's greatest expert on, if not inventor of, Art Brut. Nitkowski included two drawings and Dubuffet recognised their intense quality: in fact he immediately sent them on to Lausanne to be included in his Art Brut Collection. *"Je les admire beaucoup."* Dubuffet also expressed a keen interest in the oil on canvas paintings Nitkowski had told him about and demanded to see slides of them. He worked in a variety of media and, if the core of Nitkowski's expression is in his wild graphic line, his paintings have their own bizarre, glowing energy. As a self-taught painter he lived often with little money but always great courage, and his reputation had steadily grown throughout France.

In 1974 he had his first exhibition, in a supermarket in Angers, where he was a notorious character, whether drunk in his wheelchair or sketching in the brothels of the town, in his words *"le petit Toulouse-Lautrec d'Angers."* Drunk thus one night he met his

future wife, Martine, with whom he lived in a tiny room along with their children Flavien, Alban and Anaïs, as well as her two children from a previous relationship. The children slept in cupboards in the bathroom and the kitchen until the Secours Catholique came to their rescue. *Artension* magazine asked their readers to write to Nitkowski and in response he sent back more than one hundred drawings, free. One day he received a letter with a scrawled telephone number, called it immediately and flew off to join this anonymous woman, thus abandoning his family. She in turn abandoned Nitkowski and stole his work, leading him to yet another suicide attempt, this time with his electric razor in the bath. Suitably shocked, he returned home.

Nitkowski also had a long and often tempestuous relationship with various galleries such as L'Oeil de Boeuf, Cérès Franco and Les Filles de Calvaire. His longtime dealer was Vanuxem, whom he later accused of plying him with alcohol and women in order to take all of his pictures. Indeed Vanuxem bought the contents of Nitkowski's studio outright on a first visit and paid him a regular monthly stipend thereafter. Nitkowski is featured in numerous international collections such as the Université de Montréal, the Parc de la Villette, the FRAC Pays de Loire and the Musée des Beaux Arts of Nantes. He also had some influential admirers, including the writer Gérard Barrière and Jean-Marie Drot, director of the Villa Medici in Rome. Drot wrote of Nitkowski for his first solo show in Paris in 1982:

> Stani Nitkowski is a sleepwalker who in full sunlight knows how to seize the angels and monsters which only the night allows one to see. His paintings repeople the deserts which the bulldozers of modernity have left behind them. Indefatigable, he recommences the creation of the world, turns up the voltage with each canvas and flirts with geological incandescence. An angry saint activates him … With Stani, the reds and the blacks are cries which even the deaf can hear. I am proud to be his friend.

Like any Gallic cult figure he even had his own association, "Friends of Stani Nitkowski," suitably located on the Rue Charles Baudelaire. Yes, Nitkowski had a difficult relationship to the world, including the micromonde of contemporary art and his own extended family. The death in February 2001 of his son Flavien, aged only 21, proved a bitter final blow. After having spent his life *"écrire avec son sang"* (writing in his own blood) Nitkowski's dramatic departure is as resonant as the powerful work he left behind.

Stani Nitkowski, artist; born La Poueze, France, May 19, 1949, died Saint-Georges-sur-Loire, France, April 2, 2001.

ROCKETS REDGLARE

WAS it Rockets? One couldn't know. His fat legend in downtown Manhattan depended on rumour, gossip, secondhand reports and the rocky Chinese whispers of an entire bohemian community. Was it really Rockets who delivered drugs to Sid Vicious and Nancy Spungen the night she died? Did Rockets fight backstage with the punk rocker Richard Hell and fall on top of him, using his incredible weight as the ultimate weapon? Even Rockets's childhood was shrouded in mythology, his mother supposedly having been brutally murdered and left to rot for a full week.

Luckily his film roles as an actor cannot be challenged or obscured: he appeared in over thirty movies, from the minor *Rooftops* (1989) to the celebrated *Big* (1988), in which he played a motel clerk. Indeed, as a character actor Rockets played a variety of clerks, barmen and hoodlums in a range of impeccably modish independent films as well as hipper Hollywood fare. Any cameo by Rockets is unforgettable due to the combination of his vast physical bulk and extraordinary voice, a sort of raspy, twangy, rare vintage whine, like some stiletto sharp spiv channelled through *The Man Who Came to Dinner*. Anyone who met Rockets, and many did, had their own impersonation of his speech pattern, much mimicked yet never quite captured.

Those who love the New York indie film scene also loved Rockets, who made celebrated appearances in all the classics of the genre such as *After Hours* (1985), *In the Soup* (1992) or *Basquiat* (1996), in which he played himself. In fact his very first role was in an early groundbreaking independent masterpiece *The Way It Is or Eurydice in the Avenues* directed by Eric Mitchell in 1984. This modish black and white *nouvelle nouvelle vague* feature was also the first film of two other actors who later made their own low-budget films, namely Vincent Gallo and Steve Buscemi. Buscemi's own films *Trees Lounge* (1996) and *Animal Factory* (2000) also carry strong performances by Rockets. For Buscemi was a supportive, wary fan: "He's very charming and he knows that he can get things from people. In a way he is lazy but in another way he works his ass off hustling. Everybody that I know that knows him has given him money over the years and then you find out that he's been doing all this shit and he ends up in the hospital."

It was in hospital that he died from an impressively hardcore combination of kidney failure, liver failure, cirrhosis and hepatitis C. For Rockets was also a dedicated longtime abuser of every sort of alcohol and narcotic, the first obese opium addict since Christian "Bebè" Bérard. Longtime indeed, for Rockets was born Michael Morra at Bellevue Hospital (weighing over twelve pounds) to a fifteen-year-old heroin addict mother and thus was addicted himself *in utero*. The doctors added an opiate derivative to his formula to ease the pain of withdrawal for the newborn baby and this was the first of Rockets's endless detox cures. Rockets grew up in Sheepshead Bay, Brooklyn, among unpleasantly authentic Italian American criminals. His father was a career thug and his uncle Eddie a violent enforcer who murdered three people in front of the infant, shooting someone to death with Rockets tucked under his arm. When his father was deported back to Italy and Uncle Eddie was caught by the police, his mother took up with a fellow junkie who had once been a boxer. He used this pugilistic experience to beat mother and son to a pulp as often as he could, eventually

murdering the woman and abandoning her decaying body. As the excellent, endlessly quotable, documentary *Rockets Redglare!* (2003) by Luis Fernandez de la Reguera states, "He was a man born into a nightmare world of violence and addiction, raised in a house of hitmen and hustlers, who fights a daily struggle to remain clean, healthy and positive."

Rockets worked as bouncer at the East Village Red Bar and was a fixture on the emerging punk music scene. As a kid on Long Island he laboured as a roadie for a band called the Hassles, which included Billy Joel, and served as sometime bodyguard to the Sex Pistols. The night Sid Vicious stabbed Nancy Spungen to death, a local drug dealer named Rockets Redglare delivered a small baggie of synthetic morphine, forty capsules of Dilaudid, to their room 100 at the Chelsea Hotel. According to police reports he arrived around 1:30 a.m., took several hundred dollars and promised to supply more drugs the next day. When he left at around five in the morning he passed another dealer going in. Rockets's drug dealing and using remained rumour, whereas his appearances as an actor were highly visible. Rockets began his performance career as a standup comedian with his own show, "Taxi Cabaret," in East Village bars such as Pyramid and Club 57. In *Desperately Seeking Susan* (1985) he played a taxi driver with notable views on fashionable food: "Ya know I tried some of that sushi stuff, it's all right. I took it home, cooked it up, it tasted just like fish." Susan Seidelman's other film *Cookie* (1989) featured him as a wise guy, whilst in *Talk Radio* (1988) he was a redneck killer. Rockets's roles included a van driver in fabled photographer Robert Frank's *Candy Mountain* (1987), a threat to Daniel Day-Lewis in *Stars and Bars* (1988) and a sadistic police precinct officer in Nick Zedd's shocker *Police State* (1987). Rockets also made guest appearances in various television shows such as *Monsters* and *New York Undercover*, where he played an art rather than narcotics dealer.

However much he abused his body, and there was much of it to abuse, Rockets still managed to turn up on set, albeit sometimes

177

a day or so late. Matt Dillon suggested him for the role of a cop to Gus Van Sant and the night before the audition Rockets was apparently freebasing on 14th Street. He arrived for the audition an hour and a half late, having forgotten to put in his teeth and with track marks on his hands. But as Dillon recalls he still gave the best cold reading he ever heard: "This guy is so talented…his ability is to be thoroughly honest. You can't teach that, you can't learn that, you have that or you don't." Dillon also speaks of Rockets as "very watchable, a strong presence" and it was ever so. Swaying ponderously with his cane and missing molars through the Lower East Side or Alphabet City was a second career in itself for the actor, a continual public performance, remarked upon wherever he went. As the band Ford Falcon Blue put it in their song "Heaven in a Circle of Fire," "Rockets Redglare makes his gesture to the night on a stolen saxophone."

In many ways it was Jim Jarmusch who really made a star of Rockets in a series of his films, starting with *Stranger Than Paradise* in 1984 where he excels as an abrasive poker player, through *Down by Law* (1986) and *Mystery Train* (1989). And Jarmusch perfectly summed up his excessive thesp: "He's really like a con man with a soul. He could talk his way into or out of anything. Rockets is a real fighter, he comes from some kind of aberrant stock, he's very tough. I've thought a few times we might lose Rockets, as we all have. I'm just really happy he's still fighting, he's keeping the gloves on."

Rockets Redglare (Michael Morra), actor and performer;
born New York City, May 8, 1949, died New York City, May 28, 2001.

MICHAEL SONNABEND

THE fragile, small craft that was Michael Sonnabend has now sailed into the ocean of "Purgatorio" to find a berth suitable to a relatively blameless life. As Longfellow put it in his translation of the first Canto, "To run o'er better waters hoists its sail / The little vessel of my genius now, / That leaves behind itself a sea so cruel." The cruel sea in this case would be the contemporary art business which Sonnabend had navigated with the little vessel of his genius for forty years, always running in its better waters. But though he had overseen a series of galleries in Rome, Paris and New York whilst building one of the world's most legendary collections, Sonnabend maintained his "glamour" right to the end of his hundred odd years.

For all this time nobody knew exactly what it was that he "did" or did *not* do, other than ritualistically read Dante in the original Italian every day. The current art world is amazingly short of genuinely sophisticated and refined connoisseurs, perhaps especially in Manhattan where Sonnabend resided much of his life. Thus the contrast between the wheedling amnesiacs of this profitable *demimonde* and Sonnabend's vast erudition and wit was educational in itself. Saul Steinberg said that the best art dealers have a distinctly fictional quality, and compared to the banal businessmen and bureaucratic accountants who run the galleries, Sonnabend was entirely, deliciously fictional, an overtly secondary character in a first rate novel. Whether he could actually be classified as a dealer, or indeed as an academic, filmmaker, scholar or any fixed profession remains moot though as a *flaneur* he had ambled quietly through all of these fields.

Sonnabend was born in Buffalo, New York, an impressively paradoxical beginning to a life dedicated to culture. For Buffalo was then an infamously rough, poor and violent industrial inferno.

Sonnabend, whose agile face could have laid copyright to that phrase "a wicked glint in his eyes," would gleefully recount how as a boy he used to run errands for prostitutes along the shorefront. Without doubt Sonnabend knew the gangsters, enforcers and women of easy virtue for which this city was so notorious, but he may have exaggerated the poverty of his origins. Sonnabend moved to New York where he worked as receptionist for the Group Theatre at the height of their radical glory, then made his way to Paris where he led tours and was a doubtless amusing and highly tipped guide.

The war found him back in New York, studying French at Columbia University. Here he met his future wife Ileana, who was to transform his life from that of a penniless erudite dilettante to that of an extremely wealthy erudite dilettante. Ileana was already 30 and married to Leo Castelli; she had a young daughter and a family townhouse on East 77th Street. Sonnabend seemed outrageously bohemian to this settled family woman. For if all of them came from a Jewish milieu there could not have been greater contrast between Sonnabend's Buffalo roots and the wealth and elegance of Ileana's clan in Bucharest or Castelli's Trieste upbringing. The marriage of Ileana to Castelli was a perfect match between two successful, super sophisticated *mittel*-European Jewish families and Ileana's father happily supported Castelli in various business plans and cultural activities. Thus Castelli had started his first gallery in Paris in 1939 just before their families escaped *en masse* to New York.

When Ileana first met Sonnabend in 1943 Castelli was away in US Army Intelligence. She had enrolled at Columbia to improve her English and Sonnabend was the only other student studying Proust who knew French. She was charmed by his vivacity, his brilliant monologues and ragged past. Surrounded by wartime exiles he proclaimed himself a "refugee" and pressed for details revealed he was a "refugee from Buffalo." He was already 44 and would continue to always be older than anyone else, as a point of honour.

After the war the Castellis became increasingly involved with the New York art world and Abstract Expressionists, buying a large house in East Hampton opposite Robert Motherwell. Sonnabend was a very regular visitor and thus came to know all the artists of the period: he is to be seen expounding on de Kooning in a 1995 documentary on the painter. But as the artist Paul Brach put it, "Nobody thought there was anything going on between Ileana and Michael. Leo was always perfectly accepting of Michael, who seemed asexual, as Ileana's 'special friend.'"

By contrast Castelli was a fabled womanizer and when he picked up a French *au pair* on the beach it finally pushed his long-suffering wife to action. Castelli and Ileana divorced in 1959 though she continued to be a central figure in running his gallery and the decisive advisor for all his dealings. In 1960 she proposed to Michael Sonnabend, they married and moved to Europe. They tried opening a gallery in Rome before switching to Paris. Galerie Ileana Sonnabend on Quai des Grands Augustins opened in November 1962. Just as Ileana made Castelli the most important gallery in New York so she now dealt a roster of American art stars, such as her discoveries Johns and Rauschenberg, with an unerring eye for excellence.

The gallery never made money and the Sonnabends regularly bought for themselves the most difficult, least commercial works, often crucial masterpieces of each artists oeuvre. Thus the Ileana and Michael Sonnabend Collection contains an astonishing range of major pieces by every important postwar artist. The Sonnabend Collection also contains hugely important works of Art Deco furniture and applied arts whose majesty is thoroughly whispered throughout the antique trade.

In Paris Sonnabend would linger at the gallery chatting knowledgeably to everyone and anyone who came in. He also became a central figure in Parisian cultural life, going with wife

and dachshund every afternoon to the Flore before heading off to the theatre or the opera. He made many decisions within the gallery, not least in choosing artists, but his role and status was deliberately vague, letting Ileana remain the formidable queen of operations. In 1968 a Portuguese engineer Antonio Homem came to work at the gallery, soon proved indispensable and was eventually, when already in his forties, legally adopted by the Sonnabends. If the trio with Castelli had generated gossip this additional emotional geometry further confused roles and relationships. As Homem describes it, "Michael was an enormous catalyst for Ileana. At the gallery, it was Michael who gave the initiative and Ileana who acted. That's the way their relationship worked."

Following the turmoil of '68 and an attempted gallery in Geneva, the Sonnabends moved back to New York and opened a gallery on Madison Avenue in 1970. They then moved downtown to the burgeoning SoHo scene. The opening of Sonnabend at 420 Broadway in September 1971 was the decisive baptism of SoHo, not least for Gilbert & George's performance of *The Singing Sculpture*. If Sonnabend had been the most important gallery of postwar Paris, it was all the more so in the New York of the '70s and '80s. They showed consistently groundbreaking major artists without a break, from Vito Acconci to Jeff Koons and Ashley Bickerton. Originally Michael Sonnabend was supposed to have run the New York operation but as Calvin Tomkins put it in his impeccable profile of Ileana, "Running things was not Michael's strong point." However he remained the éminence grise of gallery operations, the deciding factor on which new artists should be adopted, having firmly turned down painter David Salle.

But most of the time Sonnabend was busy reading Dante, having taught himself Italian for this express purpose. Every day he would solemnly light a candle to read a chosen section of the *Divine Comedy*, a ritual surely derived from Shabbat Eve of his Buffalo childhood. His proclaimed sole ambition in life was to

memorize the entire book, a difficult task for anyone to set themselves, for as the beginning of "Paradiso" explains, "Because in drawing near to its desire / Our intelligence ingulphs itself so far, / That after it the memory cannot go." Sonnabend would also agree to informally tutor various unofficial students, such as photographer Sergio Vega: "I studied Dante with Sonnabend who taught me to read texts in medieval Italian. Michael would always talk about the structure of the *Divine Comedy* as a Gothic Cathedral wherein the consciousness of Western morality is carefully constructed in stages and sites."

As he grew older, and then even older, Sonnabend developed into a figure of fascination. His rumoured age became increasingly extreme and it was often debated whether he had already secretly died or was indeed actually immortal. However, as the attractive young girls Ileana found to look after him discovered, he still had plenty of energy and lust for life. Whilst the Sonnabend Gallery had become a blue-chip powerhouse embodied by Ileana, Michael became all the more mysterious, a mythic figure who had done nothing but read Dante every day for eighty years. In fact Sonnabend had done various other things, not least two successful films on Michelangelo. This remains a disappointment to those who prefer to see Sonnabend as a pure dilettante who should never have soiled his track record of obscurity by doing anything in the public eye. He could have had an unblemished life of nothing but reading and museum visiting if he had not spoilt its pristine surface by such careerist obligations.

In 1950 he had already worked on the movie *The Titan* about Michelangelo. Then, in 1989, he wrote the documentary *Michelangelo: Self-Portrait* for director Robert Snyder. This was adapted from the artists's own poems, diaries and letters as well as contemporary accounts. The film was released to great acclaim and later shown on HBO, mythologist Joseph Campbell calling it, "Awe-inspiring…a powerful work, it must be seen again and again." The film opens with Michelangelo at work on his *Rondanini Pietà*

which he began carving at age 89. As Sonnabend's script proclaims, "I am carving another *Pietà*; God grant I may finish it. How different from my first — I was 21. Beauty was my ideal then. Faith alone must guide me now, as I face the Day of Judgement."

Michael Sonnabend, gallerist, collector and Dante scholar; born Buffalo, New York, November 25, 1900, died New York City, June 1, 2001.

JACQUES BENS

T HE announcement in *Le Monde* was certainly curious, a small paid notice proclaiming: "L'Ouvroir de littérature potentielle (The workshop of potential literature) has the sadness of announcing that, since Thursday, July 26, 2001, Jacques Bens, novelist, short story writer, poet, crossword-puzzler, founding member of the OuLiPo, is excused from its meetings due to his death."

The tone of this statement gives some suggestion of the nature of this OuLiPo. L'Ouvroir de littérature potentielle is a mysterious if not clandestine organisation that has long been a deliberately oblique part of French culture but which remains central to the lives of its members, not least Jacques Bens. For Bens was a founding member of the Ouvroir and actually present at its original ten-day meeting at Cerisy-la-Salle organised in the summer of 1960 by the writer Raymond Queneau and the mathematician François Le Lionnais. Here the methods behind "potential literature" were first broached: a literature which embraces systems, programmes, complex games and self-imposed rules of great difficulty, the diametric opposite of free association, spontaneous prose or stream of consciousness. OuLiPo members are committed to experimentation and research, which lead to increasingly challenging tasks, such as the lipogram which requires the suppression of one letter, acrostic verse patterns or the classic palindrome.

Perhaps the best demonstration of OuLiPo techniques came from Georges Perec, who wrote an entire novel without the letter "e" (the most common in the French tongue) and created the longest palindrome in French or any other language. Other notable OuLiPo members include Italo Calvino and Jacques Roubaud as well as artists such as Marcel Duchamp or Enrico Baj; indeed the organisation has branched out to include "potential" painters, cooks and

185

crime writers, all using similarly restrictive forms. On November 24, 1960 the OuLiPo was officially created at the Parisian restaurant Le Vrai Gascon, and according to Bens's own typed notes he was appointed *"secrétaire définitivement provisoire"* or "definitely provisional secretary." This was a role he was to relish all his adult life.

Bens was a quintessential OuLiPo member because his single passion, writing, included every potential form, whether crosswords, technical manuals, transcriptions, ghost writing or copywriting, what he termed his *"prose secrétariale."* This emphasis on writing in its least self-important, least Romantic mode—engine instructions, recipes, inventories—is typical of the OuLiPo desire to free literature from the autobiographical. Indeed, Bens's own personal life outside full time literary work hardly rivals Hemingway.

He was born in 1931 at Cadolive, in the Bouches-du-Rhône, just beyond Marseilles. Both his parents were teachers and his father-in-law was a well-known educator of the period, a didactic formation akin to OuLiPo ideals. "I am one of the two provincials of the group," Bens declared with typical dry wit, "which isn't nothing, if it isn't everything." Bens was already the tribunal president of Le Collège de 'Pataphysique (an equally obscure organisation based around the pseudoscience of the absurdist Alfred Jarry), and this led him in turn to Raymond Queneau. Bens's scientific studies brought him close to Queneau, the legendary author of *Zazie dans le métro*, who asked the young man to work with him on the authoritative *Encyclopédie de la Pléiade*. Bens published a study of Queneau in 1962 as well as later works on Boris Vian and Marcel Pagnol. He was also a key figure for the OuLiPo as their dedicated minute-taker, secretary and highly professional scribe, for group meetings were famously protracted, complex and bilious, a taste for excellent wine being another of the members' shared characteristics.

Further proof of Bens's secretarial excellence came with his appointment in the 1980s as secretary general of the Société des Gens de Lettres de France. Bens edited several key works in the history of the OuLiPo including the seminal *Guide des jeux d'esprit* in

1967 and the definitive *Bibliothèque Oulipienne* published in several volumes. Bens published two volumes of his own crosswords, but also a large body of poetry, fiction and prose. Indeed his first book of "*prose versifiée*," *Chanson vécue* (Lived song), won the prestigious Prix Fénéon in 1958. In the same vein came such books as *41 sonnets irrationnels* (1965) and *Le Retour au pays* (Homecoming, 1968). He defined his literary terrain as "*des histoires d'amour*" and stuck to it through more than fifteen novels and short story collections. Though he won the Goncourt twice, with the historical narrative *Gaspard de Besse* in 1986 and a collection of stories, *Nouvelles désenchantées* in 1990, Bens remained a relatively marginal figure. As an archetypal writer's writer Bens would not have wanted it any other way but the title of his 1998 book *Lente sortie de l'ombre* (Slow exit from the shadow) hints at an increasingly public profile. Throughout Jacques Bens's oeuvre there is the haunting echo of mortality, a sense of death as the ultimate liberty. As he wrote in his "Chanson vécue xi": "*J'aimais si fort ma solitude / Que pour s'accomplir mon destin / Devait m'accorder cette gloire / De mourir seul sur l'ocean*." ("I loved my solitude so strongly / That to accomplish it my destiny / Should grant me this glory / To die alone upon the ocean.")

Jacques Bens, writer; born Cadolive, France, March 25, 1931,
died Bedoin, France, July 26, 2001.

HENRY COSTON

THE history of anti-Semitism is the history of France itself, for from Dreyfus to Le Pen the figure of the Jew has haunted the politics and culture of France—always accompanied by its negative, the fanatical anti-Semite. Henry Coston, who has died aged 91, was known as the "Pope" of French anti-Semitism. For Coston did nothing else throughout a long and active career but militate against every form of Judaism, real or imaginary, through books, political parties, newspapers, organisations, magazines and clubs.

At 15 Coston was already an active figure in Action Française and a devoted disciple of Édouard Drumont, a pathological anti-Semite whose notorious journal *La Libre Parole* (Free speech) was relaunched by Coston. In 1930 Coston, then 19, began publishing "Jeunesses anti-juives" (Anti-Jewish youth) and stood for political office in Oran in 1936 as the one official "*candidat antisémite*."† Coston distributed imitation one-hundred-franc notes, the reverse bearing rants about the Jewish banking system and his policy that Jews should be deported from France and their holdings seized.

An early Nazi enthusiast, by 1934 he was already in contact with the Nazi propaganda centre at Erfurt and described as one of the few "authentic National Socialist idealists" in France. In 1934 he was proudly received by Julius Streicher and began collecting regular payments from the Nazis to help with his work, such as the republication of the notorious *Protocols of the Elders of Zion*. Come the Second World War, he was a staunch collaborator with German occupation forces and in Vichy became Vice President of the Association des Journalistes Anti-juifs. Coston had created the

† See the note at the end of the book.

Office de Propagande Nationale which according to scholar Alice Kaplan was a key source of material for Louis-Ferdinand Céline not least as it was situated on the rue de Cardinal Mercier near the author's apartment. As Kaplan outlines in her definitive essay on Céline's most notorious work, *Bagatelles pour un massacre*, large chunks of this text were lifted directly from Coston's own writings, to the point of plagiarism. Meanwhile Coston himself continued to publish rabidly anti-Semitic books such as the frankly titled *Je vous hais* (I hate you, 1944), a pamphlet extolling the concentration camps.

Coston fled to Germany in August 1944, was arrested in 1946 and sentenced to hard labour for the rest of his life. This sentence was cancelled in 1952 when he was granted pardon through his numerous political contacts. He had served a bare five years in jail. After this he resumed his life's work of anti-Jewish agitation, with the added twist of negationism, being amongst the first to claim gas chambers never existed. Coston did have one other hobby, pursuing the supposed conspiracy of Masons or *"franc-maçons"* and as such he published works such as *La Franc-maçonnerie, voilà l'ennemi*, the Freemasons being a peculiarly French obsession which like anti-Semitism is as alive today as in 1901.

Coston led the way for violent fringe movements by creating his own, "Publications Henry Coston," from a postbox number in Paris. This put out his revisionist *Dictionnaire de la politique française* and *Les Financiers qui mènent le monde* (The financeers who run the world), published in 1955 and still recommended by the Front National as an economic textbook. Most of Coston's books were available from the Librairie Française, a bookshop conveniently run by his wife Gilberte in Paris. The death of *"l'archiviste de la droite nationale"* — as he was reverentially known — was kept secret until he had been given a quasi-military send-off by the Bureau Politique of Unité Radicale.

Despite his pedigree as a veteran of France's extreme right-wing organisations, Coston's last years were dogged by unfortunate revelations. One of his last publications was *Infiltrations ennemies*

dans la droite nationale et populaire (1999), about the split in the Front National and its infiltration by actually partly Jewish figures. This was directly related to the discovery that his own mother had in fact been technically Jewish: Coston himself should thus logically have been a candidate for extinction under the Nazi laws he proudly promoted all his long life.

Henry Coston, anti-Semitic activist; born Paris, December 20, 1910, died Caen, France, July 26, 2001.

MICHEL DE SALZMANN

THERE is something mysterious about people who devote their own lives to the life of someone else, whether they are biographers, social workers or religious disciples. Thus the name of Michel de Salzmann is inseparable from that of the spiritual master he served, a name still resonant with mystery and potent with myth, that of G. I. Gurdjieff. Salzmann was head of the worldwide Gurdjieff movement, called the Institut G. I. Gurdjieff in France, where Salzmann lived and the organisation was based. Salzmann worked professionally as a psychiatrist but his life was taken up with Gurdjieff seminars, informal groups and a network of publications.

As leader of the Institut Gurdjieff much of his time was occupied with tedious bureaucratic and institutional obligations but this somewhat ludicrous aspect of his responsibilities, as the official guardian of a long-dead guru's rules, should not detract from his own true understanding of Gurdjieff: "He was a danger. A real threat. A threat for one's self-calming, a threat for the little regard one had of oneself, a threat for the comfortable repertoire where we generally live. But at the moment when this threat appeared, like a ditch to cross, a threshold to step over, one was helped to cross it by his presence itself."

This "threat" of Gurdjieff had been with Salzmann ever since he was born, thanks to his extraordinary family history. For Michel de Salzmann was heir to a dynasty of spiritual seekers and his own parents had been central to Gurdjieff's career. His father, Alexandre de Salzmann, was a painter and theatre designer, a friend of Kandinsky's and Rilke's and a member of the Jugendstil group; as a celebrated *metteur en scène* in Russia and France, he had revolutionised lighting techniques with his production of *Pelléas et Mélisande*.

It was in St. Petersburg in 1919 that Alexandre de Salzmann and his wife Jeanne first met Gurdjieff. They were both immediately enthralled and spent the rest of their lives disseminating his teachings, especially in the Francophone world. It was at the famous Gurdjieff group's gathering led by the Salzmanns from the Rue Brancas in Sèvres that Alexandre introduced Gurdjieff to the writer René Daumal and so transformed the latter's work.

In 1922 Jeanne de Salzmann joined Gurdjieff at his Institute for the Harmonious Development of Man, outside of Paris at Fontainebleau-Avon. Here, as his closest disciple, Jeanne was particularly involved with Gurdjieff's sacred dances and she brought these "movements" to the Peter Brook film *Meetings with Remarkable Men* (1979). As Brook recalls in his memoir *Threads of Time*, "At Gurdjieff's death [in 1949] Madame de Salzmann found herself virtually alone, inheriting the gigantic and volcanic output that Gurdjieff had left behind. All over the world there were groups of students left rudderless...."

Madame de Salzmann began the Institut Gurdjieff and its international branches such as the influential Gurdjieff Foundation, which she created in the United States in 1953. She later moved to Geneva and remained actively involved in all aspects of the commemoration of Gurdjieff, including a television documentary on Katherine Mansfield's final few months at Le Prieuré. Jeanne de Salzmann herself died in 1990, aged 101, and despite her three decades with Gurdjieff, the final proof of her deep understanding of his philosophy was that she never published a memoir. This was an act of exceptional forbearance considering that anyone who took a glass of Armagnac with Gurdjieff later wrote intimate books on him.

Likewise her son Michel, who had known Gurdjieff all his childhood, published relatively little on him. He did contribute this portrait of Gurdjieff to *The Encyclopedia of Religion*: "Resembling more the figure of a Zen patriarch or a Socrates than the familiar image of a Christian mystic, Gurdjieff was considered by those

who knew him simply as an incomparable 'awakener' of men. He brought to the West a comprehensive model of esoteric knowledge and left behind him a school embodying a specific methodology for the development of consciousness." Salzmann also appeared in a documentary film about Gurdjieff in 1976 and wrote an introductory essay for J. Walter Driscoll's *Gurdjieff* (1985).

But it was as one of the last living links to Gurdjieff himself that Michel de Salzmann was so important. As Jacob Needleman wrote, "Now we have a very dramatic moment... the third generation, older pupils who didn't know Gurdjieff directly. This is the turning point. Time will tell whether we can continue to gather and be a channel for the forces that Gurdjieff set in motion."

Michel de Salzmann, psychiatrist; born Paris, December 31, 1923, died Paris, August 4, 2001.

MICHAEL RICHARDS

MICHAEL RICHARDS was probably working in his studio on the ninety-second floor of the World Trade Centre North Tower on the morning of September 11. According to a colleague, Richards's last two sculptures were bronze versions of himself pierced by airplanes and accompanied by meteors and flames. For the last ten years he had worked repeatedly with imagery of flight, including feathers, wings and plane parts. Likewise the work for which the 38-year-old artist will surely be best remembered was entitled *Tar Baby vs. St. Sebastian*, a bronze sculpture made in 1999 consisting of his own life-size body pierced by model planes rather than arrows.

This bizarre congruity between Richards's art and the direct manner of his death might seem typical of that odd semi-psychic ability known to artists. Christine Y. Kim, then Assistant Curator at the Studio Museum in Harlem, acknowledged, "We had scheduled that I would see his new work [that week]. His creations often dealt with technology such as aviation, ironically." But it should also be noted that Richards would have applied for this "studio-in-the-sky" specifically because of his interest in flight and aviation. He was extremely happy with this new, raw studio space granted to him as one of the fifteen artists in the "World Views" programme run by the Lower Manhattan Cultural Council, which arranged for the World Trade Center Studio Program to take advantage of the small pockets of empty space always available in these mammoth buildings.

The Lower Manhattan Cultural Council offices at Five World Trade Centre were destroyed but Liz Thompson, its Executive Director, found time to honour Richards, the only artist to have died in the events: "We think he worked late into the night. He was so promising. He was on a tear." Richards would often spend the night in his studio rather than embark on the lengthy commute back to

his home in Queens. "He would work through most of the night and into the morning," said Kira Harris, a close friend. According to a studio neighbour Richards had cooked dinner, watched the Monday night football and at midnight was still working on his sculpture. Thus "See you later" are his last known words.

Though born in New York Richards grew up in Kingston, Jamaica, and this remained a strong influence, whether in his love of reggae music and ragamuffin dancing or his elegant all-black outfits, Caribbean cuisine and penchant for the "Rude Boy" pose. But Richards had also gained first-hand experience of the deadly gunplay and street violence of Kingston, a situation which, as an astute political analyst, he saw as largely due to American intervention. At his packed memorial service at the Studio Museum in Harlem on 125th Street many of the hundreds of mourners spoke of Richards's anti-Republican sentiments and how much he would have hated any exploitation of his death for the sake of American warmongering. Many more mourners spoke of his kindness, gentleness, great generosity and genuine gift for friendship, his "cheesy" smile, shimmying shoulders, soft voice, quiet grace and inner calm. His cheerfulness and soothing ability to settle disputes were repeatedly recounted, along with the fact he never seemed angry. Performances at the service of blues, Gospel and a reggae compilation mixed by DJ Language testified to his great second love after art: music. Richards had gone against the expectations of his Jamaican family in becoming an artist, an extremely rare profession in a society often dominated by bourgeois conventions of financial success.

After receiving his BA from Queens College in 1985 and his MA from New York University in 1991, Richards completed the prestigious Whitney Museum Independent Study Program in 1993. The next year he became part of the Artists in the Marketplace program at the Bronx Museum of the Arts. All this time he was cheerfully supporting himself as an art handler at the New Museum, a studio assistant and general art world gofer, eating and drinking

at openings and relishing *la vie bohème*. He had started working around the theme of the Tuskegee Airmen, a crack team of Second World War air force pilots, Black Americans who remained racially segregated second-class citizens when back on US soil even if they were heroes in the skies. The Tuskegee Airmen were awarded more than 150 Distinguished Flying Crosses but at the same time their Alma Mater was being used for illegal experiments on Black men to test the transference of syphilis.

Using material as diverse as tar, feathers, rubber and human hair, Richards dealt with aspects of the Tuskegee history in works with titles such as *Escape Plan 76 (Brer Plane in the Brier Patch)* and *The Great Black Airmen* (both 1996). His work deployed a variety of themes and media, whether a ladder made of feathers or a chariot with broken wheel, but air transport and bonded bronze were slowly becoming his trademarks. Richards regularly cast his own body in plaster resin and then in bronze and, as a regular gym buff, was keen on sculpting his own body, which then became the literal "body" of his work. He had been working out at the gym that Monday evening before heading home to his studio in the North Tower. He was well aware of the potential metaphors within aviation, describing the Black pilots of the Second World War as only being free, really free, when they were in the air. "They serve as symbols of failed transcendence and loss of faith, escaping the pull of gravity, but always forced back to the ground. Lost navigators always seeking home."

Likewise Jorge Daniel Veneciano, who curated Richards's Artist-in-Residence exhibition at the Studio Museum in Harlem, wrote: "Each of his works engages the notion of flight in at least two important senses: as a form of flight away from what is repressive, and as a form of flight toward what is redeeming." Richards had become Artist-in-Residence at the Studio Museum in 1995–96. A similar appointment at the Socrates Sculpture Park followed and then a third artist residency in Miami. He had also begun to be included in various important group exhibitions including *Passages:*

Contemporary Art in Transition at the Studio Museum (1999-2000), *Postcards from Black America*, which originated in the Netherlands before travelling internationally (1998), and *No Doubt: African-American Art of the 90's* at the Aldrich (1996). His work was shown at the Corcoran, the Miami Art Museum, the Chicago Cultural Center and the Ambrosino Gallery in Miami (all 2000). As Richards explained in relation to his exhibition at the Bronx Museum: "The idea of flight relates to my use of pilots and planes, but it also references the Black church, the idea of being lifted up, enraptured, or taken up to a safe place — to a better world."

Michael Richards, artist; born New York City, August 2, 1963,
died New York City, September 11, 2001.

STUART SHERMAN

CULTURE is currently obsessed with the maximal, the gargantuan, the most expensive movie ever made, the opera production with a cast of thousands. The genius of Stuart Sherman was radically opposed to such bombastic spectacle. Instead he refined creative expression to the smallest number of props, simplest sets and singular performer, usually himself. Thus he travelled the international "performance" and avant-garde circuit needing no more than a kitchen table top, a pocketful of tiny objects, a suitcase of toys and his own inexhaustible invention. With matchsticks, handkerchief, toy robots, and twigs of cardboard he could stage the great dramas of humankind from Hamlet to Oedipus as improbably intimate spectacles for impossibly select audiences. "My early work," he said, "involved the manipulation of everyday objects in unusual ways. I would change the context and manipulate them in a way that altered their ordinary identity. That kind of performance was very casual: it was just like sweeping my apartment. It was more in the style of the performance of household chores."

Thus Sherman created his twelve-minute *Chekhov* with six cut-out trees decorated by handwritten dialogue from the Russian's plays. His five minute *Faust* was equally minimal and fast-paced. Whether dealing with Brecht, Chekhov or any of his other heroes, Sherman understood that the magic of language and stage image could be tuned until reduced to an absolute essence, the more poetic for brevity. He resisted being labelled a "performance artist" or anything else: "Working on the inside, I don't have a name for what I do. It's not relevant as far as helping me continue doing what I do."

Sherman was a touchstone of American experimental theatre, honoured with numerous grants and awards, yet his relative obscurity seemed part of his deliberately marginal and minimal aesthetic, which sprang from nineteenth-century literature and subsequent

modernist innovations. Like Jean Baudrillard, Sherman might well have believed that all the great cultural innovations and experiments of the twentieth century had already taken place by 1914. Typical of this taste for bold melodrama, conjuring tricks and gaslit mountebanks was his strange relationship with the Gothick writer Carson McCullers, author of *The Heart is a Lonely Hunter* and *The Member of the Wedding*. As a young man, Sherman turned up entirely unannounced at McCullers's house in Nyack, New York, and became her official companion, looking after her throughout 1967, the last year of her life. Thus he would read aloud to her all day long, in dark shuttered rooms, from *Anna Karenina*, *Le Rouge et le noir*, *Gone with the Wind* or *A Handful of Dust*.

Through McCullers, Sherman met a range of actors and celebrity friends including Tennessee Williams, Robert Forster, Julie Harris and John Huston.

> I watch as Carson McCullers blows her nose, and I think, "That is how a great writer blows her nose. If I can learn to blow my nose like that, then, I, too, can become a great writer." Despite diligent and prolonged effort, I do not become a great writer. Finally, I convince myself that these attempts are futile and I abandon them. But even now even today, at this very moment I nervously wonder: "Did I give up too soon? If I'd kept on practising, would I have become a great writer?" Who knows? Who knows?

Born in Providence, Rhode Island, Sherman went to the extremely liberal liberal arts college of Antioch in Yellow Springs, Ohio, historic home to several generations of American Arts and Crafts figures, and folk and artisan activists. He came to Manhattan at the height of its alternative theatrical madness and as well as writing fiction, poetry and monologues, he worked with groundbreaking mavericks such as Richard Foreman and his Ontological-Hysteric Theater and Charles Ludlam and the Ridiculous Theatrical Company. As an actor Sherman appeared at

Lincoln Center and the Williamstown Playhouse in Massachusetts. Branching off into his own personal universe, Sherman began creating small theatrical works to be presented in his front room and in street performances, public parks and OffOffOffOff Broadway. He was also a longtime resident of Greenwich Village and part of its rich cultural fabric, a friend of Stefan Brecht (Bertolt's son), who immediately recognised the importance of Sherman's theatrical work. As a sculptor and draughtsman, he had exhibitions at the Carpenter Gallery in New York and at MIT List, his physical art works being happily almost indistinguishable from his theatre. "The performances are animated drawings. The drawings I made were ideographic. If I depicted a person drinking a glass of water the drawing would be the idea of drinking a glass of water."

Though Sherman's performances were fleeting and transitory spectacles that vanished almost as soon as they commenced, out of a radical tradition of intentional impermanence, he did make short film and video works which capture his style. These began in 1978 and included *Edwin*, a portrait of the poet and dance critic Edwin Denby, as well as evocatively named silent performances such as *Hand/Water*, *Fountain/Car*, and *Piano/Music*. Sherman created his tableaux vivants and "living paintings" around the world in a wild range of festivals, in underground cinemas and on impromptu street corners, travelling and coming up with new ideas. As his executor Mark Bradford explained, "He would do his work anywhere for almost nothing for an audience of nobody." In the final years, haunted by AIDS and a decimated cultural community, Sherman became all the more the itinerant global citizen, ending his days in San Francisco. He was aged only 55, which though tragically youthful, being a brief, elegant figure and a numerical palindrome surely suited him.

Stuart Sherman, sculptor, playwright, filmmaker and performer;
born Providence, October 9, 1945, died San Francisco, September 14, 2001.

GELLU NAUM

G ELLU NAUM was the leading modern poet of Romania, avatar of its avant-garde and creator of its Surrealist movement. He was the André Breton of Bucharest. If this seems preposterously obscure by current celebrity ratings, it should be stressed that Naum's obscurity was the obstinate sort that challenges the norms of any totalitarian orthodoxy and ultimately qualifies as the benchmark of civilisation. Without utterly marginal poets, poets who are forgotten, comic and penniless, a culture dies. Thus it is a mark of Naum's importance, as national metaphor of resistance, that he easily outlived the long horror of the Ceaușescu regime.

There may not be suitably large numbers of people interested in the experimental artistic fringe of Bucharest in the late thirties, but, if true culture rests in footnotes, Romanian Surrealism is a vital addendum. Born in 1915, Naum was the sixth child in a well established family, his father being the revered Andrei Naum, a minor civil servant but major nationalist poet, who died as a hero fighting in the First World War. Gellu Naum had no memory of his father (who even had a street named after him in his native village) and only later discovered the extent of his renown. The child Gellu was a prodigy, who could read and converse like an adult by age 4. Consistently voted top of his class Naum was also an outstanding player of oină, the Romanian national game comparable to baseball. He was also captain of the rugby team. By 17 he was studying philosophy at the University of Bucharest and leading their team to rugby victory. He had meanwhile left home to live with a female lawyer six years his senior.

Naum became a member of the clandestine Communist Youth cell and was elected editor of their paper, which he distributed outside the proverbial factory gates. In attending underground communist meetings he first encountered the wild gypsy child

Nicolae Ceauşescu, their despised cigarette gofer. At 21 Naum was also a committed Surrealist and militant for its madness. The previous year he had met the artist Victor Brauner, who had returned to Bucharest from exile amongst the Parisian Surrealists. The Romanian contribution to Dada and Surrealism was strong, including Tristan Tzara, Jacques Hérold and Marcel Janco, but Naum soon had his own group around him. These included Zaharia Zaharia, Gherasim Luca and Dolfi Trost, as well as such associated figures as the wealthy writer Zogdan Palashi, who was to become a lifelong rival to the title of Romania's "Poet-Laureate Provocateur." Though the official Romanian Surrealist group was never larger than five to ten members, they managed as many acrimonious splits as any movement.

In 1936 Naum published his first book, *Drumeţul incendiar* (The incendiary voyager), with three drawings by Brauner. This was followed the next year by *Libertatea de a dormi pe o frunte* (The liberty to sleep on one's front), with a cover by Brauner, both extreme bibliographic rarities much sought by libraries worldwide. Naum published several further books with Brauner and through him finally managed to come to Paris in 1938, with his first wife, Mariana. Naum naturally spent much time with the Surrealists but also pursued a Sorbonne doctorate in medieval philosophy on Pierre Abélard which shifted into a study of the devil, diabolism and Hell. Naum had a deep fascination with magic—black, white, and folkloric—and was regarded as a magus or "guru" himself, assumed to have occult powers stronger than his indubitable talent for coincidence and psychic second-guessing.

In 1940 he caught the Orient Express to Venice and then on to Bucharest, arriving home the day before general mobilisation was declared. He became a corporal in the Queen's Hussars and fought in Moldovia. In immediate postwar Bucharest, Naum's first desire was to get a new passport and thus be able to leave for Paris, but by now he had finally fallen for and married the great predestined love of his life, Lydgia Alexandrescu. With Lydgia, the poet played

occult games to test their synchronicity. Lydgia would leave in the afternoon saying "See you at the cinema!" without specifying time or place. Naum would catch a random tram, enter an unknown slum of the city and then join her in the queue, two tickets in her hand, a few minutes before the film began.

The group of Romanian Surrealists, largely Jewish and communist, were cocooned during the Second World War but flourished in 1945. They mounted a major exhibition at Gallery Cretulescu in the centre of Bucharest. This included "OOO" (Objectively Offered Objects), a burnt matchstick from Naum and a row of smoke blackened gas lamps. Their game entitled "sable nocturne" (night sand), which involved emptying one's mind of thought, stripping naked and navigating a darkened room, had a certain success at the Surrealist exhibition of 1947. Breton even announced, "The centre of the world has moved to Bucharest." But, as Stalinist orthodoxy solidified, the Jewish contingent emigrated to Israel, Lucian Boz fled to Sydney and Palashi famously escaped to England in a rowing boat. Naum suffered as an invalid without official work papers until granted the fictitious position of Professor of Philosophy at the Academy of Fishermen in Poarta Albâ. Naum finally opted to work as a translator. This job was the lowest of the low, paid miserably by the page, but from 1953 to 1962 Naum destroyed himself translating nonstop, twelve hours a day, smoking his pipe and listening to Louis Armstrong. He translated well over a hundred works, including Dumas, Stendhal, Darwin and the whole of Diderot, also translating *Waiting for Godot* and much French poetry. His last translation was of Kafka's *The Trial*. Having been finally granted a passport Naum was able to revisit Paris in 1964 for the first time in twenty-five years. This he found painfully desolate, not least as he was unable to reach Brauner, who died soon after.

Naum soon became a regular traveller and practically official representative of Romanian literature abroad, albeit still censured and attacked at home. The publication of his poem "Heraclitus" caused outrage and death threat phone calls night and day for

six weeks, a favoured technique of the Securitate. In 1985, after seven years of revision, Naum finally published *Zenobia*, a huge prose poem homage to the sustaining love of his wife. This was translated into Greek and German and finally into English in 1986. International publishers had become increasingly interested in Naum. A couple of his poems had already been translated by no less than Paul Celan and in 1983, his verse novel *Tatǎl meu obosit* was published in French and translated into English as *My Tired Father* three years later. Naum even travelled to New York in 1983 and made a fabled appearance at the Romanian Émigré Club on Bleecker Street with his old friend and rival Palashi. Naum's status was only reinforced by the collapse of the Ceauşescu regime. In 1994 the French linguist and diplomat Rémy Laville published his study, *Gellu Naum: Poète roumain prisonnier au château des aveugles* (Gellu Naum: Romanian poet, prisoner of the castle of the blind) to which all subsequent writers on Naum are inherently indebted. Various fat retrospective volumes were subsequently published and a collection of his plays (which the author consistently disparaged) was gathered. In 1999 Naum won the European Prize for Poetry and in his last years was heaped with seminars and honours as a surviving silver Surrealist. As Naum put it himself: "In the autumn he gathered fruits one by one then he quietly climbed the tree and fell asleep there waiting to dry and to fall down amongst dead fruits."

Gellu Naum, poet, translator and playwright;
born Bucharest, August 1, 1915, died Bucharest, September 29, 2001.

ROLF HOFFMANN

ROLF HOFFMANN was the creator, with his wife Erika Hoffmann-Koenige, of one of the most important collections of modern and contemporary art, the Sammlung Hoffmann in Berlin, but was equally renowned in the fashion trade for the transformation of his family firm van Laack. He was also notably handsome, tall, urbane, charming and utterly fluent in a wide variety of languages and social milieux. Hoffmann seemed the archetypal citizen of the world but his position in German business and cultural politics, his patrimony and philanthropy, was local in the best sense.

Hoffmann was born in 1934, and while still a schoolboy began work at the family clothing business, Heinrich Hoffmann. When many were going in the opposite direction, under Rolf's direction the business moved upmarket into the luxury trade under the new name of van Laack. The high-end luxury niche has proved one of the most profitable in fashion retail, and the small, regional family firm was turned into a highly remunerative international concern.

In 1963 he married Erika, a student in art history who later was to found the successful Lady van Laack line, and the two encouraged each other's rapacious cultural interests. They began collecting works from the Italian Arte Povera movement and the Zero group—their first purchase, in 1968, was a sculpture by Takis. The Hoffmanns' collection of Soviet Constructivism influenced van Laack's graphics, packaging and design, and led to limited edition clothes based on original Constructivist designs from the 1917 Revolution. Van Laack ran advertising featuring the Belgian artist Marcel Broodthaers and included a "Shirt Art Gallery" for emerging artists within their offices, which also featured a mural by Blinky Palermo. Andy Warhol painted a diamond dust portrait of the Hoffmanns in 1980 and personally modelled their shirts for a fashion show in their Manhattan loft.

Rolf Hoffman was an early investor in downtown Manhattan real estate, even contemplating relocating his company to the city at the height of the Baader-Meinhof gang threat. At the age of just 50 Hoffman sold the business, switching his energies to the family property portfolio and art collection. The Hoffmans' close friendships with artists led to business opportunities, buying a major building on Lafayette Street with the French painter, François Morellet and his son, Florent. Hoffman also became a pioneering investor in Tribeca, where he created the area's first luxury building with 24-hour lobby reception and a groundbreaking high-rent-only loft building.

One of Hoffmann's boldest plans, and his only unrealised project, was a proposal in 1990 to build a Kunsthalle in Dresden. For this the Hoffmans commissioned the artist Frank Stella to create a maquette, his first architectural creation, which would have stolen a dramatic march on the Guggenheim Bilbao. Those who have seen Stella's plan consider it one of the most extraordinary museum buildings ever proposed – Philip Johnson even erected a version of it in his own sculpture garden. The scheme fizzled out in 1993 due to governmental sloth but the Hoffmanns' commitment to their reunified country did not.

They became early supporters of the Berlin scene, moving residence and collection to the city. The Sammlung Hoffmann was set up in 1997 in Berlin, and gives Berlin a rare chance to see international contemporary art, whether Felix Gonzalez-Torres and Ron Mueck, Rineke Dijkstra or Pipilotti Rist. The collection is equally strong in established figures such as Lucio Fontana, Gerhard Richter or John Coplans. In 2000, Hoffmann set up the Preis der Nationalgalerie, Berlin's equivalent to the Turner Prize, and he was active in the International Councils of the Tate Gallery and of MoMA.

Rolf Hoffmann, businessman, property developer, art collector;
born Naumberg, Germany, July 12, 1934, died Berlin, October 17, 2001.

LANCE LOUD

REALITY television inherently breaks those participants it also makes, a sadistic voyeurism integral to its excitements. Yet Lance Loud not only survived being the undoubted star of the first ever "reality" show, he also managed to turn this into an extended performance spectacle for the rest of his life. The pleasure of any reality show is in watching its subjects fail dramatically but when Loud found fame in 1973 in that groundbreaking, twelve-hour fly-on-the-wall PBS show *An American Family*, his stated ambition was to become a flamboyant homosexual bohemian "character" and at this he succeeded, wildly. The fact that Loud was only a teenager at the time and that he was a member of "Gay Lib," all conspired to launch him into instant stardom.

An American Family filmed for seven months the daily life of a normal West Coast nuclear group, the Louds of Santa Barbara, then relayed this across the United States week by week. As the producers hoped, this standard suburban family with four children, swimming pool and four-car garage generated plenty of drama, not least when the unfaithful father was thrown out by his wife. But even more riveting was the outrageous appearance of their 14-year-old son Lance, already a flaming homosexual militant with dyed white hair and blue lipstick, perfectly happy to ham it up and queen it out for the networks.

Inevitably Lance Loud became a gay icon as he steadily took over the series and practically made it a one-boy solo show. When the series was shown again in 1990 Loud commented, "I'm amused. It's no big deal. We have nothing to sell or promote because of it. We're still a very close family." The show had actually been recorded

in 1971, just a year after the Stonewall riots and Loud was the first person in the world ever to "come out" on television, whilst being watched by some ten million viewers. Loud even appeared on the cover of *Rolling Stone* in 1974, albeit when it was a far more radical publication than today.

That same year he appeared in concert in Tampa with Zappa's Mothers of Invention. As soon as he could, Loud naturally lit out for Manhattan where he was already living by the time the television show was eventually aired. In New York Loud became a downtown local legend in that avant-garde scene between Warhol's Factory and the punk rockers of CBGB. Loud formed his own band, The Mumps, whose frenzied, wonky performances rocked the clubs, his charisma overcoming any vocal deficiencies. He called himself "the Fred Astaire of Uncool" and thus defined his aesthetic: "My whole art is the art of clumsiness, of cosmic left-handedness ... sticking your foot in your mouth so many times that you get athlete's foot between your teeth." Or as a reviewer put it: "Lance has star quality, which is not to be confused with talent."

The Mumps appeared on the first Max's Kansas City compilation, no small honour in itself, and in 1994 a full retrospective CD *Fatal Charm* was released which included classics like "Muscle Boys," "Awkward Age" and "Dance Tunes for the Underdogs." As Loud readily admitted on the sleeve notes, "We had a lead singer who could sweat better than he could stay in key." Mumps songs can still be found on compilations such as *The Great New York Singles Scene* (1982) or *DIY: Blank Generation – The New York Scene (1975–78)* (1993), which features their seminal semi-hit "Crocodile Tears" with its snappy refrain, "You bought the sofa that I wanted for me!"

Loud was joined in Manhattan by his now divorced mother and they moved in together to the notorious Chelsea Hotel. As the punk scene died, Loud shifted to the new disco-celebrity culture embodied by Studio 54, where he managed to maintain his VIP status as "boy-toy" to the so-called Velvet Mafia. He also acted in a variety of independent films, including Amos Poe's *Subway Riders* (1981),

where he starred with the likes of Robbie Coltrane, and the cult *Inside Monkey Zetterland* (1992), where he appeared amongst many other cameo roles of the LA set including young Sofia Coppola.

In 1981 Loud had moved back to his native California, working as a journalist for the gay political magazine *The Advocate* as well as for *Interview*, set up by his hero, Warhol. Loud was a highly successful glossy journalist, mainly covering movies and music whilst also playing the part-time rent boy and full-time underground eminence. He kept a secret journal of his assignations with high-power closeted Hollywood players and revelled in his clandestine life as a quasi-hooker.

Loud may have termed himself "a gossipy old pencil pusher in the bloom of health" but his love of narcotic erotics was hardly healthy. He matched an addiction to gym body-building with a dedication to cocaine and became a full devotee of crystal meth, dangerous sex and Formula One fast living. By now a fabled Silver Lake eccentric, an animal activist living in a run-down Echo Park estate surrounded by hundreds of his adored stray cats like a gay diva version of Grey Gardens, he wrote gossip columns, reviewed films, interviewed the famous and pruned lime trees. He remained an ambiguous semi-star, being regularly pestered to attend concerts by the San Francisco band The Loud Family, and unable to use his own name as his AOL handle because some pop-culture fan had already taken it. He was even played several times as a character by other actors, not least in the experimental video work *Gone* (2000). Loud knew literally everyone, including Rufus Wainwright: "Do you know Lance Loud? He sort of chaperoned me into LA and when he first heard the song 'In My Arms' he said, 'Rufus, you're so butch.'"

Loud may have died young, AIDS-related hepatitis C claiming him at age 50, but he carried his alternative celebrity to the end, a revered performer of the act that was his own life. Days before he died in the Carl Bush Hospice he wrote for *The Advocate* about his imminent demise: "I've been sent on a journey to places even bleach can't reach. For years I had told myself that all my unbridled

drinking, drugging and unsafe sex were going to lead exactly here. But I never really believed it."

All too appropriately there was a television documentary crew recording his last hours. *An American Family* had by then become a staple of late-night reruns and media studies dissertations. Loud remained amused and resigned to the resilient power of the programme: "Maybe it will be viewed—maybe long after reality programming as a concept has bitten the dust—that what we did was noble. I guess I could drag out my favourite Leonard Cohen line and say, 'And wasn't it a long way down and wasn't it a strange way down?'"

Alanson Russell "Lance" Loud, actor, performer and journalist;
born La Jolla, California, June 26, 1951, died Los Angeles, December 22, 2001.

RAVEN CHANTICLEER

MANHATTAN is rich in eccentric spaces and improbable places, but few of its venues could match the Harlem African-American Wax and History Museum for sheer charmed oddity. Located just down the hill from Columbia University, but in the rather different social milieu of West 115th Street, the museum was essentially the basement of a personal residence — in fact it operated as a private institution at the whim of its founder and owner, the impresario Raven Chanticleer.

It was the unique flavour of Chanticleer and his persona that made a visit to his museum such a special occasion. Chanticleer had been inspired to create a waxwork display of famed African Americans after a visit to Madame Tussaud's in London, where he noted the singular lack of Black faces and according to shaky legend — for Marie Tussaud actually died in 1850 — personally reprimanded "Madame" herself about this overt omission. Returning to New York from this revelatory European jaunt, Chanticleer set about creating his own wax versions of African American notables including Malcolm X, Josephine Baker, Martin Luther King and even "Raven Chanticleer."

The fashioning of these figures was a laborious and skilful process which included the creation of all their clothes, props and effects, sewn and styled by the man himself. Each figure, not least Madonna in "Blackface" took a full month, starting from the feet up with papier-maché and plaster. Chanticleer had even embarked on a book about his waxwork techniques to be entitled *Taking Wax to the Max*. For the genius of Chanticleer was to stress not authenticity or likeness but rather a sort of approximate simulacra of these celebrities, conjured as much by his spirited explanations and comments as by any tangential facial resemblance.

Thus a tour of Chanticleer's theme park, or rather theme room, was essentially a tour of his own life story, his colourful past and sometimes surprising connections to these stars. There are other all-Black wax museums and indeed the National Great Blacks in Wax Museum of Baltimore long refuted Chanticleer's claim that he had created the first in 1985. There are also doubtless wax museums where the statues are more realistic, more professional and more recognisable, but these other institutions lack one essential ingredient: the presence of Raven Chanticleer himself.

Thus whilst visitors were trying to figure out whether that could really be Duke Ellington looking quite so pugnacious, or a curiously small Magic Johnson, Chanticleer would amuse and entertain with his extremely elegant and famously forceful diction. The two-dozen wax statues and his numerous paintings of Black life tended to take up less time than Chanticleer's own tales of his days at the Sorbonne, his fashion career and various precocious prizes.

Certain cultures are known for their larger-than-life characters and in the African American tradition as in the Irish, Welsh or Congolese, the dazzling dandy, the showman and trickster, the schmoozer and self-mythologist are a much loved archetype. Thus it would be a cliché to say that Raven Chanticleer's most striking creation was himself and it would be a slight to this creation to dwell on factual bones for surely his heady brew of anecdote and association was far richer than any "truth."

His parents may well have been sharecroppers in South Carolina and his real name was probably James Watson but his own version claimed a mixed Barbadian Haitian ancestry firmly rooted in the Harlem Black bourgeoisie. He almost certainly studied abroad as well as at the prestigious Fashion Institute of Technology in New York and had a successful career designing costumes for his own dance troupe, the Raven Chanticleer Dancers. Chanticleer creations were stocked by a variety of fashion

boutiques including Bergdorf Goodman and his outrageous outfits from the seventies featuring transparent panels and bin liners launched a certain hi-tech punk look, though his speciality was designing for women of a certain size.

Chanticleer bought his elegant brownstone in its then less than elegant environment back in 1985, when Harlem still really was Harlem and just whispering the word "gentrification" was enough to guarantee a mugging. Chanticleer was a central, immediately noticeable figure in the local civic politics of what he called "Harlem Village," and was crucial, in his own eccentric and unlikely manner, to the improving fortunes of that area. Chanticleer not only built his own museum with his bare hands, he also created a nonprofit organisation, the Learning Tree, to distribute toys to deprived neighbouring children. He believed above all else in education and that was the real purpose of his wax museum, to stir African American pride and teach the crucial lessons of responsibility, fiscal and personal.

No, perhaps what he really believed in above all else was Raven Chanticleer, and quite rightly. As he said regarding his own imposing waxwork in his own museum, it was there "just in case something should happen to me. If they didn't carry out my wishes and my dreams of this wax museum I would come back and haunt the hell out of them."

Raven Chanticleer, dancer, designer and artist;
born Woodruff, South Carolina, September 13, 1928,
died New York City, March 31, 2002.

LARRY RIVERS

LARRY RIVERS was a very famous artist from a relatively young age and a truly notorious loudmouth, drug fan, sex fiend, raconteur, gadabout and troublemaker from a definitively younger one. He was also a professional sax player, actor, film director and writer, whose 1992 "unauthorised autobiography," *What Did I Do?* is the funniest, frankest and most shockingly ballsy account of a twentieth-century legend ever penned. Rivers knew absolutely everyone in the widest cultural milieu, slept with many of them, men and women alike, and lived to dish their dirt, magnificently. He spared nobody, least of all himself, with his constant insecurities about his art, his voracious appetite for sex of every stripe and his equally wide penchant for drugs—heroin preferably.

Born to Russian Jewish immigrant parents in the Bronx, New York, his real name was Yitzroch Loiza Grossberg and he grew up in a house whose cultural aspirations were confined to two Van Gogh prints, a free offer from the Bronx Home News. Rivers retained vivid memories of this upbringing, not least of having sex aged 16 with the dark blue velvet armchair in his mother's living room. "The armchair was the youngest in the room." His first performances as a budding sax player were for the local Young Communist League. He also found a new name. According to Rivers he was given this fresh nomenclature by a nightclub MC in Massachusetts who

announced, "The music tonight has been supplied by Larry Rivers and his Mudcats." However his family claim he took the name from a Black appellate court judge called Rivers to give himself "Black airs" for his jazz career.

In 1942, Rivers enlisted in the US Army Air Corps and at Fort Dix, New Jersey, was inducted into the Air Corps Swing Band to play tenor saxophone. Training as a radio operator in South Dakota was followed by radar training in Boca Raton. Luckily, a neurological condition which had made Rivers's left hand shake since childhood was noticed and he was given a medical discharge and a generous pension for life. Rivers enrolled at the Juilliard School in New York as a composer, where he became friendly with a fellow student, Miles Davis. "Miles and I would prepare for the exam by going outside to smoke some marijuana. It seemed I was the only White person in the school that he spoke to."

By the end of the Second World War Rivers was already married to his first wife Augusta Berger. Meanwhile, as a member of Musicians Local 802 and baritone sax for the Johnny Morris Big Band he was playing all over America, fuelled by marijuana and speed, and soon enough he started shooting up heroin, a longstanding pleasure: "I was influenced by the best of the bebop musicians. I talked like them, drank what they drank, smoked what they smoked and occasionally injected into my veins the dope they took. The only thing I complained about was that I wasn't born a Negro." In Manhattan, Rivers jammed with Zoot Sims, Allen Eager and Al Cohn, the White avant-garde of bebop. Joining the Herbie Fields Band, Rivers wrote a richly suggestive song, "Headhunters," which he played at the fabled Roseland Ballroom in 1946. Even when professional engagements had dried up, Rivers continued to carry his horn with him everywhere, enthusiastically jamming with anyone who would let him. In fact Rivers managed to play alongside as many famous jazz names as he showed with famous artists or worked with legendary writers. In later years Rivers maintained his own five piece group, the Climax Band.

It was on a jazz tour that the artist Jane Freilicher, wife of the band's piano player, suggested he might paint. "Why don't you try it, man? I think you'll dig it." Rivers put brush to paper for the first time on a beach while the rest of the band played cards. Rivers was first taken to MoMA by a zoot suited saxist friend to smoke grass in the garden. He had never heard of it before. "That place was something else! I wasn't even high for the last half hour." Rivers was soon bringing his first paintings, made on laundry shirt boards, down to the union floor to show everybody, and painted a mural of "Bird" Parker at home on his living room wall.

Married life with two children was hardly to his taste; Rivers would say, "I'm going downstairs to buy a pack of cigarettes" and not return for days. As his wife put it, "Larry knew what he wanted from life much too strongly—his freedom, his drugs, his women, his men, his music, his taste for everything wild and different, his intense desire for immortality whichever way it would come." By now Rivers had enrolled with Hans Hofmann at the New School and had his first solo show, strongly influenced by Pierre Bonnard, in the spring of 1949 at the Jane Street Gallery. This garnered a rave review from Clement Greenberg in *The Nation* who called Rivers "a better composer of pictures than was Bonnard himself in many instances." It also gave Rivers his first sales, future representation by the Tibor de Nagy Gallery and a taste of success. As the filmmaker Rudy Burckhardt said, "You had a big success at 25, which means the rest of your life you had to make comebacks. So you had to make about six comebacks."

Rivers acted with the poet John Ashbery in his film *Mounting Tension* (1950) and appeared in another film acting to type as a dedicated drug addict in a coffin. In the key 1960 beatnik film *Pull My Daisy* by Alfred Leslie and Robert Frank, Rivers plays a stoned train conductor, alongside friends like Allen Ginsberg, Jack Kerouac, Gregory Corso and Delphine Seyrig. Rivers also acted in films by his friend Kenneth Koch, as befitted a full-time member of the New York School of poets. The best known of these poets, Frank

O'Hara, also became Rivers's one serious homosexual relationship, a love affair that included seminal collaborations such as their 1957 lithographic series *Stones*, the surreal text "How to Proceed in the Arts" and a set for O'Hara's 1953 play *Try! Try!*.

Rivers's sexual tastes were always wide, from maternal furniture to young girls, occasional boys and even, so he claimed, his dog Amy, "but she howled and I stopped and we remained just good friends." He certainly had an astonishing variety of sexual anecdotage, usually involving celebrities and such interesting partners as the Seagram heiress, Phyllis Lambert, to fifteen-year-old Donnie, for whom he gave a sweet sixteen party. He seemed to live his life in constant anticipation of erotic gratification but as Anne Tabachnick revealed, "Larry didn't have gay episodes to have sex but to improve himself! He thought by hanging out in gay company he would learn to be classier. No, it wasn't the homosexuality, it was the upward mobility."

Rivers was certainly on his way. For 1951 he spent the year in Paris where he was strongly influenced by Gustave Courbet's *Burial at Ornans* in the Louvre. Back in America, Rivers created his own equally large version, of his dead grandmother, called *The Burial* (1951). This he sold to Gloria Vanderbilt for $750. Leo Castelli commissioned Rivers to make a giant female sculpture in the centre of his East Hampton drive, which Jackson Pollock tried to run over. Rivers's first solo show with Tibor de Nagy in 1951 was a success and the gallery guaranteed him $25,000 a year as an advance against sales. Rivers was creating paintings of notable originality, flying in the face of Abstract Expressionist orthodoxy and perhaps predating Pop with his fluid versions of American iconography.

The breakthrough was his 1953 version of *Washington Crossing the Delaware*, which still manages to hover ambiguously between ironic and patriotic, and remains the central painting in his aesthetic. "At a time when not making a million by the age of 30 was not a definition of failure, I was not doing badly." In 1955 MoMA purchased *Washington Crossing the Delaware* for $2,500 and displayed

it next to abstracts by Franz Kline and Philip Guston, confusing the assumed abstract hegemony. Most of his contemporaries were fans of Rivers, Willem de Kooning declaring, "Looking at a Rivers painting is like pressing your face in wet grass." Rivers became even more famous by appearing on the television quiz show *The $64,000 Challenge* in 1957. Attracting forty million viewers, this show pitched Rivers against a working jockey with a knowledge of art history. Rivers won $32,000.

By now Rivers had divorced his first wife and found himself attached to his Welsh babysitter Clarice Price, moving to Europe with her in 1961, partly to get married in London but also for two exhibitions. In Paris they lived in a small studio in the Impasse Ronsin next to the Nouveaux Réalistes Niki de Saint Phalle and Jean Tinguely, who became fast friends. Rivers showed at Galerie Rive Droite, Ashbery wrote the catalogue essay and Jean Seberg commissioned a portrait, with her husband Romain Gary attending all the sittings. The Pop collector Bob Scull took Rivers for a pressed duck dinner at La Tour d'Argent and under the table handed him $1,500 for a large painting from the "Vocabulary Lesson" series.

In London Rivers showed with Gimpel, became a sellout celebrity on the lecture circuit, and was friendly with Francis Bacon and a very young David Hockney. Whilst touring Morocco on a break from all this glamour, Rivers naturally hung out with Jane and Paul Bowles or lingered at the pool of the Mamounia in Marrakesh with Diana Vreeland. Rivers had signed an exclusive contract with the Marlborough Gallery in New York in 1962 and they were selling his larger paintings for up to $10,000, at the time a fabulous amount. In 1965 a fifteen-year retrospective of Rivers's work began a five museum tour across America. For its slot at the Jewish Museum in Manhattan, Rivers created a new work, his largest yet, a huge multimedia panel entitled *The History of the Russian Revolution from Marx to Mayakovsky* (1965), now in the Hirshhorn. Equally spectacular was Rivers's version of Stravinsky's *Oedipus Rex* at Lincoln Center

in 1966 with Jason Robards as narrator, a contemporary design firmly booed by the first night audience for a record five minutes. In 1967, Rivers carried his straight soprano sax to Africa for an NBC documentary directed by Pierre Gaisseau in whose film *Round Trip* Rivers had already appeared as himself. This seven-month adventure nearly killed Rivers and certainly ended his marriage. Their shoot in Nigeria almost turned into exactly that, for they seemed only seconds away from being executed as White mercenaries by the local military. Rivers's diplomatic rescue made front page news whilst his film *Africa and I* won the Chicago Documentary Festival in 1970.

Rivers never ceased to make art and love with passionate intrigue even if he eventually reluctantly gave up heroin for amphetamines. He also became especially interested in film, making over 250 videos. His 1969 documentary *Tits* was followed by a video about his mother, *Shirley*. Rivers's art may have become less modish in later years but it remained engaging, his 1988 triptych of Primo Levi being bought by Gianni Agnelli for *La Stampa*. Rivers also remained acutely aware of his status, or lack of it, on the current cultural map:

> All I can see is my obituary in *The New York Times*. Will it begin at the bottom of the front page, "Genius of the Vulgar Dies at 63," continued inside with one of the *Times*'s awful photos of me and the usual reference to the name my parents gave me, Yitzroch Loiza Grossberg? There won't be much sympathy of course: I am dying at a pretty ripe old age, and I have lived my life to the hilt, had success, money, fame, accomplishment, and an abundance of sensual satisfaction, and I am leaving this life loved by friends, cherished by a grateful family, and adored by some pretty sexy women; I should die happy.

Larry Rivers (Yitzroch Loiza Grossberg), artist and saxophonist;
born New York City, August 17, 1923,
died Southampton, New York, August 14, 2002.

EDDIE COHEN

EDDIE COHEN embodied the glamour of Hollywood at its height: the tough, smart, capably cruel yet ultimately charming movie executive, with the added spice that his kingdom was Latin America, not Los Angeles. Being a Vice President of 20th Century Fox from 1937 to 1962 would be hard to rival today in terms of social dazzle but doing so in South America, when that continent was still truly elegant, involved a lifestyle few contemporary executives could dream of. Cohen also had the advantage of one of those flavoursome backgrounds that the film industry used to breed, a remix of Durrell's *Alexandria Quartet* with Fitzgerald's *The Last Tycoon*.

Cohen was born on the stroke of midnight in Alexandria to a cosmopolitan Sephardic family of that milieu. His own father was born in Algeria or Jerusalem (names and dates shift so in this world) and was a practicing Mason of highest degree. His mother was an English teacher in Bombay who also knew medieval witchcraft, so the young Cohen grew up drinking potions and performing incantations to her orders. Following Sephardic tradition, they had had an arranged marriage — she was still in India and he in Algeria and they only met for the ceremony in Egypt.

Eddie was the eldest child followed by a sister also born in Alexandria before the Cohen family immigrated to Guatemala. Being fluent in many tongues, for he spoke to each parent in a different language, Spanish with his father and English with his mother, the precocious Cohen was equally fluent in Arabic, as well as French, Portuguese and Italian, all serving him well.

Cohen started work young, only completing primary school, though he wrote famously elegant letters. Cohen's first and most unpleasant job was as night guard in an abattoir but by 16 he was already managing a cinema theatre in Ecuador. Typically, on discovering that movie-house mogul Arthur Loew was in town, Cohen

tracked him down and as a brash teenager showed him the sights. Decades later, in 1976, Cohen was yachting near Glen Cove when someone pointed out the mansion of Loew, by then ancient but still famed for his cinema chain. Cohen insisted on docking and knocking at his door, whereupon Loew immediately remembered the hospitable adolescent who had guided him round Ecuador before the war.

Cohen started with 20th Century Fox as a film rewinder and by 26 was already Vice President, the youngest ever Fox executive, flying around their distribution chain. Cohen had always kept a French passport, renewed without difficulty at the French Consulate in Venezuela. But one day when the war had started they spent suspiciously long with his papers before asking: "You're French, but you're actually a Jew?" Cohen fled, leaving his passport behind and asked for assistance at the American Embassy. They not only issued him with new documents but recruited him to the Office of Strategic Services to work for them in Latin America.

Cohen worked as an agent everywhere from Panama and Argentina to Chile, where he was instrumental in dismantling German submarine transmitters. Cohen succeeded in a particularly dangerous mission within an unspecified Panama embassy and in Argentina was issued with foreign correspondent papers as cover. Indeed with his languages and nonpareil contacts—he was a friend of Batista's in Cuba and regularly flew with Perón in his private plane—American intelligence kept him on long after. Even when he died Cohen was still on their books, and as late as 1990 was contacted during the Gulf War to do unofficial work as an Arabic translator.

Part of Cohen's effectiveness was his boundless curiosity about everyone he met from whatever echelon of society, and an efficient combination of charm and threat, bullying and seducing. At restaurants he was notorious for sending back dishes two or three times, as well as asking to "try" various items, leaving it unclear if he was planning to pay for them. But he was also much loved, heading to the kitchen to speak to his oldest friend the chef or embracing the

maitre d'. The opposite of a snob, Cohen would swiftly transform every waiter into his closest confidant and as such, of course, they hardly needed to be tipped. Yet if he had to give somebody money, especially large sums for clandestine purposes, he knew how to do it with perfect aplomb.

Cohen's technique was to befriend everyone from barman to airline executive then immediately demand outrageous special favours. He flew all the time and probably spent more time in the air than on the ground. An expert in aviation, he always demanded to see the pilot as soon as he embarked. Indeed Cohen also insisted on meeting the whole crew, daunting behaviour from someone who usually traveled economy or for free. And if he did not like what he saw he would say so, often filing official complaints, the ultimate back seat driver of jumbos as well as limousines.

Running Fox Latin America, Cohen traveled continuously whilst moving horizontally through swathes of political, social and showbiz society. Cohen also found time for a romance with Isabel Sarli, a Miss Argentina turned erotic film star (the Centre Pompidou even mounted a retrospective of her kitsch sex romps) and apparently also married a Russian Jewish woman of whom nothing is known other than that they were soon divorced. This ensured that his second marriage in 1954 to Lucia Hazan took place in Montevideo rather than in staunchly Catholic Argentina.

Having met Cohen at some grand dinner, they were married within three months. As he would boast, he married her not only because she was beautiful, but because she was Jewish. Hazan spoke perfect French from her time at the Alliance Française in Turkey and had even sung Italian Fascist marching songs in Argentina. With Hazan he had his two children, Sibyl and Cynthia, who had typical Hollywood upbringings; birthdays at the Fox private cinema and Swiss schooling at Le Rosey with the sons of David Niven and the Shah of Persia. Their jet set upbringing bore fruit, Cynthia marrying into the Argentine aristocracy whilst Sibyl became an artist dividing her time between New York, Paris and Milan.

In 1962 he divorced and remarried the devoutly Catholic widow of Mexico's major cinema exhibitor. Naturally Cohen took over and expanded this chain and at age 80 opened a vast multiplex in León. Cohen now lived a life of domestic content with a house in Mexico City, a weekend house in Cuernavaca and a spectacular mansion in Acapulco. Cohen was also busy with manifold investments, including a brace of *estancias* snapped up in the sixties and an Italian restaurant in Miami named Marcella's.

Always a fan of the Arab world, there was something inherently Mediterranean if not Semitic about Cohen's style, from his velour zip-up tracksuits and autocratic *machista* moustache to his love of oratory and formal circumlocution. From his finger never strayed the yellow gold ring his father gave him at 13, decorated with one word: "Eddie." But Cohen had also been so many other things, with as many names as identities, born as Exra, known as Azra then Eduardo. This Exra was born and died surrounded by pyramids, from Egypt to Mexico, and was buried according to Hebrew rite in the Jewish cemetery of Mexico City. Here he is guarded by the two blessing hands of the Cohen tribe on his tombstone, the same Cohens who protect all of this graveyard.

Exra David "Eddie" Cohen,
film executive, intelligence operator and cinema exhibitor;
born Alexandria, Egypt, November 10, 1917,
died Mexico City, May 22, 2003.

ARNOLD WEINSTEIN

A RNOLD WEINSTEIN was one of those beloved Manhattan figures whose vast number of famous and infamous friends, long Bohemian legend, arcane expertise, and wide reputation as *bon vivant* and raconteur somehow obscured his many serious achievements. Weinstein was a scholar, teacher, published poet, and highly successful songwriter and librettist as well as award-winning Broadway playwright, yet he preferred to play the dilettante and so was perceived as such.

His suite at the fabled Chelsea Hotel was numbered 7–11 and like that store seemed open all night, welcoming a continual array of fans and well-wishers, from old-timer drunks to youthful academic researchers. The walls were hung askew with gifts from many artist admirers and the floor and grand piano agroan with books. His balcony was one of the few in the city to afford a view of both the Hudson and East rivers, proof of his range.

Weinstein was born in 1927 in New York, if conceived back in England, to British parents who were, as he later discovered to his delight, related to Mike and Bernie Winters of music hall fame. Growing up in brutally rough Harlem and then the Bronx, Weinstein was attracted both to the vivid street life all around him, this specifically American idiom, and his burgeoning intellectual pursuits, a love of language and indeed languages, dead or alive.

During the Second World War he enlisted in the US Navy and saw service with the rank of Fireman on a destroyer—this past as a "sailor" became no small part of his mythology. Returning to New York he enrolled at Hunter College on the GI Bill, whilst throwing himself into the febrile creative downtown of that era. It was then he met his longtime friend, the artist Larry Rivers, and moved in with him at 77 St. Mark's Place. Indeed one of Weinstein's finest pieces of work was Rivers's 1992 autobiography, *What Did I Do?*

that they spent several years writing together. In this Rivers recalls those early years: "He spent long hours learning two useless languages and working for the Phi Beta Kappa key he has never worn. I appreciated his rent money and his presence." His happy vision remains of "Arnold at a table, smoking a thin cigar, translating a Greek poem."

With his accumulation of useless languages, including Greek, Latin, Yiddish and Ladino, Weinstein went on to Harvard to receive a Classics degree. He also received a full Rhodes Scholarship and double Fulbright to boot. Thus it was while sojourning in Italy that his involvement with music began, when he was asked by the composer Darius Milhaud to create a libretto. The final result being "too American" for the Frenchman's taste, it was handed over to his young American student William Bolcom. The result was "Dynamite Tonite" (1963). Whilst in Europe Weinstein naturally continued his wilder social adventures. As the songwriter Fran Landesman recalls:

When we first met Chet Baker in Rome he brought along his very best friend Arnold, because Arnold was always a friend of all the jazz men. As far as I knew, he knew everybody. We all went to party at the amazing palace of Mussolini's jazz-loving son, a pianist. I went under the piano and there was Arnold already, I don't know why he was under the piano but we started fooling around and then he cried out, "No, you're Jay's wife!"

Both Fran and Jay Landesman worked with Weinstein on the cabaret revue *Food for Thought* which opened in St. Louis in 1962 and transferred to Yale. Jay recollects:

The show had a great song, "Food, Glorious Food." It was supposed to run a year and ran a week. Back then Arnold drank a lot, straight vodka, gallons of it, he even drank Larry Rivers under the table. Arnold did comic versions of High Yiddish and Low

225

English, he used compound sentences that rhymed—we thought he was a genius!

Or, as Fran puts it:

He had a very good concept of Weinsteinian English, he would always say "Shall we commit sittage?" instead of "Shall we sit down?" or "Shall we commit some danceage?" not "Let's dance." Back in St. Louis he was keen on this medicine Paragoric with lots of opium. We drove round the city getting two ounces at every chemist. He was drinking wine and someone came up: "I didn't know you were a wine connoisseur—I thought you were just a Paragoric connoisseur." Arnold replied, "Oh, I can tell the difference between a good Paragoric and a so-so one."

Weinstein's first and perhaps most successful piece of straight theatre was *Red Eye of Love*, a surreal comedy set in a meat store. The money for its first professional production in 1961 was raised from a variety of friends, including the pop maestro Jerry Leiber, Roger Stevens, producer of *West Side Story*, the budding mogul Hal Prince, and such artists as Willem de Kooning, Franz Kline and Philip Guston, who each gave Weinstein a painting to sell. The play opened at the Living Theater on 14th Street to excellent reviews, won an Obie and Weinstein was signed up by the powerful agent Audrey Wood, who represented Tennessee Williams. But it never moved to London as expected and dwindled to cult, only being republished in 1997.

In 1962 Weinstein created the musical *Fortuna* with the composer Francis Thorne and two years later *Dynamite Tonite!* brought together Barbara Harris, Gene Wilder, Lee Strasberg and even Mike Nichols, the first play he ever directed. After disastrous reviews—and one performance—it closed, but was subsequently revived five times, always to acclaim and penury. Around this time Weinstein took up teaching, everything from English literature to

226

playwriting, Greek and Latin, his courses much in demand from Yale to Columbia University. The playwright John Gruen vividly recalls Weinstein's style:

> I remember the dazzlement of sitting in one of Arnold's classes. Robert Lowell's adaptation of Prometheus was about to open. That day at the Yale School of Drama, Arnold had the original Greek text strewn in front of him and Lowell seated beside him. Arnold spot-translated the two texts, comparing the Aeschylus to the Lowell and then having Lowell explain his choices. I can still see Arnold pounding out the Greek rhythms to Lowell's amazement and delight.

Outside academia Weinstein collaborated with the New York School poet Frank O'Hara on a musical comedy, *Undercover Lover* (1961), adapted Kurt Weill's *Mahagonny*, wrote the play *The Party* (optioned but never produced by David Merrick) and with Bolcom created the opera *McTeague*, which was directed by Robert Altman in 1992. Later Weinstein would work with Altman again on writing a musical adaptation of his 1978 film *A Wedding*. The Bolcom-Weinstein team also produced an opera version of Arthur Miller's *A View from a Bridge*, working closely with the playwright, which opened at Chicago Lyric Opera and came to the New York Met Opera in 2002. There was also an adaptation of Ovid's *Metamorphoses* (1973), the musical *Casino Paradise* (1990) and a version of Brecht's *Galileo Galilei* (2001) written with Philip Glass. But Weinstein was probably best known in his latter years for the elegant cabaret songs crafted with Bolcom. These received regular performance in small downtown spaces and were issued as a series of records, one proudly featuring Rivers's sketchy charcoal portrait of Weinstein.

Interviewed in 1967, Weinstein spoke dryly of his work as President of FFOF or "Foul Fumes of Failure," a worldwide subsidiary of ITOF, the "International Theater of Failure." "Failure fans," he said

have a hunger for immortality and they like to rub against other failures because that way they have a little contact against death and are, as it were, inoculated against it. I suppose failure has gone to my head. You see failure excites me. It gets me hot. I like to roll in it. Tousle its hair. Pinch it out of shape. I like to kick it around the room for laughs. It makes me devilishly attractive. Life is too short! Great failures never die!

Arnold Weinstein, librettist, classicist, playwright and scholar;
born New York City, June 10, 1927, died New York City, September 4, 2005.

JEAN CLAUDE ABREU

J EAN CLAUDE ABREU was last of a generation of gen-
tlemen who regarded even the mildest self-promotion as utter
anathema and would doubtless consider a necrology, in a quotidian
publication of bourgeois sympathies, a vulgar abomination. Be that
as it may one must somehow honour the passing of so impeccable
a figure, one whose resistance to any form of fame ensured all his
contributions to our culture went firmly forgotten. Genet claimed
"style is to refuse" and Abreu's refusal to allow himself any sort of
public profile was perhaps an ultimate, wry dandyism. As a man of
letters, conversationalist, mountain climber and jazz expert, a man
whose knowledge of literature was as extensive as his love of the
visual arts, Abreu was the ultimate enthusiast. He embodied the
altruistic "amateur" in the French sense, with his encyclopedic and
impossibly retentive knowledge of everything from Formula One
to chess, tennis and even yoga, of which he was a Parisian pioneer.

Abreu was born in Paris to a French Armenian mother and
a father from the fabled Abreu family of Santa Clara, Cuba, a
land-owning dynasty whose wealth is only matched by the elegance
of its Old World connections. The ancient Abreu roots remain tan-
gled back to families as varied as Jova, Vatable, Batlle and even artist
Francis Picabia who spent time during the First World War with
relatives in Cuba. Santa Clara was single-handedly created by this

family and is dominated to this day by a sculpture of its founding Abreu. If they were suitably grand, with occasional members tempted into aristocratic pretensions, Jean Claude himself was always quite clear "we are not like that, let us not forget we cannot compete."

Educated at the École des Roches in Normandy, where his passion for American jazz was first lit with a clandestine windup, Abreu went to Harvard to study science before going to live in Cuba, where he resided at the renowned Quinta Palatino. This eccentric mansion was built by his grandmother, who filled it with 360 exotic simians, which were donated to Harvard upon her death. Abreu assisted with aspects of the family business, but essentially, as a young man with a magnificent bachelor retreat overlooking Havana's old harbour, he knew everyone, from writer Lezama Lima to Julio Lobo, the "Richest Man in Cuba." He was also constantly traveling, by ocean liner of course, returning regularly to Europe and even spending six months in Mexico City as a simultaneous translator for UNESCO.

In 1952 Abreu succeeded and began improving and developing land around the suburbs of Havana, such properties being requisitioned with the Revolution. Abreu left Cuba soon after the revolution but maintained his kinship with the island — indeed after his demise a full mass was said in favour of the eternal peace of "Juan Claudio" given by Monsignor Carlos Manuel de Céspedes, Vicar General of the Archbishopric of Havana. This was held, complete with children's choir, at the art deco church of San Agustín and attended by no less than Dr. Eusebio Leal Spengler, official City Historian and conservator of Havana's Patrimony.

If Abreu had moved permanently back to Europe by 1960, he had already been spending much of his time outside Cuba, not least in Zermatt, the alpine town he had discovered with delight. Already back in 1956, Abreu had begun construction on his magnificent mountain residence, named Chalet Turquino after the highest summit in Cuba, the very first building constructed in town by a foreigner. With its twelve bedrooms and adjoining bathrooms and

beautiful traditional construction, Turquino soon became the centre of an international roster of visitors, from Alan Clark and Mark Birley to actor Robert Montgomery and painter Ernst Fuchs, many of whom subsequently found a place in Zermatt as well. Indeed Abreu was creator of Zermatt society, transforming it from a remote village into a highly fashionable resort. But naturally Abreu was not there merely for the parties; much of his time was spent climbing the nearby mountains, all of which he conquered, Matterhorn and Monte Rosa included of course.

If Abreu could take credit for "inventing" Zermatt at the same time he was busy creating another monument, the magazine *L'Œil* which was first published in 1957, entirely thanks to his generosity. Having been contacted by the writer Georges Bernier with the idea of creating a luxurious, highly sophisticated publication to cover all visual and decorative arts, Abreu agreed to become backer and publisher. This revered publication (the only magazine to be found in Dr. Lacan's waiting room) still appears today and was subsidized by Abreu until 1972 when he sold the title. Characteristically he ensured that his name never once appeared on the masthead or in smallest print whatsoever.

Abreu's interest in the arts began while back in Cuba, with friends like Wifredo Lam and Cundo Bermúdez, and continued in an eclectic manner, juxtaposing an Egyptian falcon with Courbet, Claes Oldenburg or Alan Thornhill. A major contribution to his collection also came from his aunt, the legendary Lilita, close confidante of those composers les Sept and an adored muse to writers such as Saint-John Perse and Jean Giraudoux, who left Abreu many major works by Vuillard, Bonnard, Klee and even an occasional Picasso. Over the decades the collection was displayed with *soigné* relaxation in a series of suitably delicious apartments around Paris, Abreu being *au fait* with the work of the major decorators of the day, not least fellow Cuban exile Emilio Terry. Grandest of these abodes was an *hôtel particulier* with its own park in the Marais, which he swapped for a high-ceilinged, ground floor apartment on

Rue Verneuil, his final habitat, adorned with perfect pitch by the Italian designer Renzo Mongiardino.

In 1960 Abreu had married Mary-Sargent "didi" Ladd, a Boston debutante who had graced the cover of *Harper's Bazaar* and whose fine family contained Republican politicians, intelligence operatives and indeed portraitist John Singer Sargent. An entirely enviable couple, the Abreus entertained on a generous scale and were intimate with an astonishing range of people on every continent, the sort of people whose inherent glamour depends upon its being hidden from the larger public. These might include Surrealist poet Joyce Mansour and her Egyptian playboy husband, Nan Kempner, Hans Bellmer, reclusive financier Alain Thorel, laird Simon Fraser, screenwriter Paul Gégauff, shipping magnate Jean Alvarez de Toledo and a judicious scattering of varied crown princes.

But some of Abreu's most favoured figures were his *fournisseurs* or specialist suppliers, not least his English tailor who catered to his strict palette of grey suits and blue shirts – for Abreu was one of those men for whom the term "French suit" was an automatic insult. There was also his expert car mechanic and his personal horological provider. Abreu was continually loyal to these artisans and would go specially to Geneva for any work that needed doing on watch or automobile, of which there was often a lot, as he had a delight in alterations and improvements. For Abreu had a brand theory that reflected his core philosophy, never buying from the best-known source but the secondary, more *recherché* competition. As he put it with his usual Anglo-Gallic admixture: "Second to best, *plus difficile à trouver, encore plus cher*" (Second to best, harder to find, even more expensive). Thus his man at Gübelin in Geneva would create a version of the Rolex Explorer made from white gold, absolutely indistinguishable from others but far more costly. He would also have his "trombone" collar stiffeners crafted from white gold, precisely because they were never visible. Or he would drive his new Aston Martin DB4 over to Switzerland to have it fitted with radial tires and family seating. This was to accommodate his progeny, two

daughters and a son, on their numerous sporty trips through the mountains, doubtless emulating his favourite Formula One drivers.

Having remarried in 1973, to the equally ideal WASP beauty Georgina "Georgie" Manly, Abreu continued his charmed existence of reading, skiing, climbing and collecting – friends and *objets* alike – and not least listening and improving his important jazz collection. A tootler himself, Abreu had a particular love of Pee Wee Russell, matched by his passion for Duke Ellington, Count Basie, Miles Davis and Louis Armstrong. In fact one of his few recorded public acts was to vote on the international panel for the Jazz Hall of Fame put together by his old friend Ahmet Ertegun. For Abreu was the ultimate fan, a full-time fervent admirer without guile or cynicism. "My father was, quite simply, nourished by the talent of others," as his son Miguel suggested at his funeral, an event attended by *le tout Paris* from the Ganay brothers to François Pinault, Barbara of Yugoslavia and Jean d'Ormesson who gave an oration recalling their yacht trips through Aeolian islands. Here, he arose early to see Abreu on deck playing his clarinet, but with typical discretion, absolutely silently, so as to wake no one. Abreu was, to quote the son again, "always happy to play the role of the modest observer, a rationale which gave sense to his gentle retreat from all that we might term 'action' in general."

Jean Claude Abreu, publisher, mountaineer and musicologist;
born Paris, January 11, 1922, died Meudon, France, September 9, 2006.

TONY SMITH

TONY SMITH was an engaging exemplar of English ultra-bohemianism whose rich history and loquacious *bonhomie* almost, but never quite, overshadowed his exceptional skills as draughtsman and painter. As a lifelong afficionado of *vin de table* and pro puffer Smith was a many-fabled mainstay of Soho's infamous Colony Rooms where he could happily outdrink even his dear friends Francis Bacon and Dan Farson. Smith may not have received the full formal recognition his gifts surely required, hampered perhaps by a Surreal flavour no longer in favour (and sharing a name with *two* better known artists) but anyone fortunate enough to meet him could never doubt his calling or charisma.

And his life was as adventurous as the stories he told. Indeed his friendship with playwright Bill Naughton led to long conversations about what eventually became the play and movie *Alfie*, with the main character largely modelled on Smith himself. Smith was born into the extended network investigated by that revelatory 1957 book *Family and Kinship in East London*—with at least a hundred relatives within walking distance—not least the notorious "Two-Fingers" Badcock. Smith survived extreme poverty, early tuberculosis and a wartime bomb blast near his cot in the hospital. Evacuated during the war to Wales he discovered the green of the countryside that was to recur in much of his work.

As a young boy his spirit was noticed by those well-meaning educationalists who went into the East End after the war to bring opportunity and try to change the class system. He attended the youth club more than he attended school and was on the first expeditions of the Duke of Edinburgh Award scheme, climbing with Sir John Hunt. His extraordinary talent for drawing was noticed but he became a pleater—and he remained proud of his gift for intricately pleating circular sunray skirts. Smith stayed close to the youth club

milieu and even later chose to go back to the East End to take charge of the very club he had attended himself. Here he built climbing holds into the walls so the children could travel round it without ever touching the floor and made them a disco and a boxing ring.

The success of this club attracted the attention of the Krays, who paid a visit. The kids watched the interchange between the Krays and Smith, but out of earshot. When the Krays said they planned to give money for boxing, Smith wanted to say no. But when they said, in a rather more threatening manner, "You're not going to be silly about this are you?" he had second thoughts and shook his head emphatically: No. It established his reputation as "the man who said No to the Krays."

News of his youth work spread and he was invited to Paris, where he worked on the streets of Belleville, and also to Copenhagen. Back in Bethnal Green he brought together social science students from Oxford University with the meths drinkers on his patch—to understand properly, the students had at least to taste the meths. But it was a chance encounter with a student from St. Martin's School of Art, who saw his drawings, that took him out of the East End—along with his witnessing of a double murder that made it prudent for him to absent himself. Once again the postwar welfare spirit did what it was supposed to do. Although he did not have a single examination, or much schooling, the London Council Council gave him a full grant to attend St. Martin's.

This school and indeed the sixties suited him well. An admirer of Alfred Jarry, he was also involved in the early beginnings of the Bonzo Dog Doo-Dah Band; likewise all-night sessions at Ken Colyer's jazz club were important events. A prize took him to New York, where he astonished himself by visiting Rothko and the architect Philip Johnson, whilst he was probably more at home at the Pen-y-Gwryd hotel in North Wales, where he worked on vacations.

Back in London Smith founded a basic design course at the Camden Institute which became a seminal force in the development of adult education. He was recognized as an inspirational teacher

and thrived in the intellectual climate of the Central European cosmopolitans who became his students. One of these students, Helen Bunzl, led him to new frontiers: the Salzburg music festivals, Cap d'Antibes and visits to Venice. When he first saw Giorgione's *The Tempest* in the Accademia he fainted.

In the 1970s he married Jane Howard (née Carter), who already had four children, whom he adored. They went from London to the Lake District, where they renovated Fieldside Grange, a house that became a magnet for friends and holidaymakers, only a step away from the ancient Castlerigg Stone Circle. Together he and Jane had a daughter, Harriet. The Lake District became his spiritual home and the subject of many of his paintings. He taught art and sailing at the Brathay Outward Bound Centre, and climbed every inch of the fells.

There were to be two more homes close to his heart. His house in Saint-Jean-de-Fos by the river Hérault in France, hung with the extraordinary paintings that grew out of his experiences over twenty-five years spending time there with his last partner, Ann Bone. And a cottage in Oxfordshire, where he was surrounded by the affection of the students he taught privately, who became a family almost as extended as the one into which he had been born.

Anthony George Smith, painter, youth leader and teacher;
born London, November 25, 1941, died Oxford, Good Friday, 2008.

DASH SNOW

DASH SNOW had everything any artist today could require, from that cool moniker to a spectacular look, hair down to his waist, a giant beard, dazzling shades, acres of full-body *tatouage* and best of all his own gang of equally youthful and exotic fellow artist friends in deepest downtown Manhattan. His actual artwork was also guaranteed to gain attention thanks to his use of such provocative elements as his own semen, his own cocaine stash, his own blood and the torn or collaged detritus of throwaway modern life.

Excessive behaviour, especially involving recreational drugs, was a favoured theme of Snow's team, lovingly documented in his short films and polaroids. Having made narcotics central to his oeuvre it was perhaps inevitable they would return the favour and bring his career to a premature close. And thus it was that Snow died from a heroin overdose in an East Village hotel aged only 27.

Opiates refuse to go out of style—indeed it is curious that in some sixty years since the bebop jazzers and Beatniks nobody has come up with a better marker of hardcore hipster integrity than the taking of heroin—and Snow's habit was crucial to his cooler-than-thou legend. But his love of drugs may also have eased some aching.

For Snow's other advantage or disadvantage, an ambiguity which was to haunt his reputation, was to come from an impeccable lineage of enormously wealthy haute bohemia, his direct family being among the most serious contemporary art patrons in America. His father Christopher Snow was a musician, and his mother came from the legendary de Menil Schlumberger family, a French oil dynasty long settled in Houston, where they have their own museum designed by Renzo Piano. To make this family heritage all the richer, Snow's grandfather was the high-society Buddhist guru Robert Thurman, thus making his aunt none less than Uma Thurman.

Another of Snow's de Menil aunts set up the Dia Art Foundation, which diverted vast chunks of the family fortune into sponsoring contemporary artists with their most ambitious projects, whether Donald Judd buying his own town in Texas, Walter de Maria setting up his *Lightning Field* or Michael Heizer creating a giant desert earthwork. The Dia Foundation has its own enormous museum in Beacon, Upstate New York, but it also bought artists their own buildings, including the *Dream House* in Tribeca, a trippy installation by La Monte Young – a secret key to Snow's aesthetic as he even adopted that artist-musician's hippy-biker look of huge facial hair and constant sunglasses.

The fact that Snow was wealthy and well-connected was only so piquant because everything in his life and art was predicated upon a stance of rebellion, marginality, outlaw bravado and illegal behaviour. His loose group of other artists such as Dan Colen, Ryan McGinley, Nate Lowman and Terence Koh all lived and showed downtown, not least in the furthest reaches of Chinatown, exhibiting work loaded with "bad boy" theatrics of sex and excess with such galleries as Peres Projects, Maccarone and Rivington Arms.

Part of their pleasure was to shred phone books and papers, turning hotel rooms into "hamster nests" of tactile squalor, and even creating a version of such an installation at Deitch Projects in SoHo, where slackers and skaters were free to come linger, graffiti the walls and make their own fine mess. Every generation needs its own version of this same bohemia, often with surprisingly minor variants, but the fact that today one needs money, family money if necessary, to live this sort of life in Manhattan itself rather than some outer borough, added a comic twist to this set.

Likewise Snow's work may not have been startlingly original, his collages seeming especially *vieux jeu*, but their potency was largely charged by the narrative of his own creative existence, by the persona and aura of the artist, of key import in our media-led art world. Some of his best works dealt directly with drugs, not least the memorable appearance at the 2006 Whitney Biennial of a

jagged sculpture featuring a generous crusting of cocaine, though those who tested it for a taste could testify this coke was *not* the real thing.

Snow's rebel urge started early, including being sent away to a reform school in Georgia as a teenager, but really hit its stride when he was a very young artist in an increasingly conformist and conservative New York, where he first made his mark, literally, as a 15-year-old graffiti artist spraying the city with his trademark tag "SACE." Indeed there still remains a portrait of the young Snow above the F train stop at Allen Street. Part of this neo-hippy, neo-hobo "Old Weird Amerika" aesthetic included a sartorial nod to such early seventies icons as The Band, where vast beards of Civil War-era aura and Dylanesque weskits and preacher hats became *de rigeur*.

Such nostalgia, suggestive also of free-love communes, ensured not just an emphasis on sex but also young love and young parents, Snow marrying the artist Agathe Aparru at only 17. That idealistic union ended in divorce but in 2008 with his new partner, the model Jade Berreau, he had a daughter with a name worthy of the Zappa clan, Secret Magic. That another of her given names should have been "Nico," as in the notoriously long-addicted singer, suggests the depths of this generation's respect for such previous icons of glacial decadence.

Snow was not only living out his own novel, or more probable VH1 Special, but that of all those alternative cultural maveriks who came before. Perhaps it is appropriate that instead of a classic OD at the Chelsea Hotel, Snow's own demise should have taken place, yes, in the East Village, but in an elegant and notably expensive boutique hotel symptomatic of that neighbourhood's utterly complete gentrification.

Dashiell "Dash" Snow, artist; born New York City, July 27, 1981,
died New York City, July 13, 2009.

JAY LANDESMAN

J AY LANDESMAN was famous, infamous, everywhere from Los Angeles to London, and all points in between, especially St. Louis and Manhattan, for doing nothing. Yet for someone who had proudly done nothing for decades he had also, paradoxically, done *everything*. Thus though his only self-proclaimed occupation was drinking martinis and seducing ladies, Landesman could also claim to have done the following: invented the Beatniks; run an antiques empire; written musicals, novels and memoirs; masterminded a celebrated cabaret where he booked everyone from Woody Allen to Lenny Bruce; kickstarted the organic food movement; published the first punk novel; founded the Groucho Club; and even inspired Britain's most successful chocolate brand, Green & Black's.

Jay wore old fashioned white suits and a sharp hat. Like his namesake Gatsby, he held up, or just barely supported, the most bohemian bars of London and would have nothing to do with me. Over the many years of our passing, glancing, acquaintance, beginning when I was just a schoolboy at Soho's French House (back when still named the York Minister), Mr. Landesman had managed to blank me, forget me, ignore me, for many more nights than I might care to count. Imagine my surprise then when I received a filthy, clumsily addressed envelope, as if penned by a dyslexic child, at my Tribeca apartment; this truly mysterious missive proved to be an actual fan letter from my old nemesis. Here, in spidery hand and jazzy slang he proclaimed my obituary of his friend Larry Rivers a "masterpiece," and with some pomp appointed me henceforth as his own official obituarist.

Flattered, flustered, eager to take up this role I subsequently spent much time, a great deal of time, too much and not enough, accompanying him to his favourite clubs or holed up in his Islington basement angling notes from his ceaseless stream of anecdotage.

Jay had lived in Islington since 1964, moving there from New York, and my own parents had bought a house in the borough a decade before. So my obituary obligations (my "death duties" one might say) only required a ten minute stroll round the corner to Duncan Terrace. This house, a bright yellow door at number 8, was notorious for its regular parties and irregular high jinx, its creative piles of rubbish, bits of potentially rare junk, supposed antiques, frightening art works and general squalor. Here Jay did battle with his better half, the wife Fran, with whom he had been in a scandalously "open" relationship since they married back in 1950. Fran was a petite, sassy sophisticate whose own success as a songwriter, whose works had been covered by everyone from Ella Fitzgerald to Chet Baker, was a source of open bitterness. The dilapidated mansion also contained, off and on, the two sons of this unusual union, the doomed rock star Miles (named after his parents old pal Miles Davis) and the successful yet eternally grumpy journalist Cosmo, spectral figures shifting through the shadowy bannisters.

Yes, Jay had been everyone and known everywhere but his main thing was *Jay*, a seemingly blissful love affair with himself that lasted forever. Part of this commitment was expressed by the penning of endless memoirs, which no less a publisher than Bloomsbury had somehow agreed to issue in countless volumes, all with punning titles like *Rebel Without Applause* (1987) and *Jaywalking* (1993). On top of these regular hardback tomes, Landesman began to put out yet further autobiographical reminiscences from what was secretly his own press, even paying a murky Latin American ballroom dancer with the appropriate name of "Taverna" to write an "official" biography to cover the same ground again. But it had to be admitted that however many times it was told, over midnight martinis at Groucho's or in magazine profiles, Jay's story really was good.

Born in St. Louis, Missouri in 1919 Jay was the youngest of four children, his father Benjamin an artist who had been sent to that city by the German government to decorate their pavilion at the 1904 World's Fair and stayed on as a successful muralist. His mother

"Cutie" was from a large and poor New York Jewish family and Jay was always rightly proud of his long Semitic heritage, though far from observant or practicing, other than at the cult of "Landesmania." Jay grew up within the family junk business and soon opened his own emporium in the poorest and most dilapidated part of the city, which with his eagle eye for any sort of oddity soon became a success.

In 1948 he created *Neurotica*, a denunciation of postwar American "squaredom" which in just nine issues heralded and launched the Beats. His partner on this project was the impeccably named Gershon Legman, an academic sexologist who assured Landesman with absolute prescience, "With me you're going to end up a footnote in history. I promise you that." *Neurotica* published everyone who was no one, always Landesman's favourite sort of writer, though many went on to glory, not least Kerouac and Ginsberg, Judith Malina, Kenneth Patchen and the young Marshall McLuhan. *Neurotica* was eventually reissued in a single volume with an introduction by John Clellon Holmes, the writer credited with coining the term "Beat Generation," who here captured his old friend Landesman with unrivalled accuracy: "He believed in indulging his own curiosity and only things that were counter, wry, eccentric, special and excessive stimulated him. For, in the struggle of progress versus decay, Landesman frankly opted for the latter, and this, I believe, was the closest he came to having a guiding principle. It was also the dark secret of his appeal."

Next Landesman created his own highly unusual cabaret nightclub, the Crystal Palace, in an old St. Louis gay bar, where he managed to book not only the almost adolescent Woody Allen, who he always considered one of his protégés, and a teenage Barbra Streisand, but also Lenny Bruce with whom he remained close. Landesman also launched his career as a writer of musicals with *The Nervous Set*, staged at his own club in 1959 and then on Broadway starring the young Larry Hagman of *Dallas* fame. The show flopped fast in Manhattan but did leave behind the two "standard" songs written by his wife Fran, much covered in the

subsequent decades, "Spring Can Really Hang You Up the Most" and "Ballad of the Sad Young Men."

The Crystal Palace was a huge success but clearly in the wrong town, and in 1964 Landesman boldly moved to his natural home, London, where he immediately became a central roundabout in the swinging city, befriending or even on some occasions being befriended by everyone from Lennon to Peter Cook and the nascent Pythons. In buying his ramshackle cottage on Duncan Terrace, Landesman was yet again way ahead of the curve, luckily using the only aesthetic clairvoyance which can actually make one rich — the property market — as Islington was set to boom and eventually make the transition from ultra-bohemians such as himself to actual bankers. Number 8 soon became a well established haven on the groovy circuit; it even hosted a key event in the Destruction in Art Symposium of 1966, when Raphael Montañez Ortiz smashed up the family piano (on which Fran had written her hits) with an axe, the sculptural carcass proving irresistible to Johnny Rotten on a later visit when he attempted to pluck its broken strings, a work eventually accepted by the state in lieu of tax and transferred from Jay's fecund basement to the Tate.

Landesman was soon established as one of the charismatic characters of London, a winningly exotic combination of Southerner, handsome Hebrew and discount dandy with his signature suit, fulsome beard and fedora. Known and feared in the most modish bars, Jay always refused to answer that dreary question as to what he "did" other than to proffer his card which proclaimed him a "Cultural Conduit" like a version of Nietzsche's dictum that "what is great in man is that he is a bridge, not a goal." As just such a bridge he created the psychedelic hot spot The Electric Garden, closed swiftly after an explosive performance by Yoko Ono, and launched the macrobiotic movement, his longtime partner Craig Sams going on to create Green & Black's chocolate.

Landesman also launched several publishing houses, putting out a surprise bestseller with *The Punk* in 1977, whilst his

republication of *By Grand Central Station I Sat Down and Wept* sparked a revival for his old friend Elizabeth Smart. Likewise Landesman helped create London's most fashionable watering hole, the Groucho Club, where he became a happy fixture. As Clellon Holmes put it, "His personal preoccupations had the maddening habit of becoming cultural tendencies ten years later." But secretly, or rather openly, Landesman loved his doomed projects more than any of his successes, branding himself a "failureologist" and assuring Peter Cook that he was trying to develop a new style of comedy which was not obliged to be funny. "Congratulations" was the maestro's only response.

Of course I never read any of his books, those endless memoirs, a shelf in themselves, for as with all of my friends I deliberately never read a word he'd written. For one simply does *not* read the literary productions of one's friends; as Auden said, a friend is someone who will read your mail while you are out of the room and might have added "but who will never read a single published word you have penned." There was no real need to read Jay, merely being with him was so much better for, to quote Holmes one last time, "he worked at his life the way writers work at a book."

Just taking the bus with him from Islington to Soho for his classic martini was an adventure in itself, whether thanks to the attractive Jamaican conductress or some derelict genius of his youth slumped upon the adjacent seat. Landesman lasted unusually well, whether thanks to the macrobiotic diet or the cocktails, only well into his final ninetieth year losing his whereabouts; whereupon his sons kept him on display propped in his Islington window, bundled up like Santa Claus or Guy Fawkes in a variety of amusing disguises, where he soon became a point of local interest and source of much gossip as he had been, and longed to be, all his rich life.

Jay Landesman, cultural conduit; born St. Louis, July 15, 1919,
died London, February 20, 2011.

ROBERT VELAISE

T HE reputation of Robert Velaise may have been limited to his immediate profession, the international film industry through which he cut a swathe for more than fifty years, but its resonance approached that of legend. Velaise lived, worked and indeed played in a manner befitting the moguls and stars of the golden age of Hollywood, while maintaining a rigorous business ethic and an utter disinterest in the celebrity in which he traded.

Perhaps best known as a producer of *The Go-Between*, for which he won the 1971 Grand Prix at Cannes, Velaise was highly regarded in the international movie world for decades before that and for decades after. His death at the age of 96 at his fabled penthouse in Paris's most prestigious 7ème arrondissement closes a certain chapter of cinematic lore; the pan-transatlantic jet set of postwar prosperity, when the entertainment business and the "high-life" still had a genuine glamour not yet degraded by their mass banalisation.

And like all the mythic characters in that milieu — we are talking the era of Alexander Korda, Welles, Mamoulian and Pressburger — a certain *mittel*-European mystery lingered around Velaise; not only was he able to shave a couple of decades off his age, his athletic figure, Huntsmen suits and trademark pompadour resisting the

ravages of time, but he also, like any proper film producer, was born under a different name.

Velaise was born in Zurich in 1914 to Louis and Lucie Weil Bloch, and having completed his gymnasium schooling decided to indulge his lifelong wanderlust and moved to Milan, where he worked briefly in an art gallery, followed by London and Paris. It was here, so the story went, that Velaise planned to go into the clothing, tie or *schmatta* business, but a family friend explained that the future was now in the movies. He was aided by Robert and Raymond Hakim, family acquaintances making their way as producers. Indeed, one of the films Velaise became involved with *Le Jour se lève* (1939) by Marcel Carné and financed by the Hakim brothers, proved to be an enduring classic, as were an impressive number of his subsequent acquisitions. Velaise had a sixth sense about which films would be successful.

He returned to Zurich and persuaded MGM to employ him without pay, and was soon appointed the youngest national sales manager for Switzerland. In 1936 he was asked by MGM to move to the European head office in Paris and he became deputy manager for Europe. For winning Europe MGM's salesman of the year award, he was sent to Los Angeles, and with that came a much-coveted visa for America.

Velaise had many whispered clandestine connections, not least his wartime activities; speaking perfect German (on top of his mother tongue, Swiss-German) and carrying a Swiss passport, he was asked by the French government to travel behind enemy lines and spy on the German army, bringing back valuable information. Expecting Switzerland to fall after France, he persuaded his parents to leave with him for America. After the war he continued to travel regularly but now for his own business, having left MGM to operate theatres in midtown Manhattan and the deep South, notably Louisville, Kentucky. This small chain of cinemas, rumour had it, included a rather daring choice of films which may have prompted Robert Weil to choose a more neutral sounding surname

with the invention of "Velaise." Back in Paris he launched Vauban Productions, which produced such films as the 1957 comedy *Les Œufs de l'autruche* (*The Ostrich Has Two Eggs*), and the boulevard drama *Nina* (1959) and began to distribute the rights to classic French and Italian films. He was often seen in the company of such legends as Marlene Dietrich and Zsa Zsa Gabor, not to mention the notorious beauty Flor Trujillo, daughter of the Dominican dictator.

Velaise also maintained his ability to spot talent, not least in a young British actor named Peter Sellers, who became a close friend and the star of *The Wrong Arm of the Law*, a 1963 comedy produced by Velaise. There were other planned projects with Sellers, Velaise buying the rights to the book *The Memoirs of a Cross-Eyed Man* (1956) as a vehicle for the actor, but both of them proved too busy for further collaboration.

Velaise had by then moved to London, partly to be closer to Sellers but mainly because of his marriage to a young heiress. Isobel Craig Mitchell was the only child of a Boston industrialist and the Melville Edinburgh clan. When Mitchell and Velaise first met in Cap Ferrat she was 18 to his 43, a finishing school debutante. But rather than being chased by the older man it was she who rammed his convertible Alfa Romeo with her family Rolls Royce in order to further their acquaintance. Though blessed with three children the marriage did not prove happy. After the divorce Velaise moved back to Paris, while also establishing his summer residence in Tuscany, shuttling between Switzerland, the Americas and England, not least to look after his children.

Along with the success of *The Go-Between* the real business of Vauban Productions was distributing film rights to classic films. In the 1960s and '70s, producers were always going bankrupt and were happy to accept offers for their rights. So Velaise became an expert in rescuing companies and scooping up legal tender to their properties at bargain prices. His impressive roster included such classics as *À bout de souffle* (1960), *La Notte* (1961) and *Senso* (1954).

In 2003 he was awarded the Chevalier de l'Ordre des Arts et des Lettres for services to the French film industry, especially for saving films which would probably otherwise have disappeared.

He also found marital happiness, settling down into a long relationship with Diana Krsnik, who true to tradition was much younger and granted that domestic contentment he had always sought. He was able to maintain his routine of long summers waterskiing in Italy and longer winters in the Alps, remaining a master skier on all surfaces up until the age of 84.

Robert Velaise (Robert Jules Weil Bloch), film producer and distributor; born Zurich, November 1, 1914, died Paris, March 5, 2011.

MICHAEL FLORESCU

COUNT MICHAEL FLORESCU was the epitome of a certain Westminster school type; precociously intelligent, if not the "best mind of their generation," their talents have led them a curious dance far from the standard successes of their class, their brilliance actually *enhanced* rather than contradicted by lack of obvious achievement. Erudite and charming, if also dangerously acerbic and far too well-read, their range of interests, rather than actual profession, mark them eternal maveriks. Florescu may have been an antiquarian, critic, hotelier, chef and collector, but above all he was a splendid character, naturally bordering the fictional. Indeed in his signature teddy bear Alpaca coat he seemed straight out of a MacLaren-Ross backroom bar, positively Trapnelian.

Born mere Mike Fior, to a prosperous Hebräeo-Roumanian dynasty whose townhouse stared down the Wallace Collection, after Westminster he spent time at the Lycée Français before being sent to Dijon to learn French and to mix a Kir. Michael then attended Trinity College Dublin, taking rooms at Botany Bay, which formerly harboured Oscar Wilde and Bram Stoker. This was Trinity's bohemian heyday and Michael knew everyone from Brendan Behan to J. P. Donleavy and Gainor Crist, the fabled drunk immortalized as the "Ginger Man." It is uncertain whether Michael actually received a degree, hardly the point of the institution in that era, but being deeply involved in local theatre as actor and director, he eventually spent five full years in Dublin.

After traveling widely, working as boom boy and scriptwriter, opening his own antique shop on the Fulham Road and fathering two children, Daisy and Aaron, Michael soon moved to America. And here in New York, in a great immigrant tradition, he mysteriously became a "Florescu." This name, supposedly from Genova as well as Wallachia, might have had some complex, distant connection

to his family, but all that mattered was it *suited* him so. Likewise his title, which veered from Count to Prince, was as much granted to him as honourary favour by friends as assumed by the man himself, who was certainly one of nature's nobility. As he would protest, "I pray you to refrain from addressing me as Count, I'm simply a bird of passage living off the crumbs of others." In New York, the newly-minted Florescu worked as a director of the prestigious Betty Parsons Gallery, though full-time employment was hardly his forte. As the artist Richard Tuttle affectionately recalls, Florescu was usually to be found puffing weed in the lavatory or sleeping off its effects deep in his office chair; on one occasion when an exhibition was about to open and nothing had yet been done Parsons herself was forced to take the broom to the floor, whereupon Florescu leapt to his feet to wrest it off her, "You can't, you're a *legend!*" to which she replied, "This is America, Michael, where *everyone* does everything."

After many Manhattan years as an art critic, antique dealer and occasional hamburger cook, Florescu married Serafina Bathrick, an academic and occasional star of the films of artist James Benning. Together they happily went way West to her farm called Lightyears near Avoca, Wisconsin. Here Florescu took on his ultimate incarnation as gentleman farmer, the supplier, chef and *maitre d'* of their own "private" or "underground" restaurant. Growing all their own food, raising their own game, the fame of their very small and selective dining club soon spread. Seating no more than twenty at tables under the grape arbour, Florescu would supervise the cooking whilst, summoning his best Bemelmans *grand hotel* manner, moving smoothly between the increasingly international guests. As his old friend Donleavy put it, "there is a tinge of aristocracy about the Midwest," and the secret chic of such rural obscurity suited the ever graceful airs of "Signor Mike from Manchester Square."

Count Michael Florescu (Michael Fior), antique dealer, playwright, chef and farmer;
born London, April 30, 1937, died Fitchburg, Wisconsin, September 25, 2011.

JAMES METCALF

FROM his long reign as grand seigneur of Santa Clara del Cobre, high in the Michoacán mountains of Mexico, James "Jimmy" Metcalf could look back on an extraordinary life in which he knew everyone and did everything. His was a life which echoes two Woody Allen films — *Zelig*, about a man who constantly reappears throughout twentieth-century history, and *Midnight in Paris*, about an American enjoying the highest haute bohemia of a mythic Paris. Metcalf was the classic GI who came to Paris after the war to make art, as well as love; he conquered that city as he was later to dominate what was practically his own town in Mexico — albeit one ruled through expertise and generosity. For here Metcalf had almost single-handedly saved an indigenous industry — metalworking — and its ancient skills and traditions; he turned Santa Clara into a model of cooperation and sustainability.

Metcalf was born to artists. Both of his parents worked with stained glass, notably on the windows of St. John the Divine in New York. Metcalf himself began working with his hands at a young age, being providentially already registered as a sculptor when at 18 he joined The Fighting Blue Devils, the 88th Division of the US Army. During the Second World War, Metcalf was involved in ferocious fighting at the Furto Pass, in northern Italy, and lost three fingers of his left hand. This not only assured a heroic presence at any cocktail party but also guaranteed a handsome lifelong military pension.

Metcalf then attended the Pennsylvania Academy, and whilst learning welding made and installed windows in churches and cathedrals all around the United States. Already committed to the utopian ideals of William Morris, it was natural that Metcalf should enlist at the Central School of Arts and

Crafts in London, where he studied metalwork with the last great European smith, Francis Adam, who had been official sword-maker to Emperor Franz Joseph himself. Typically, Metcalf also became close friends with both Eduardo Paolozzi and Richard Hamilton.

Starting in 1953, Metcalf spent much time in Deià, Mallorca, where resident guru Robert Graves became obsessed with him as a figure of masculine creativity, naming him Hephaestus: "If you want to know anything about metal, here is the man!" Graves also enlisted him to create the wood engravings for his book *Adam's Rib*.

Metcalf lived in Paris from 1956 to 1965, taking a studio on the Impasse Ronsin, a legendary row of ateliers ("that most distinguished site of modernism" according to the critic John Russell) where his immediate neighbour was Brancusi and fellow young artists included Niki de St. Phalle, Jean Tinguely, Yves Klein and designer-sculptors Les Lalanne. Here he willingly taught his fellow artists metalworking techniques, as he was to do throughout his life, and soon found himself at the centre of Paris society. With his striking good looks he was often confused with his friend, the budding actor Alain Delon, with whom he made the rounds of every *boîte* with fellow playboys Rubirosa and Aly Khan. Thus Metcalf met everyone, from writers such as Harry Mathews and James Salter to an older generation of artists, including Duchamp, Man Ray, Magritte, Wilfredo Lam and William Copley.

On moving back to New York in 1965, where he worked on Spring Street in the then emergent SoHo, Metcalf already had an impressive track record as an exhibiting sculptor; but he soon tired of the contemporary art world, with its emphasis on individual success as judged by sales of work. He thus fled to Mexico. He had been a rakish American war hero in Paris and was treated as such in cosmopolitan Mexico City, where he was befriended by such writers as Octavio Paz, Carlos Fuentes and Carlos Pellicer, even introducing Paz to Duchamp.

He also found a wife, possibly his third, the fabled Mexican actress Pilar Pellicer, one of three renowned beauties from that

highly cultured family. One sister was Brando's girlfriend whilst the younger sister, Ana, was also eventually to become Metcalf's wife. And it was with Ana that Metcalf found at last not only true love, but also a working partner, with whom he set about restoring the glories of Santa Clara. Here Metcalf worked, taught and inspired the local population, with the result that whilst his French was of impeccable old-fashioned sophistication (his aunt, after all, was headmistress of Switzerland's most exclusive finishing school, Le Rosey) his Spanish was pure peasant.

At Santa Clara he worked with the native artisans in their forges, where vestiges of a pre-Columbian technique survived, demonstrating what they could do with their technique of forging from a thick block of copper. He won the town the commission to forge the Olympic Torch for the 1968 Games in Mexico City, convincing officials that a forge akin to the Greek forge at the time of the very first Olympics was still alive in Mexico.

For more than two decades, Metcalf and Pellicer directed a craft school within the Mexican technical education system, which became the jewel in the crown of Mexican popular arts. If life there was relatively isolated, certainly compared to the pan-international high society of London, Mallorca and Paris, Santa Clara had soon become something of a pilgrimage destination for art historians, writers and researchers. Visitors paying homage over the years included Alain Robbe-Grillet, Seamus Heaney, W. S. Merwin, Alastair Reid and Graves himself. Laura Bush visited the town when her husband was governor of Texas and was so impressed that she later acquired a trove of Santa Clara silver for the White House collection.

Not least thanks to Roy Skodnick, the official biographer whose long-awaited work was finally published in 2000, there were two documentaries made on Metcalf and Santa Clara as well as a travelling exhibition and attendent catalogues. Metcalf's adventure in Michoacán might be titled "News from Somewhere," as opposed to Morris's *News from Nowhere*, for Santa Clara del Cobre is a real

place—bridged into this new century—fusing ancient arts with contemporary methods. And here Metcalf is buried, in the garden of the hilltop town he so transformed, among his own sculptures, a soldier at rest.

James Metcalf, artist and educator; born New York City, March 11, 1925, died Santa Clara del Cobre, Mexico, January 27, 2012.

DOROTHEA TANNING

LONG assumed to be already dead and often confused with someone else, Dorothea Tanning managed to maintain the mystique of the true artist, muse even, whilst all her contemporaries fell victim to the obligatory museum retrospective and illustrated biography. Yes, she was still alive, and all of 101, and no, she was neither Leonora nor Dorothea Carrington. What Tanning maintained above all else was the grand patrician aura of the lover of arts, connoisseur and patron, the "amateur" in the French and best sense of the word, for whom literature, music, theatre and civilised conversation were as important as her own work.

What made this the more refreshing was that unlike certain self-promoters and media darlings, unlike those who hustle to maintain their supposed importance, Tanning had actually produced a handful of major, significant artworks. Whenever I went past that rather noble corner of Fifth Avenue where she resided I thought with a discrete, private pleasure, "Ah, the last of the secret society of Surrealists is still hidden here, being herself, even in our own ghastly era" and would tip the metaphoric hat up at her curtains, chintz I recall. Thanks to that unusual name, and no Surrealist should be called "Smith," every passing sun bed emporium blaring "TANNING" would make me think of her though I hardly knew her, triggering a brief flow of pleasant associations and bus musings, until the next shop caught my eye.

She loved poetry — she wrote it and supported it, financially and more importantly morally, and actually actively read the stuff. She loved flowers and was expert upon them. She was witty, sharp, smart, had known everyone and still knew a vast range of intriguing, important people. And I really liked her apartment. Everyone loved to talk about her in terms that recall those Japanese Living National Treasures, whether America's greatest contemporary composer, Robert Ashley, to whom she was somehow related or the Filipacchi family who rightly treated her with utmost reverence.

The first time I went to interview her, after more than an hour of highly enjoyable dirt dishing she paused dramatically, "And now I think it's time ..." So I scrambled to my feet agreeing I certainly should be on my way, I could not exhaust her any further, after all she was already over ninety, "No, no ... it's time for the *champagne!*" Two bottles and as many hours later I emerged onto the sparkling mica of the midsummer pavement, feeling like Rufus, "drunk and wearing flip-flops on Fifth Avenue" filled with a bonhomie, an old-fashioned well-being worthy of Sedona, Arizona in 1947 or Paris in the early fifties.

She did not like being labeled a "woman" artist and she did not like being branded a Surrealist and she would have surely hated the boom in exhibitions, books, PhD dissertations and catalogues devoted to the theme of "Female Surrealists," one of which, inevitably, is dutifully trundling round the institutions. Indeed Tanning had lasted long enough to already fall prey to a first flurry of such academic researchers coming round to prove their already-fixed assumptions, and had given them suitably short shrift, exploding their neat categories: "I am not even a *woman*, let alone a Surrealist!"

I had read her book *Birthday* (Lapis Press, 1986) which was incredibly good, an exceptional piece of writing quite aside from all art historical interest — a book I remain surprised is not better known nor regarded as a "Modern Classic" or whatever they call them nowadays. In fact, if she had done nothing else, the creation of *Birthday* would have been achievement enough. I also got her

to sign a collection of poems that she had chosen and paired with her own paintings, many by her many writer friends, which made clear the literary affinities, the skein of poetic associations, within her own work, Surrealism having of course been first and foremost a literary rather than visual movement.

To tell the truth I was never really interested in Max Ernst anyway, his looks, though obviously impressive, were too Aryan for my taste, and thus luckily I had no temptation to dwell on him. Likewise Leonora Carrington, also Ernst's lover and hence the occasional confusion, never struck me as particularly engaging. For she even shares her name with another woman artist, that Dora of Bloomsbury-fame (who even had a feature film, the eponymous *Carrington*, made all about her) and the first duty of any artist is to have a unique name that not one other artist shares. Dorothea Carrington's work also seemed a bit kitschy and derivative, an impression confirmed by a 2010 exhibition at Pallant House, Chichester, where such sketchy whimsy failed to awe.

By contrast Tanning's work never seemed overtly indebted to Ernst, or any other artist, and her most famous painting, *Birthday* of 1942, is a key Surrealist image, resonant, disturbing, long-lasting and closely-matched by *Eine Kleine Nachtmusik* of the next year. Anyone who knows about poetry knows that one only has to write *one* good poem—in terms of posterity that's all anyone is likely to achieve. Likewise one great, really memorable painting should be sufficient to go down in the annals of art history, and with *Birthday*, Tanning has surely won her immortality already. In terms of her own poetry, I would suggest that just one really good title is something, and no title was more appropriate than her perfect invention of "Sequestrienne" (2002).

But that's not all! For even if her later paintings are perhaps not quite one's *tasse*, there was to be yet one more major breakthrough in an entirely different medium, namely the soft fabric sculptures she started in 1969. These not only prefigure the work of Louise Bourgeois, who certainly saw them, but also that of Sarah Lucas,

who had not seen them but was later astonished by their similarities. These are truly weird, utterly uncanny objects, especially when assembled in tableaux groupings, such as the installation *Hôtel du Pavot, Chambre 202* (1970–73) at the Pompidou. And they broke completely new ground in their compound of corporeal presence and "women's work," all that stitching, synthetic fur and sensual softness. With this clearly female concentration on the body, on sex, fatness and femininity, Tanning single-handedly kickstarted a whole style, heralding an entire subgenre of such work.

I would prefer to remember her as an elegant dilettante, a *grande dame* in eternal exile, a latter-day society hostess, the Dada Mrs. Dalloway, one who never had to try too hard. But the truth is that Tanning was also a damn good artist, despite herself. Just three of her major early 1940s paintings and a room of her early 1970s sculptures should be enough to convince anyone of her continued importance.

The last time I talked to Tanning was on the phone and after that classic clatter of all nonagenarian telephonic openings, distant kitchen noises and female helpers and several false starts, she could not have been clearer. "I'm just too old to talk to anyone ... I have to die, it's been going on for far too long, I'm far too old, I'm sorry but I really have to die. It's time I died now." Tanning has at last achieved her ambition and as she put it in that perfectly entitled poem for herself, "Secret" (2002): "Why hear congratulations for doing nothing but live?"

Dorothea Tanning, artist and poet; born Galesburg, Illinois, August 25, 1910, died New York City, January 31, 2012.

SIMON LANE

SIMON LANE was one of those writers whose published oeuvre is only matched by the supreme fiction of their own existence, the mythic resonance of their travels and tribulations, those who boldly spin the text of their own legend daily, or more likely nightly. He was the absolute embodiment of the English gentleman-novelist in permanent exile, a self-described "drinker with a writing problem." It was reassuring to know that in the most distant exotic corners of the world Lane would always be there, in an impeccably stained handmade suit, propping up some impossibly dangerous bar, dispensing outrageous wit and wisdom.

Born in Birmingham, Lane studied theatre design at Wimbledon Art School before launching himself across the globe, seemingly supported only by his verbal brilliance, good looks, perfect wardrobe and genius to amuse. Whether in New York, Milan, Berlin, Mexico or Sydney he instantly accrued a loyal band of supporters who helped spread news of his adventures and pay the bills. The last decade of his relatively short life was spent in Rio de Janeiro, where he explored the extreme night life while producing some of his final and best writing.

The risk with such deliciously *rocambolesque* figures is that the value of their own writing is obscured by the larger narrative of their life—the primary text of their actual work replaced by annotations and footnotes of anecdotage. Like the "Unspeakable Skipton" or his original Baron Corvo, like X. Trapnel or his own original Maclaren-Ross, like Peter Fallow in *Bonfire of the Vanities* or Jeffrey Bernard as played on stage—at a certain level of notoriety, public persona becomes itself a work of art. Certainly the circumstances of publication of Lane's first novel were impressive, the founding stone of his subsequent reputation. Having moved to Paris in 1988, Lane had the honour of seeing his debut book published by Christian Bourgois,

one of the most important editors in the world, publisher of everyone from Borges to Solzhenitsyn, Salman Rushdie to García Márquez. In fact this remarkable coup was entirely thanks to an all-night drink-fuelled poker game, whose ultimate stake was the obligation to publish Lane's novel, a gambling debt that was rightly honoured. Entitled *Le Veilleur* (*The vigil or watchman*), the the book had the added distinction of never appearing in its original English but only in a French version by the renowned Brice Matthieussent, translator of such kindred spirits as John Fante, Bowles and Bukowski.

And as with such writers, termed in French "*figures de l'excès et de la provocation*" the ideal arc of Lane's career was somewhat deflected by his own entertaining antics. For example, no sooner had he secured one of New York's leading literary agents than he found himself invited to a party to celebrate her leading writer, whereupon Lane became notably drunk and mortally insulted firstly her most important client, then loudly trounced all her other authors and finally her own professional reputation. Lane thus managed to find himself fired within less than twenty-four hours of being signed.

His penchant for leaping on restaurant tables — "All you frogs are collaborationists!" — was only matched by his taste for every sort of stimulant, whether the constant cigarette, the opium or what he called "getting into *behaviour*," his own code word for cocaine. Wherever one went in the world there were always such stories, or echoes of stories, about Lane, this eternally romantic boulevardier leaving a long trail of laughter and disaster.

Having spent a decade in Portugal and in Paris (in Wilde's old hotel room), Lane moved to Rio in 2001. Wherever he went, and he went everywhere, he was always surrounded by beautiful, mysterious and often wealthy women who seemingly fell instantly in love. Just as loyal were his male fans, often met randomly during epic benders. Lane was married once, and only had one child, but he had countless amours with a fantastical range of women, from Norwegian African designers to Asian junkies and Amazonian actresses. Attending a wedding in the South of France along with

his wife, Lane soon realised he was in love with the bride and cunningly befriended the groom. The four of them got on so well that the couple invited Lane and his wife along on the honeymoon, whereupon he swiftly ran away with the newlywed, eventually abandoning her in Rome having realised he was simply infatuated with the idea of stealing a bride.

His last great love was Betsy Salles, whom he initially seduced by jumping stark naked into her family pool and with whom he lived in Brazil. It was here Lane revived his career as a performer, having already played a sailor in a Derek Jarman film, acted in the first film written by the now-celebrated Édouard Baer, and worked alongside Tom Conti in the 1995 film *Someone Else's America*. He hosted his own radio show in Paris and was latterly a stringer for Global Radio News. His thespian flair extended to his own mortality, for on learning he had cancer Lane decided to wrap his head in an elaborate and startling bandage, an amateur Apollinaire, to signify his illness in a suitably dramatic fashion.

Lane was always close to artists, having had an exhibition himself at the Centre Pompidou of his own limited editions, drawings and prints, and he performed often with the leading Brazilian artist Tunga, who illustrated his last published work, *The Real Illusion* (2009). Lane's "Paris Trilogy," beginning with *Still Life with Books* (1993) followed by *Fear* (1998) and *Twist* (2010), is in some ways comparable to Edward St. Aubyn's trilogy, a classic of English social-tragi-comedy surely ripe for revival in a single volume. Several other books were published in Brazil including *Boca a boca* (2005) and *Noite em Pigalle* (2007), titles all the more evocative in Portuguese. Lane also left behind a final manuscript, considered by those lucky enough to have read it as perhaps his masterpiece: "Brazil, Eternal Promise," a portrait of his adopted home.

Oliver Simon Lane, writer, wit, raconteur and performer;
born Birmingham, England, May 19, 1957, died London, December 28, 2012.

JACK-ALAIN LÉGER

"**M**ELMOTH" was his secret code name as an award-winning singer-songwriter, Paul Smaïl his *nom de plume* when conjouring the scandalous memoirs of a young working-class Moroccan immigrant, Dashiell Hedayat his alias as one of the world's most furtive psychedelic rock stars and Jack-Alain Léger his plain given name when penning his million-selling thriller *Monsignore* (Laffont, 1976). For Jack-Alain Léger had as many pseudonyms and disguises as varied careers: a militant manic-depressive homosexual, public intellectual or "intello" as they call them on the continent, prolific author and, strangest of all, both hippy music legend and bestseller hack—an unholy Gallic combo of Syd Barrett and Lord Archer.

Adding a further frisson of glamour, Léger was also infamously suicidal, finally throwing himself out of his Parisian window at the age of 66, perhaps in homage to that philosopher and fellow defenestrator Gilles Deleuze—whom he had known, as he had known everyone, forever. One of his best loved songs was entitled "*Vous direz que je suis tombé*" (You will say that I have fallen), another begins with the first line "*je suis a la fenêtre*" (I am at the window). Léger had often spoken of this possible suicide, to rejoin

his mother in the same method of self-extinction. To further complicate the issue of his many identities, his official name "Léger" was not even his real one, having been born Daniel Théron in 1947 in Paris. But he was determined not to carry the name of his much-loathed father, who in turn — and this gets complicated — was a literary critic under the pen name Jean Bruèges.

As a young man born into a family heritage of both manic depression and pseudonymous creativity, Léger began writing at 13 but first came to notice at a tender 21, under the guise of Melmoth, "one of the living dead who can never find tranquility," with his first album *La devanture des ivresses* (The shop window of drunkenness) which won the highly prestigious songwriting award, the Grand Prix de l'Académie Charles Cros. That same year, 1969, the first novel by Melmoth appeared simultaneously, published by the most modish house of that era, Christian Bourgois, and suitably entitled *Being*.

Two years later he reappeared as an even more extreme mystic-hippy-rock avatar, one Dashiell Hedayat. Thickly moustached, leather-jacketed, eyes continuously concealed behind dark shades, he concocted a name from two of his heroes, Dashiell Hammett and Persian writer Sadeq Hedayat. Few made the connection with that vanished cult figure Melmoth, not least as Hedayat became a regular on television as an exemplar of the French counterculture rocker, backed as he was by the most revered of all such musicians, that ultra-acid, mind-blowing ensemble Gong. Thanks to this close collaboration with Gong, his 1971 album *Obsolète* has long been a highly collected slice of precious vinyl, selling for up to 500 euros and recently reissued as a deluxe CD. For it is a classic of that epoch, best appreciated stoned out of your mind in a small darkened apartment in some lost provincial city — Lyon perhaps — its lyrics a heady mélange of drugs, occultism and free-jazz poetics, all played out at interminable guitar drone length. "Long Song For Zelda," for example, is long indeed and brings together Scott Fitzgerald's doomed wife with tarot cards, incense, fluttering candles in a mirrored bathroom and "*des nuages d'héroïne*" — those

clouds of heroin, "horse power, horse power." The album's biggest hit, "Chrysler," consists of Hedayat repeatedly calling out just the brand of that American car, along with its colour, "rose" or "pink," over eight minutes of churning Gongism. Hedayat also published four books—*Selva oscura* (Flammarion, 1974); *Jeux d'intérieur au bord de l'océan* (Christian Bourgois, 1979); *Le bleu, le bleu* (Christian Bourgois, 1971); *Le livre desmorts-vivants* (Christian Bourgois, 1972)—not to mention French translations of the verse of Leonard Cohen and Dylan, most notably his slim volume *Tarantula* (Christian Bourgois, 1972) for the first time.

But by now "Léger" himself had also appeared with a series of novels, beginning with *Mon premier amour* (Grasset, 1973) and going on to glory with the unexpected bestseller *Monsignore*, a sort of parody detective tale published by the mainstream giant Laffont, which became a hit movie starring Christopher Reeve. Léger continued to put out endless books, more than anyone could be expected to keep up with, a sort of Gallic gay Joyce Carol Oates, but he was also a master at provoking official scandal and then appearing on all the major TV programmes to defend his latest outrage. This began with *Autoportrait au loup* (Autoportrait as a wolf, Flammarion, 1982) which revealed in detail the full extent of his very extensive homosexuality—a subject that was to become one of his recurring leitmotifs along with his severe bipolar melancholia, twin chat show staples over the decades.

To spice things up with a little ethnic flavour, Léger then reappeared as Paul Smaïl, supposedly a North African immigrant aged 30, whose memoirs *Vivre me tue* (Living kills me, Balland, 2003) proved a great success, so much so that he followed it up with three more such accounts of hard living in the ghetto. For Léger clearly knew well these young immigrant males—much as another of his heroes, Jean Genet, had also lived and loved in this exotic milieu—and one of his most controversial and courageous books came directly out of his experience of this *demimonde*. For *Tartuffe fait ramadan* (Tartuffe does Ramadan) published in 2003 to near

universal outcry was far from being a simplistic denunciation of Islamism; rather by comparing the religious hypocrisy and political cunning of Molière's villain with contemporary cowardice regarding the real truth of so much Islamic teaching, he bravely demanded that France reclaim its enlightenment values in the face of such intolerance. As such Léger was not afraid to publicly state that he was an acknowledged "Islamophobe" whilst also a stout—in every sense—defender of gay rights, disenfranchised youth and feminist politics, having penned some of his best recent work under the female alias of Eva Saint Roch.

The tradition of multiple pseudonyms or "homonyms" has been both highly avant-garde, as in Fernando Pessoa, and also notoriously lowbrow as in those professional science fiction and adventure pulp hacks. As a pamphleteer, provocateur and preposterously productive writer, Jack-Alain Léger managed to bridge both of these literary worlds with his unique style and mordant honesty. "For me," as he would never fail to admit, "literature is a question of life or death."

Jack-Alain Léger (Daniel Théron), singer, composer, writer and performer;
born Paris, June 5, 1947, died Paris, July 17, 2013.

RENE RICARD

"SUCK my pussy, you star!" Rene Ricard loved a shocking opening line, something so punchy that he was often physically assailed or thumped upon first meeting people. He also loved heroin, opera, crack cocaine, eighteenth-century furniture, bondage, French literature, hardcore S&M and the very wealthy. "YOU ARE FORTUNATE / ENOUGH TO BE SPEAKING TO RENE RICARD / … A FRIEND TO THE RICH / AND AN ENEMY OF / THE PEOPLE … / THIS IS SHE."

For fifty years Ricard cut a unique swathe, one might say a "sashay" through the many worlds of Manhattan, where the dingiest *demimonde* abutted the smartest social registrar and where "René" (uttered with something between a sigh and groan) was a seemingly eternal fixture. Ricard was one of those hidden motors of the city without whom it is almost inconceivable. Like spotting Woody Allen with his clarinet, spying Rene with crack pipe and dog-eared Rimbaud meant that New York was same as it ever was. But as of February 2014 it is no more, since Ricard died suddenly and unexpectedly of cancer aged 68. And as one of the last long-time residents of the Chelsea Hotel his death also definitively marks the demise of that bohemian institution.

Ricard was a poet and art critic especially celebrated for his writing on close contemporaries such as Julian Schnabel, Francesco Clemente and Jean-Michel Basquiat, his 1981 *Artforum* essay "The Radiant Child" being a crucial component in Basquiat's career. As Apollinaire to the eighties art firmament, Ricard was almost as much a star as those painters themselves, though always acutely conscious of his own relative failure next to their greater glory. Back in 1977 Ricard appeared on television vaunting his own penury and how Brice Marden called him a "dilettante" — certainly compared to the wealth of such artists, Ricard lived a

life of genuine poverty, albeit consistently supported by them, or their wives. Ricard famously fought with Basquiat over a painting he claimed had been promised to him – a central plot device in the 1996 Schnabel movie – and anyway boldly lost or pawned all the art given to him by his famous friends, if not sold on the street for drugs.

Ricard was also a ready muse and model, whether in a 1970s study by Mapplethorpe of the poet-as-leather-queen or in memorable Nan Goldin images of him at his most handsomely crack-ravaged. Ricard's 1979 debut book of poems was the first publication by the Dia Art Foundation, and was followed by at least five slim volumes and fanzines. Ricard also scrawled his poetic shards and bittersweet epigrams on scraps of card, walls or battered found canvases, and these striking "paintings" were regularly exhibited, not least recently in London at the gallery of his friend Ronnie Wood of the Rolling Stones.

Albert Napoleon Ricard was born in Massachusetts into the oldest of old New England grandeur, according to his own legend, for rather than any *poète maudit*, Ricard's real fantasy was closer to being some Boston Brahmin like Robert Lowell. Ricard escaped to New York at just 18 to become a regular at Warhol's Factory, where he inevitably ended up starring in several movies, not least playing Andy himself in *The Andy Warhol Story* (1967), though his most impressive role remains in the perfectly named *Underground USA* (1980) directed by Eric Mitchell. For the camera loved Ricard and he loved it back with all the flourish of a fallen ingenue. As a great fan of *The Art Newspaper*, when Ricard was introduced to Anna Somers Cocks, its Chief Executive, she immediately mentioned that his voice sounded extraordinarily like that of her friend Jayne Wrightsman, that *hautest* high society patroness of the Met, whereupon he fell to his knees in gratitude at the greatest compliment he could ever imagine.

Once at an opening for Lou Reed photographs at the Hermès store on Madison, Ricard turned up fifty minutes after the event had ended and attempted entry by assuring the bouncer of his eternal intimacy with "Lou." As we stood outside Ricard boasted "I have even had my suits complimented in *The Art Newspaper!*" Revealing that I myself had written this he snapped back "Of *course* you did darling, of course…" Introducing him to the young Hermès heir that I happened to be with, Ricard cried out "*Everything* I am wearing is Hermès, top to toe, it's all *1972* …" before adding in fury, "and I can promise you that I will *never* wear Hermès again after tonight, *never!*" Whereupon he hurled both his vintage loafers into the gutter in disgust and strode aware barefoot and magnificent.

Gone now, all gone, and gone forever his trademark phone monologues, where he would start talking mid-phrase, entirely without introduction, rambling brilliantly through salacious gossip of the cattiest kind, an astonishing performance that could last up to an hour, until he replaced the receiver equally abruptly with his inimitable whispered hiss, "that's it baby… it's over and out from *Radio Rene.*"

Albert Napoleon "Rene" Ricard, poet, artist and provocateur;
born Boston, July 23, 1946,
died New York City, February 1, 2014.

MICHAEL SPENS

SOME thrust their greatness upon you whilst some, like the late Michael Spens, are not afraid to keep their achievements to themselves, operating with that born discretion which once went by the name of "gentleman." As a scholar, soldier, editor, writer, conservationist, collector, publisher, paterfamilias, architect and adventurer Spens led a remarkable life, all the more remarkable for his refusal to allow it to be curtailed by terminal illness. For if his death at the age of 74 seems premature, he was in fact supposed to die some two decades prior, his steely survival baffling all medical expertise.

And until the end Spens ran his cultural fiefdom with his usual attention to detail; not only editing the journal *Studio International* but also writing articles on his many areas of expertise, from design to contemporary art, his worldly urbanity undimmed by distance, based as he was on his estate in Fife. For if Spens was indubitably Scottish, it was a specific Scottishness, both proudly patriotic and inherently cosmopolitan, with an clannish faith in decency. This lent Spens the suggestion of some John Buchan hero, his modesty in the face of his military past adding to this aura of a Richard Hannay *de nos jours*. Furthermore Spens was, unlike most of his caste, a committed nationalist and even stood as Scottish National Party (SNP) candidate in the Orkneys in the early 1970s. Likewise it was perhaps his taste for modernism — most egalitarian of creeds — that fuelled a distaste for any form of snobbery, his education at Eton and Corpus Christi ultimately as unimportant as the relative grandeur of his ancestral heritage.

In fact Spens joined his father's own old outfit, the Argyll and Sutherland Highlanders, and served with distinction in both the Middle East during the Suez crisis and in Berlin at the height of the Cold War. Spens continued his military career as a longtime

Territorial Army officer even if he eventually turned down an approach to join the SAS in 1969. That said, a certain frisson of the clandestine services still lingered around Spens, encouraged perhaps by his extraordinarily wide range of contacts around the globe—the obligatory network of any editor—and his careful circumspection, not to mention his movie-perfect presence as the quiet but knowing clubman.

Spens was certainly conversant with as many countries as cultures and it was typical of his almost Ruritanian elegance that his only official title (or the only one he publicly acknowledged) was Knight First Class, Order of the Lion of Finland. This honour went some way to acknowledge one of his greatest achievements: the restoration, indeed salvation, of the Vyborg Library, built by Alvar Aalto in 1935 in what was then Finland, before its annexation by the Soviet Union. Far from any straightforward saga of architectural conservation, the saving of Vyborg was closer to an adventure story, as at the time nobody even knew if the building still existed. Yet the preservation of this modernist masterpiece should surely be seen in the context of Spens's equally loving and expert restoration of his own medieval castle at Cleish.

For Spens himself long practiced as an architect, winning the Saltire Award for Housing Conservation (1975), the European Award for Architectural Heritage Intervention (1976), and the Norfolk Architectural Association Award for Housing (1986). He also became a beloved Professor at Dundee's School of Architecture and Urban Planning and served on the Committee of the National Gallery of Modern Art, Edinburgh, and on the Scottish Arts Council. But Spens was perhaps best known as a writer of essays and criticism as well as ten highly regarded books, including the official works on the landscape architect Sir Geoffrey Jellicoe, whose aristocratic disdain for social pedigree matched his own.

Spens was equally involved in publishing, whether with the Architectural Press, Ernst & Sohn in Berlin or most notably Academy Editions, which specialized in those theoretical avant- (or

"retro") gardes from Post-Modernism to Deconstruction. These publications were invaluable to a whole generation of architecture students and emergent practitioners and though their themes might seem far from Spens's own concerns, tipped as they were to the modish, they demonstrated once again the range and flexibility of his intellectual inquisitiveness. Spens's taste for rescuing historic institutions was also evident in his resuscitation of *Studio International* in 1982, the revered magazine founded in 1893, which he relaunched thanks to the generosity of the Sackler family.

Spens leaves behind six children from his two marriages, to Caroline Sedgwick-Rough and to Dr. Janet McKenzie, and the manuscript of his last great work, a biography of Morton Shand, the architectural writer, grandee-grandfather to Camilla, Duchess of Rothesay, and revered oenophile—a figure surely suited to Spens's own rare blend of connoisseur, critic and professional polymath.

Michael Spens, architect, preservationist and editor;
born Windsor, England, October 24, 1939,
died Dundee, Scotland, March 28, 2014.

SONIA "SPIDER" QUENNELL

SONIA "SPIDER" QUENNELL was one of the great beauties of her generation, a career that already seemed somewhat antiquated even in her own heyday. For, paradoxically, though the professional beauty has never been more prevalent—"top model" being an ultimate celebrity role—the rather more discrete and certainly less well paid society equivalent has almost disappeared. For Spider, being beautiful was certainly a vocation, a lifetime achievement which she maintained right to the bitter end—seemingly passing for an eternal 35 regardless of any ghastly chronological reality—but she did not think to exploit it in any remunerative or public manner. Spider had in fact once been offered a modelling contract but did not go because it was raining.

Thus though Spider did once grace the cover of *Vogue*, whilst likewise posing as muse for her host of artist admirers, her everyday life was taken up with the more enviable task of amusing, outraging and exasperating her vast circles of friends and acquaintances, those whose very grandeur or talent ensured her entry into some of the most desirable footnotes of the twentieth century. Her purlieu was infinitely large whilst also ruthlessly selective, specialising in a certain social and intellectual smartness hard to conceive today and exemplified by such redolent names, at random, as Teddy Millington-Drake, Hercules "Hercy" Belville, John Huston, Loulou de la Falaise and Queensberry.

Born into the *hautest* of *haute juiverie*, her mother a Montefiore no less, Quennell grew up in central London in curious circumstances, only finally spying her actual father Kenneth Leon—a Harley Street specialist—as he strolled along Oxford Circus. Spider and her sister, her only sibling, cried out to him across the thoroughfare

whereupon he immediately vanished once more – perhaps to India – never to be seen again. Spider grew up instead with her stepfather Sir John Ellerman, a wealthy shipowner, whom she seems to have loathed as much as she did the rest of her family.

Sent for safety's sake down to Brighton during the Blitz it was here that Quennell spent the rest of her adolescence, living with the singer Gertie Millar and even apparently enjoying some sort of local schooling, before coming into her own as a teenage goddess. And thus it was, in the first full bloom of her *jeunesse*, that at age 16 she was picked up in the Isles of Scilly by the first of her many, many admirers, namely the painter Johnny Craxton and his traveling companion Lucian Freud, both of whom immediately insisted she must sit for them. Spider did more than that, not only moving in to live with the two artists at their bohemian London *ménage* but also starring in a series of portraits by Craxton (the most important of which is with the Tate) whilst persistently rebutting Freud's varied blandishments including his repeated demands to capture her exotic charms in paint.

Otherwise she was entirely happy throughout her long peripatetic life to allow herself to be sketched and snapped by any number of celebrated friends – whether Cecil Beaton posing her regally with a pagoda crown, Adrian Daintrey shading her fabled cheekbones or designer David Hicks creating a surreal composite of her most striking features; whilst photographers such as Derry Moore and Clifford Coffin took some of her best portraits, the latter producing her full colour *Vogue* cover in 1947.

Spider loved to play the ultimate comely Jewess, and with her half fantasy theatrics was very good at sending herself up; her utterly exaggerated ways, outrageously affected for theatrical effect, proved highly amusing. "Darling, darling I've seen it all before" was her own way of fending off the modern world and God knows we all need one. Such self-dramatisation was particularly appreciated by writers and editors such as Alan Ross, Ivan Moffat and Francis Wyndham, and those many works of fiction

in which Spider appears, sometimes with the lightest of disguises, would merit their own separate bibliography.

But it was her meeting with Peter Quennell, whom she married in 1956, that was to be the most decisive factor in her life, not least providing her with both of her best known names, as he nicknamed her "Spider" in homage to her extraordinarily long limbs redolent of some Spider Monkey. Quennell also adds in his autobiography *The Marble Foot*, "I recollect once hiring a horse called 'Spider' which shied and threw me...." Quennell, whose star has somewhat faded today, was a famous and famously prolific writer and editor; he was known for his charm and gentlemanly elegance as well as for his countless books and articles, not to mention his impossibly active social and sexual life. Quennell was some twenty-three years Spider's senior, and this was to be the fourth of his fifth marriages — a union that lasted more than a decade, much of it devoted to a dizzying, positively Edwardian round of country house parties and long weekends at every sort of stateliest stately. Thus Spider's scrapbooks carefully plot her progress through this infinitely grand circuit, a last gasp of old fashioned high society; here, houses such as Petworth and Easton Neston, Russborough and Mottisfont, La Malcontenta and La Fiorentina, are caught adorned with everyone from Freya Stark and the Sitwells to Ian Fleming, Paddy Fermor and Cyril Connolly or such *grande dames* as Antonia Fraser and Diana Cooper. A typical copperplate caption, capturing an entire vanished world, might run slopingly, "Peter St. Just at Willoughby House." Spider was absolutely suited to this sort of existence where the highest bohemia and loftiest aristocracy happily swayed upon their mingled pinnacles; she made a perfect foil to Quennell, or "PQ" as she called him, becoming perhaps the best known of his many young and beautiful spouses. Spider did not even really object to his notoriously roving eye and possibly even welcomed the arrival of the fifth and final wife; indeed, though they had no children themselves, she remained long devoted to his son from that last marriage, the Parisian film director Alexander Quennell.

Herself the absolute opposite of promiscuous—even if malicious gossip linked her to many, most notably Desmond Guinness—the only other great love of Spider's life was the producer and screenwriter Wolfgang Reinhardt, also older by some twenty years, and son of the great Max. She lived with Reinhardt in New York and Rome until his death in 1979. Having adopted a largely Italian life, it was on one of her periodic visits back to Britain that she infamously commandeered a wheelchair in order to cleverly wangle her way onto a busy flight, only to be met at Heathrow by an official ambulance, which whisked her protesting to the Hospital for Tropical Diseases from which she had some difficulty escaping.

Although Spider only once indulged in actual paid employment, creating the costumes for Reinhardt's final film *Hitler: The Last Ten Days* in 1973, her exceptional flair and acute visual sophistication made her not only a celebrated dresser but also a creator of perfect spaces, whether a mere tabletop or mansion. A ferocious and ferociously witty, outspoken snob when it came to clothes and houses rather than people, she could also be frightening, one Dowager recalling, "She denounced my hat so vehemently I never dared wear it again." To the end Spider devoted great energy and detail to making sure everything was exactly right in her world, even spending a fortune to have all the brown spots removed from her hands by Joan Collins's plastic surgeon. And as Philippa Jellicoe concludes, "She could have been all sorts of things that she wasn't—she could have been a leading model, she could have been a famous decorator. Spider really was exceptionally good at everything to do with looking good."

Sonia Geraldine "Spider" Quennell, beauty; born London, August 30, 1926, died London, June 7, 2014.

ULTRA VIOLET

"I say the name out loud several times 'Ultra Violet, Ultra Violet.' By luck or by choice, my name contains the five magical vowels." Thus Isabelle Collin Dufresne, scion of the *hautest* French bourgeoisie, boldly rebaptised herself a "Superstar" at the request of Andy Warhol. Indeed it was Warhol who had insisted that she find a new name to suit her burgeoning career as his muse, actress, collaborator and camp follower, his own suggestions being "Poly Ester" and "Notre Dame" both of which she happily rejected. "While reading an article on light and space in *Time* magazine, I come across the words 'ultra violet.' They leap out at me. I cut them out with the gold scissors I use to cut the split ends of my hair." Andy was immediately amused by this *nom de guerre*, "It will be an ear-catcher." And so it proved to be, as "Ultra" went on to be one of the brightest stars in his vast firmament, celebrated for her wigs dyed various shades of bright violet and her array of torn exotic garments, all in her signature violet colour scheme.

In fact Mademoiselle Dufresne had already led a suitably eccentric existence long before meeting Warhol – a life dedicated to a love of art, and specifically male artists. Born in 1935 in Grenoble to a family descended from the sixteenth-century fiefdom of Antoine Terray, with extensive family connections,

including various ministers of education and de Gaulle himself, their current prosperity came from her paternal grandfather Marcel. It was he who built their summer home, La Gaillarde, a modern mansion on the Mediterranean coast complete with their own harbour and boathouse on twelve miles of coast. As a rebellious child Isabelle had first tried to run away at age four, attempting to walk all the way to Paris. By six she was going by bus to a Catholic school outside Grenoble, but was soon made a boarder when it was reported she'd been making eyes at the driver. Trying to be thrown out of the Sacred Heart convent, she smuggled a radio under her robes to play jazz at mass and smoked cigars lit with a hundred franc note. At 13 she escaped by bicycle, with no underwear, and went to the nearest café to drink her first whisky, smoke a cigar and read the financial newspaper. Picked up by a club friend of her father's, he brutally took her virginity in his car. As she admits, "Years later I am to have a multitude of lovers, as I try to fill my endless need for love." Caught on repeated bicycle escapes from the convent at night, she was actually exorcised, with two nuns holding her down while a priest intoned the Latin prayers and sprinkled her with holy water.

After further escapes her parents took her to a child psychologist and she was finally imprisoned in a house of correction, in a cell with one barred window. Eventually liberated at Christmas 1952, she was sent to New York the next year to stay with her older sister at the Sacred Heart finishing school on Fifth Avenue. "The moment I step onto the crumbling dock, I feel at home. I sniff the New York air. It smells free. I am free."

Thus aged 18 with a job in the office of the French cultural counsellor, she entered the full Manhattan social whirl that was to be her life. She also had the first of her many artist lovers, Antonio Pellizzari, with whom she visited Nantucket, Milan and Paris. Then with a wealthy yachtsman, she followed the American Cup from Newport to Palm Beach until a new lover, a rich married man who piloted his own plane, bought her a small apartment

building on the East Side, even then worth over a million dollars. In 1959 at the opening of Leo Castelli Gallery she met the mystic artist and collector John Graham, aged 78 to her 24, and soon moved into his basement flat, a *grand amour* that lasted two years, his hundreds of love letters finally being donated to the Smithsonian. More adventures followed when she was asked by the once lady-in-waiting to the Queen of Egypt to deliver an eighteenth-century Russian spoon to Dalí at the St. Regis: "The moment we exchange glances we are certain we are made for each other." This long love affair, in which the main sexual prop was a gold lobster and where she drank his urine to improve her genius level, was to consume her life until 1963 when she first met Warhol. On visiting him at the Factory she attempted to seduce him, to his absolute horror, though they became immediately inseparable for the next decade.

Acting in several Warhol movies, including *The Life of Juanita Castro* (1965), *I, A Man* (1967) and ****** (1967), her most mainstream roles were probably in *Midnight Cowboy* (1969) and *Taking Off* (1971) by Milos Forman, another of her lovers, as well as the art movie *The Secret Life of Hernando Cortez* (1969) by her longtime boyfriend, the sculptor John Chamberlain. Ultimately Ultra appeared as an actress in some some twenty films, not least having real on screen sex as a prostitute in Norman Mailer's *Maidstone* (1970), whilst playing "herself" in at least twelve documentaries. She appeared on stage with the Ridiculous Theatre on the Bowery, and sang in a contemporary opera at Julliard, releasing her own rock album on Capitol Records and starring in a production of Picasso's play *Desire Caught By the Tail* at the Festival de la Libre Expression in St. Tropez in 1967. A whole suite of Kodacolor portraits of the scantily clad actress were created at the time by Pierre Bourgeade, whilst curiously enough this very same play offered the only New York theatrical role ever taken by the young Sylvester Stallone.

But mainly, with her violet-striped Lincoln Continental featuring her interlocking "UV" logo, Ultra was famous for being Ultra,

a glutton for publicity. As such her life revolved around famous names and places: tea with Chanel in her salon, dancing with Nureyev at El Morocco, supping with Onassis and Callas at Maxim's, meeting with Messiaen, accosting Howard Hughes in his Beverly Hills bungalow, yachting with Sam Spiegel, lunching at Le Pavilion with Crick and Watson, hanging with the Duke and Duchess of Windsor or simply knocking on Picasso's studio door in Vallauris, declaring "Here I am!" As Warhol put it in his book *Popism*, "It was uncanny the way she always managed to be right on the spot the second the flash went off."

By the 1970s, Ultra was somewhat distanced from Warhol whilst pursuing her own unique lifestyle, not least a passionate affair with yet another artist, Ed Ruscha, whom she adored as "King Edward." The passion was reciprocal for as Ruscha reminisces today:

> Ultra was a gorgeous ball of hilarious energy. She was rarely negative about anything and looked upon the world as full of possibilities and her personal playpen. She would pick out any object in a drugstore and imagine its use to be anything other than what it was meant for. This was, maybe, her form of self-amusement, but amusing for anyone standing around. She would eat bits of pure gold and bathe in a tub full of milk. She could be incredibly perceptive, as when she described John Chamberlain as "a ferocious pussycat." This quote could also apply to herself.

By this time Ultra had retreated into more mystical pursuits, following a full scale breakdown, she reconciled with her family in France, devoted herself to studying all the world religions and eventually became a devout born again Catholic, repenting of her lifelong excesses. She practised every form of meditation, including self-hypnosis, worked in a church soup kitchen and even had her own cable television show on consciousness expansion. As Vincent Fremont, longtime Vice President of Andy Warhol Enterprises concludes,

Andy took polaroids of her long tongue, one of her prized assets besides wearing purple and dying her hair purple. She definitely was a curious fixture in the New York art scene in the 1960s and through the 1980s. I remember at the Vanity Fair "reunion" shoot by Todd Eberle of those who knew or worked with Andy that Ultra was impatient and told Todd to hurry up because she had "some place to go." Everyone turned around to look at her with sarcastic expressions of doubt about her statement.

Or, as if writing her own epitaph Ultra herself put it perfectly, "I crave recognition. Recognition is as necessary to me as oxygen. Without it, I will wither and die."

Ultra Violet (Isabelle Collin Dufresne), artist and muse;
born La Tronche, France, September 6, 1935, died New York City, June 14, 2014.

BERNARD HEIDSIECK

"PUDIC PURE
or
ob
scene gasm S'PIERCE VERSE"

BERNARD HEIDSIECK knew how to kick start a piece, and anyone lucky enough to witness one of his performances could attest to the flair and drama, the sheer loudness and excitement of his poetry. Heidsieck was also known for two other salient facts, indeed his name was rarely mentioned without their whispered addendum: that he was a member of the famous French champagne family and he was a professional banker.

Poet bankers are notoriously rare, Eliot being the obvious example, but Heidsieck was of an even bolder breed, his poetry being so radical, so extreme, that it made an ever engaging contrast with the sobriety of his daytime employment. Few thus would fail to be struck by the sight of the longtime Assistant Director of the Banque Française du Commerce Extérieur, conservatively dressed in black suit and tie, seizing the microphone to proclaim: "ZZZZZZZZi PLUS *ZZZZZZZZi* VITE *ZZZZZZZZi* PLUS *ZZZZZZZZi* VITE."

For though Heidsieck was always impeccably dressed, with polished shoes fit for any financier, his poetry was so far at the outer limits of any avant-garde that most bankers might flee in horror at only its distant echo. As a collaborator, friend and patron of many of the most important experimental artists, from Brion Gysin to Steve Reich, John Giorno and John Cage, Heidsieck was as much of a visual practitioner and performance artist as literary fixture. As a provocateur he pushed all boundaries until those who had previously exclaimed "But that's not 'poetry'!" were now forced to add, "And that's not 'art' either!" Or as he put it himself, "Why sound poetry? I

have no idea! And in the end I don't care. That's just how it is! Why? Rather, instead, why *refuse* this new opening?"

Born into the direct line of Heidsieck descendents, one of the oldest champagne firms founded in 1785, the family name always proved something of a liability. For like that fellow drinks dynasty Guinness, there have always been really rather a lot of Heidsiecks and of wildly varying fortunes. Heidsieck's father was the eldest of fifteen children, with the two eldest owning half the company shares, and upon his death in 1975 his brother sold the company. Heidsieck himself eventually sold his own remaining shares to finance his artistic activities.

Though he had been born in Paris in 1928, Heidsieck grew up in suitable provincial prosperity in Reims, centre of the Champagne region, and only returned to Paris to study at the prestigious Institut des Sciences Politiques. He then embarked upon his infamous job with the Banque française du commerce extérieur, where he became "*directeur de service*" and remained until retirement.

Indeed Heidsieck's penchant for the provocative, whether incorporating actual tax returns and bank details into his poetry or using such titles as "Spermatozoïdes II Sécretion," was surely partly due to this highly conventional background. For as a young man – already a banker – Heidsieck had discovered with astonishment the world of atonal and electronic music thanks to the renowned Domaine musical concerts organized by Pierre Boulez. Heidsieck realized that by comparison poetry was completely behind the times and was determined to get it up to speed, to make it as challenging and uncompromising as this new music. Heidsieck went on to collaborate with many composers, not least Iannis Xenakis, and was very aware of the relation between his work and their scores. "At the frontier of music, so, sometimes! Yes! Without doubt! But at the frontier only! At the frontier all the same!" Yet he was also at pains to point out that this poetry was "nothing to do with the 'Sprechgesang' of Schoenberg" and was rather "sonic material constituted of the word or sound 'said,' 'spoken' and not 'sung.'"

However defined — and it has been called many things over the decades not all of them complimentary — Heidsieck could rightly claim to be the inventor of *poésie sonore*. He dated this form to 1955, when he realized poetry needed to "leave the page and become active once again" and created his first audio-poem. Also known as lingual music, verbosonics, or *poésie concrete*, Heidsieck was this movement's most active spokesman, not least in helping set up the annual Swedish Radio Text-Sound Festival. As a tireless performer and promoter, he harnessed his organizational abilities to this most recondite of cultural activities. Thus in 1976 he created the Premier Festival International de Poésie Sonore to the bemused amusement of his high society contemporaries.

His forebears may have been the Futurists, Dadaists and Joyce, but Heidsieck was determined his poetry should be heard and experienced physically rather than read on the page. He was swift to point out that this was a return to poetry's origins going back to ancient oral traditions and medieval bards, albeit with rather different results, "boule BANG bille bulle / bonds BANG bulle bat." Heidsieck loved to perform, whether at the Paris Biennale of 1965 with two *pompiers* on stage or at far flung Concrete Poetry festivals with the Electric Weasel Ensemble, the elegance of his formal attire adding an extra frisson to his loud and speedy delivery of abstract sounds.

And whilst sound poetry might cynically be dismissed as just some dated fad of modernist *n'importe quoi*, in fact its performative imperative prefigured both rap and slam. Likewise its emphasis on the interactive, mutable text anticipates current digital aesthetics. Heidsieck, whilst ceaselessly traveling the festival circuit, put out innumerable cassettes, records and DVDs of his performances, along with old fashioned printed books, collaborative art works, and his own collages and drawings. Having been introduced to the latest tape and electronic equipment, Heidsieck produced cut-up versions of his texts, literally splicing sounds and words together using street noise, children's cries and ambient rumble. *Poème-partition V* (1956) covered a single day from one in the morning

till midnight, whilst *Poème-partition A* of 1958 used a medical LP with all varieties of cardiac rhythms, which he transcribed into an abstract pattern of basic breathing. His most radical, and certainly most legally ambiguous, compositions were the "Biopsies" which used elements of everyday life, questionnaires and administrative papers from his bank as part of their fabric, even turning his social security number—F 1 28 11 75 117 10 221—into a poem.

As such Heidsieck was greatly in advance of current concerns, *Biopsie 8* from 1966 using his ID card and driving license. "This has to do with the numerical systems in which we are all trapped. Even our smallest gestures leave a trace which allow, as with a credit card, to identify and to situate us at any moment." Closest to his concerns as a banker was one of Heidsieck's best known works, *Vaduz—Capital of Liechtenstein*, commissioned in 1974 for the inauguration of an art foundation in that eponymous tax haven, whose performance offers the listeners "a visual sign of its weight, variety and beauty, in all the awe and panic of its ever burgeoning wealth." In 1989 a pop promoter hired Heidsieck to perform at the music club Elysée Montmartre, opening for English singer Anne Clark. Here Heidsieck launched into *Vaduz* and within the opening bars of this twelve minute masterpiece was met by a hail of vocal protest, followed by glasses, tumblers and bottles. Or as he put it with wise resignation, "I had made the acquaintance of the brutal spontaneity of an audience which hadn't been forewarned."

This long career, or anti-career, culminated in his receiving in 1991 Le Grand Prix National de la Poésie, as well as a large retrospective exhibition at the Villa Arson in Nice and, perhaps most importantly, the publication in 2013 of an enormous tome of over 1,000 pages containing all of his texts to date.

At the age of 23, Heidsieck had married the artist Françoise Janicot, who had spent much time with the writer Jane Bowles in the hammams of Tangiers and subsequently became celebrated for wrapping herself up with string, from toe to head, on stage. Along with their two daughters they occupied a fabled apartment on the

Quai de Bourbon on the Île Saint-Louis, the *hautest* of bourgeois addresses. This was a spectacular warren of high-ceilinged rooms filled with an astonishing variety of papers and art *objets*, an Ali Baba's cave of conceptualism, which became an informal salon for a whole network of international artists. This apartment also became a well-known installation in itself, reproduced as a wall-sized image for Heidsieck's last exhibition of collages at Galerie Natalie Seroussi. This taste for high bohemian decor has been inherited by at least one of their children, the Comtesse Nathalie de St. Phalle, whose private hotel in Naples, a member's only club for the cosmopolitan connoisseur, is likewise adorned with artworks from all around the world, some fitting legacy of her father's fabled flair. She survives him, along with his other daughter Emmanuelle Leduc and his widow.

The pleasing paradox of Heidsieck's conservative social milieu and revolutionary artistic activity was exemplified by a requiem high mass at Saint-Louis-en-l'Île, itself a suitably *grande église*. This formal and old fashioned memorial was attended by everyone from Foreign Minister Roland Dumas to veteran street artist Jacques Villeglé, along with some very *grandes dames* indeed. Or as Heidsieck might have summed it up himself:

WOUND
PEARLS drip dribble trickle drip
PEARL POOOoooooOSH
totter topple

Bernard Heidsieck, banker and sound poet; born Paris, November 30, 1928,
died Paris, November 22, 2014.

ALEXANDER "SANDY" WHITELAW

SANDY WHITELAW was the last representative of a lost Hollywood of cosmopolitan sophistication and the fact that he was actually a proud Highlander, long based in Paris, was typical of that milieu. Though his actual age was one of his many closely guarded secrets, his transatlantic accent and celebrated anecdotal repertoire dated him to a certain magic era, even if his enthusiasm and energy suggested a far younger man. Whitelaw had been a soldier, sportsman, director, producer, actor and artist, not to mention raconteur, drinker and seducer, all of which granted his presence something of the sulfur whiff of a long-vanished Los Angeles glamour.

Always known as "Sandy" though christened with the more imposing title of Graeme Alexander Stewart Lockhart, he was born in Westminster to a storied Scottish military family, his father a career soldier, and was rightly proud of the statue in Trafalgar Square of his great-great-grandfather General Henry Havelock. Schooled privately in Switzerland, Whitelaw moved to Italy immediately after the war; he eventually moved into one of the grandest palazzos of Venice, where he lodged, intimately, with the Di Robilant dynasty. It was during this adolescent Venetian sojourn that Whitelaw first met many of the major figures in the international film business. He finally returned to Britain to take the first part of the Economics Tripos at Trinity, Cambridge, on a scholarship, before electing to be educated at Harvard. From there he joined the Royal Horse Guards and thus could boast that not only had he been in the "Blues" but also sung the blues, as a key figure in the early R&B London club scene, singing and strumming with everyone from the future director-producer Luciano Ercoli to Rex Harrison's son Noel. The latter he knew from a shared love of Alpine skiing and indeed Sandy represented Britain at the 1955–56

Winter Olympics in Cortina d'Ampezzo where he competed in the Men's Giant Slalom.

Thus by the time he arrived in Hollywood, young Whitelaw had already been a cavalry officer, Olympic athlete and wandering bluesman — a man armed with a mastery of seven languages, lethal tennis backstroke and striking good looks. It was hardly surprising that he rapidly found employment as assistant to David O. Selznick, not least on *A Farewell to Arms* (1957) and accrued an impressive roster of girlfriends. These included Afdera Franchetti, the Venetian Baroness and wife of Henry Fonda who introduced him to her step-daughter, only a few years younger than herself, the burgeoning actress Jane Fonda. The two immediately began a tempestuous on-and-off affair, albeit remaining friends forever after. On one occasion Whitelaw knocked at her door only to be greeted by "*Warren?*" An argument ensued with Whitelaw smashing a mirror whereupon Beatty himself turned up. "Instead of saying 'Jane, is this man bothering you?' he sort of said, 'Listen I know what you guys are going through. I once had a problem like that when I threw a bed out of the window in Philadelphia.'" Whitelaw finally broke into Fonda's apartment to steal her diary, "something I am not especially proud of … I thought she was out. Actually she was in her bedroom and scared I was a burglar so she didn't say a word. I wanted to read her journal, so I stole it and tiptoed out of the apartment." But it was all about her career rather than her lovers. "She was so neurotic and so self-involved, I didn't really like her … but I was sort of in love with her if that makes any sense."

Meanwhile Whitelaw's own Hollywood career was blossoming, not least working with Ray Stark as Associate Producer on *Night of the Iguana* (1964) for which he had to look after the star Ava Gardner.

> I was terrified … a nervous wreck meeting her again. I had a whole
> thing with Ava before Iguana. I had been sent over to see her in
> Madrid about her doing a movie. It was most bizarre, the whole

meeting. We went out, we had a long night on the town which ended up completely weird. And it ended up very badly with her screaming, "Why are they always sending faggots to see me all the time?!"

They ended up becoming very good friends, albeit not to the extent of many of Whitelaw's friendships with the opposite sex. "She was not my type, and I was not tempted to mix business and pleasure with her, but I liked her very much. I ended hanging out more with Burton and Taylor."

Whitelaw went on to act as Associate Producer on numerous other films including *Taras Bulba* (1962) starring Tony Curtis and Yul Brynner and shot for MGM in Salta, Argentina as well as John Huston's *Reflections in a Golden Eye* (1967). Whitelaw also knew *le tout* Hollywood, in all sorts of ways, battling off the ever persistent Montgomery Clift in the back of taxis—"Now Sandy, are you going to be my *real* friend?"—befriending Rosemary Clooney, aunt of George, and discretely dating everyone from actress Maggie Pierce to Jacqueline Bisset. Through Ilya Lopert of United Artists, Whitelaw moved back to London as Head of European Operations, where he continued his ever expanding collection of friends, celebrities and lovers, working with all the major talents of that time. "I always say I was responsible for Pasolini's death because I made him so rich with the *Decameron*." In Kenneth Tynan's journals of August 1971 we find a taster of Whitelaw's conversational versatility: "Dinner with Roman and Whitelaw. Sandy says he has made a list of countries in the world where it is possible to live a free and liberal life. There are five of them: Sweden, Norway, Denmark, Holland and Britain. And what do they have in common? They are all monarchies. This worries him since he is a convinced republican."

In 1975 Whitelaw directed his own first feature *Lifespan*, a science fiction mystery starring Klaus Kinski and the young Tina Aumont, described at that time by porn titan Tinto Brass as "one of the most beautiful women in the world." Indeed in a memorable

scene, Aumont is tied up naked in a "double helix" bondage knot, an image much reproduced throughout the S&M subculture. The film also features a specially commissioned score by Terry Riley, the inventor of Minimal music, whose self-sufficient album of this soundtrack *Le Secret de la Vie* (1975) has long been one of the composer's greatest rarities. One track in particular, "The Oldtimer," pays homage to Whitelaw himself as an affectionate nickname. *Lifespan* was shot in Holland and greatly inspired Polanski's own *The Tenant*, whilst the film has enjoyed a profitable afterlife as a cult DVD release. Its theme of immortality was particularly close to Whitelaw and indeed is the underlying leitmotif of his last, unmade script, "Time to Go." Whitelaw's second movie, *Vicious Circles* (1997) was perhaps less appreciated, a thriller starring Ben Gazzara set amongst a high-class prostitution ring in Paris, the city which by now Whitelaw had adopted as his home. Whilst Whitelaw only directed once more, as an anonymous contributor to the sexploitation romp *Vénus* (1984), he had by now become best known in the industry as the leading English subtitler of French films.

Whitelaw provided subtitles for over a thousand films, including such international hits as *Les Choristes* (2004) and *La Haine* (1995) and collaborated closely with Claude Lanzmann, who called him the "house gentile" or *goy de sérvice* on *Shoah* (1985), this work being published at the director's insistence as a book—the only subtitles to have ever received such an honour. Whitelaw was subtitler of choice for all the major directors such as Malle, Truffaut, Chabrol and Pialat, and on all the most challenging translations, such as the linguistically complex political comedy *Quai d'Orsay* (2013). Whitelaw even had a memorable long-running battle with Jean-Luc Godard over the nuances of his Shakespeare citations: "In the end I had to make a special journey all the way to Rolle just to close the issue and get my money from him." Whitelaw's work writing subtitles garnered him a modicum of celebrity; he was interviewed by the mainstream film magazine *Trois Couleurs* as well as *The Wall Street Journal* where he was quoted quipping

that it was "like getting paid to do crosswords." Whitelaw also adapted scenarios, translated scripts and worked as a language coach for actors, not least on set in Romania for *Amen* (2002) by Costa-Gravas.

Whitelaw enjoyed a separate long-running career as a character actor, working often with directors who were industry friends and who chose him, partly, for his resonant Hollywood associations. Thus in Wim Wenders's *The American Friend* (1977) Whitelaw stars along with other such movie mavericks as Sam Fuller, Nicholas Ray and Jean Eustache. In the celebrated French drama *The Beat That My Heart Skipped* (2005) he plays the mysterious music impresario Mr. Fox, and many of his role titles give some indication of his clandestine dark charms: Mr. Swift, the Arms Dealer, *un invité au bal noir*, Le Big Boss, the Vigil Man. For tall and thin as a Giacometti, with the ghost of a crewcut, signature black frame glasses and blue Cohiba haze, Whitelaw lent a classic touch to his many cameos, channeling something of the aura of a *mondain* hitman.

In real life, in so much as he deigned to participate in such a thing, Whitelaw was a connoisseur of art, design and wine, haunting the tertiary auction houses of Paris in search of bargains. One of his greatest coups was finding an original picture by Grace Kelly – someone he had known back in the day *bien sûr* – which he snapped up for only 128 euros, before selling it for 28,000 euros. Likewise as an oenophile he was expert at buying rare vintages for next to nothing, finding non-French wines at Bordeaux auction houses where they went otherwise neglected. In 1989 he met his one and only wife, Elisabeth Théret, a Chinese scholar and manager of the Pigozzi Contemporary African Art Collection, whose decades of difference in age would challenge one's discretion.

Elisabeth was his greatest treasure, next to the pleasure of a full wine-fuelled night with this master of long-range retrospective anecdotage. This was a man rightly at the centre of that game Six Degrees of Kevin Bacon, whose friends and accidental acquaintances ranged from Annie Liebowitz to Harrison Ford, who he'd

picked up as a teenage hitchhiker, "I just found Terence Mallick a dentist in Paris—a very *bad* one I'm happy to say." It is typical that when *Rolling Stone* magazine interviewed Mick Jagger about the song "Miss You" and its exceptional harmonica player, he revealed, "Yeah, Sandy Whitelaw discovered him playing in the Paris Métro." For Jagger well knew that Whitelaw was a personage who required no further introduction.

Alexander "Sandy" Whitelaw, filmmaker, actor and collector;
born London, April 28, 1930, died Paris, February 20, 2015.

ROBIN PAGE

MAXIMUM rock 'n' roll was kickstarted in October 1962 when the young Robin Page took his cherished guitar and threw it off the stage before brutally kicking it through the streets of London, down steps and pavements, until it was nothing but a bunch of twisted shards and strings. That this was officially an artwork, with the final fragments exhibited at the ICA, only made its nihilistic glee the greater. Entitled simply *Guitar Piece* (1962) this work is now celebrated as an iconic moment in both performance art and rock lore, its reverberations and *wah-wah* echo to be heard across the gamut of pop culture.

Page's piece is credited as the direct inspiration for the scene in Antonioni's *Blow-Up* (1966) where a band trash their instruments, as well as Pete Townsend's trademark guitar abuse and even the guitar theatrics of Hendrix. Thus in the dictionary of rock guitar legends there are only two Pages, Robin and Jimmy. Rock depends on gesture, visual pose as much as music, and Page's deliberate destruction of his own instrument—a cathartic expression of love and hate towards this symbol of his passion for music—struck a chord whose angry resonance still lingers. The art historical arc of this action might start with Picasso's fragmented Cubist guitars and pass through Dada's Cabaret Voltaire and such proto-punk acts as Bruce McLean's Nice Style band.

Page played music all his life, starting as a teenager in a band in British Columbia and busking as he traveled the world, but that was only one expression of his compulsively creative existence. Born in London in 1932, Page's father was a humorist who worked at Disney's Hollywood Studios; Page credited the Mickey Mouse artist's manual as his first introduction to abstraction, "Remember...his ears are always shown in profile." Brought up in remote logging country on the West Coast of Canada, Page became

something of a celebrity at Vancouver School of Art, not only for punching his professor but for his clipped beard swagger as an early Beatnik hipster. Later Page was the first to realize that this boho look had become a uniform and it would be more shocking to dress as a conservative businessman, in suit and tie—a style adopted long before Gilbert & George.

Page began as an abstract painter whilst supporting himself as a cartoonist like his father—a rare combination only shared by Ad Reinhardt. Young Page hitchhiked across Canada and Northern America and eventually came to Paris where he hoped to work with his heroes Yaacov Agam and Vasarely. Page actually achieved a certain success as a "hard-edge" painter, exhibiting in several seminal shows such as *West Coast Hard Edge* (1954), but his real flair for high jinx and theatrics naturally led him to the nascent Fluxus movement. In Paris, Page lived a genuine hand-to-mouth existence, busking with Peter Golding (later the inventor of "designer jeans") and dossing in a windowless closet at the notorious Beat Hotel. Becoming close to such artists as Robert Filliou, Dieter Roth and Dorothy Iannone, it was natural that when Page moved to London in 1962 and Daniel Spoerri organized the Festival of Misfits—a joint exhibition at the ICA and Gallery One—Page was asked to participate.

Likewise during the Destruction in Art Symposium (DIAS) of 1966, Page announced that he would tunnel all the way to Australia and set up his professional drilling equipment in the Better Bookshop, unfortunately hitting a water main long before the Antipodes. One of Page's other most celebrated works created during his London years was an impressive, large-scale chalk image of Joseph Beuys, complete with begging bowl, which Page drew on the pavement outside the National Gallery, and from which he finally earnt some money, albeit coins from tourists. Equally memorable performances included a table-top recreation of the Battle of Waterloo with toy soldiers and a running commentary from contemporary accounts, and a mock interview with a dying Vietnam GI, who could only drool and bleed to camera.

Despite numerous art school posts all over the world Page always found it hard to survive and most of his creative life was spent in a state of perfect penury worthy of Murger's *Vie de Bohème*. Page had a truly peripatetic existence, whether in Cologne, Leeds, Munich or Nova Scotia, and a truly marginal one also, despite his ever-supportive girlfriends and wives, photographer Raissa Smilis and Carol Hodgkins, not to mention his daughter Rachel. And despite participation in such prestigious shows as *documenta 5* in 1972, there was always a powerful feeling of frustration with the art world; after all Page was a man of many talents—a cartoonist, musician, highly talented figurative painter, hard abstractionist and key Fluxus performer, who never seemed to win full recognition. Much of this sense of amused grievance fuelled his last great creation when in 1987 he received a visitation from the spirit of Bluebeard, dyed his famous beard bright blue and began to to create the Bluebeard Amuseum Collection. How fitting that to mark Page's demise his family should have initiated the First Global Blue Beard Event with everyone encouraged to sport their own big blue beard, whether real or assumed, "Be silly and most of all have fun!"

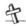

Robin Page, musician, painter and performer; born London, November 2, 1932, died Ganges, British Columbia, May 12, 2015.

TERRY SELLERS

TERENCE "TERRY" SELLERS was often confused for a man but only by those who had never met her, let alone been professionally tortured by her in her own dungeon, where gleaming high heels, wasp-waist corset and bustier made no secret of her fulsome femininity. For if Sellers was famous as an author, she was notorious as a longtime dominatrix, operating within a series of specialized bordellos or being flown around the world for highly remunerative sessions with a select clientele. Sellers's best known book, which appeared in numerous editions and languages, was *The Correct Sadist*, a lightly fictionalized guide to the best manner whereby to manage one's man, whether through handcuffs and chains or whip and needle—a useful tour of the potential weapons available to the more adventurous of the gentler gender in the battle of the sexes.

Sellers was also a key player in that rightly celebrated milieu of Downtown Manhattan at the end of the 1970s and beginning of the '80s, when bankruptcy, fear and urban degeneration made the city one of the most exciting and dangerous of cultural hotspots, a genuine "scene" to rival Weimar Berlin or Swingeing London. Sellers was a perfect fit with this tight-knit group of musicians, filmmakers, actors and artists, her special brand of well-groomed menace making her an immediate hit in this heady arena of drugs, darkness and decadence.

Like so many of that time and place, Sellers came from somewhere very different, in her case Washington, DC, and from a seemingly different era—a glamorous admixture of Sadean eighteenth-century France and secretarial 1950s middle America. Sellers became a student at St. John's College in Santa Fe pursuing Classical Studies—and indeed there always remained the polychrome trace of something vaguely Hellenic if not Sapphic

in her steely demeanour—before escaping to New York as soon as she could, aged just 19. This was June 1972 and Manhattan could not have been rougher, dirtier, more exciting or more stimulating, especially for this aspirant dancer who soon gathered a wide côterie of local admirers, from writer Kathy Acker to photographer Jimmy DeSana, with whom she created a series of memorable dungeon portraits.

For Sellers, as a muse and unofficial stylist, was responsible for a large injection of the S&M theme into the culture of that era, whether working with her close friend Anya Phillips on the graphic design and clothing for such bands as James White and the Blacks or modelling naked for her painter boyfriend Duncan Hannah. Sellers also acted herself in some of the most subterranean of the "underground" films that everyone then made, creating something of an immediate splash in *The Foreigner* (1978) by Amos Poe. Perhaps Sellers's best known appearance was as the striking cover model for *Buy*, the 1979 first album by James Chance and the Contortions, where she sports bright red lipstick on an otherwise blank white visage, stern shades and the shreds of a "deconstructed" bikini. Sellers even appeared in that seminal 1980 group exhibition, *The Times Square Show*, and her artworks—morbid keepsakes and candid snaps—had their own network of collectors.

But it was in 1981 with the publication of *The Correct Sadist: The Memoirs of Angel Stern* that Sellers won wider acclaim and an almost mainstream worldwide audience; the book was first, appropriately, issued in Germany under the deliciously Teutonic title *Der korrekte Sadismus* (ikoo-Buchverlag), and then went through several small press houses, including the nicely named V.I.T.R.I.O.L., before emerging with Grove in 1985, then at the height of its reputation. Published in French as *Ange de cruauté* (Diachroniques, 1990) and Italian as *La sadica perfetta* (Shake, 1996), this determinedly cult memoir was received with a deluge of reviews, attacks and counter-attacks, which built it into something more like a late-twentieth-century counter-classic. Sellers toured

extensively reading or rather "performing" the work everywhere from Skin Two nightclub and Jackie 60 to Columbia University, the Congress of the International Freudian Movement and Centre Pompidou. *Harper's Magazine* begged to publish a stand-alone chapter but Sellers viewed their bowdlerized version an insult and refused point blank the prestigious publication. Perhaps the only disappointment was that the original series of photographs by DeSana, intended to illustrate the book, had been eagerly snaffled instead by William Burroughs for DeSana's own work *Submission*.

Her book's high-strung sequence of linked autobiographical stories with titles such as "Basic Etiquette for the Slave," was the perfect vehicle for Sellers, who had been keeping detailed diaries since her precocious girlhood and whose literary jottings had already appeared in such local journals as *X* and *BOMB*. She also produced her own literary magazine, appropriately entitled *Verbal Abuse*, and later created a fetish website affiliated to *Penthouse*. Sellers continued to write, voluminously, for the rest of her relatively all-too-short life and there are large groaning box files full of manuscripts to be found in her archive at the fabled Fales Library Downtown Collection held by New York University. Sellers went on to receive an academic degree in Forensic Abnormal Psychology from John Jay College of Criminal Justice in New York and published various subsequent books, including *The Obsession* (V.I.T.R.I.O.L., 1986) and a follow-up to *The Correct Sadist* entitled *Dungeon Evidence* (Velvet, 1997) as well as a new introduction for the most recent edition of Richard von Krafft-Ebing's *Psychopathia Sexualis* (Solar Books, 2010).

Sellers also maintained a combustious online presence, launching her own exhaustive website back in 1998 and seemingly still running the show down on the Lower East Side even when relocated to rural New Mexico. Sellers's long-awaited final novel *One Decadent Life* is available online in installments and despite her premature demise at only 63, her place in the canon of transgressive American literature seems secure. As a longtime expert on

abnormal psychology and criminology. Sellers herself could only relish the irony that looking up "Terry Sellers" now inevitably leads to her homonym, a notorious multiple murderer and drug addict who longed to be known as a modern Bonnie and Clyde.

Terence "Terry" Sellers, writer and dominatrix;
born Washington, DC, October 5, 1952,
died Santa Fe, New Mexico, January 25, 2016.

TIM HUNT

"I want this place to be a cabinet of curiosities — a *Wunderkammer*" proclaimed Tim Hunt of his eponymous gallery devoted to tribal and contemporary art, opened in 2015 in a townhouse on East 73rd Street. Hunt was a delightful curiosity himself and as much *wunderkind* as *Wunderkammer* — a strikingly attractive, impeccably tailored English eccentric who at only 30 was whisked to New York to become a key player within The Andy Warhol Foundation for the Visual Arts. Due to this prominence as the sole official agent for Warhol's prints and photographs, many in Manhattan were not even aware of his previous career as an African and Oceanic art expert at Christie's, let alone the extent of his lifelong gallivanting.

His precocious demise was so sad not only because he was just 60, but also because he was the most charming, kind and witty individual imaginable, of whom nobody had one bad word, rare enough in the art world let alone that catty hothouse of the Warhol empire. With boyish floppy fringe, dazzling outfits and trademark specs, Hunt was a better bred hybrid of Austin Powers and Kingsman, and like them his taste for action was reckless. In this he was close to his brother, the racing legend James Hunt notorious for his drinking and womanising, neither of which Tim himself felt obliged to resist — perhaps a genetic disposition to addiction fuelling every sort of naughtiness. This, combined with an absolute disinterest in the boring obligations of self-preservation, proved comically insouciant and ultimately fatal. Whilst at Oxford, Hunt was a founder of the Dangerous Sports Club and as such boldly leapt off Clifton Bridge on a bungee cord, the first living human to do so, whereupon he was summarily arrested; he likewise fell foul of the law smuggling a skeleton onto the Cresta Run. These were genuinely perilous activities carried out with utter panache, the

familial thrill of the Hunt sadly leaving the fabled matriarch Sue to outlive all four of her sons.

Born in Cheam, young Hunt seemed the classic public schoolboy, from Wellington to Christ Church, always remaining some fresh-faced adventurer from another era. Hunt was *flanning* around Paris where he discovered tribal art: "You would run into it occasionally in people's apartments the way you didn't ever in London." This led to joining Christie's African and Oceanic team under the revered leadership of Hermione Waterfield and Bill Flagg. For much needed cash to help with girlfriends and recreational fuel, Hunt became a model for several campaigns including Bergdorf Goodman. All of this was bound to appeal to Fred Hughes, the head of Warhol enterprises, who he would see on trips to America: "If Fred was around I would just pop by, so I got to meet Andy and hung out with him as well. When Andy died Fred asked if I'd move…and help him sort his things out. So that's how the New York chapter began for me." And chapter it was if not triple-volume novel, as Hunt was installed at the late artist's house. "Andy had an enormous habit of collecting, just crazed—and a lot of that stuff was at the house." This painstaking inventory was all done with polaroids and legal pads, and included finding $14,000 of fresh cash in Warhol's bedside drawer, a classic moral quandary for any young researcher. Hunt's work culminated in a hugely successful Sotheby's sale whose $23 million windfall funded the Foundation where Hunt flourished.

He also married Tama Janowitz, that veritable downtown celebrity and bestselling author of *Slaves of New York*, and they became the most ubiquitous A-list couple, "team Tim and Tam." They also adopted a much adored daughter Willow, a laborious process involving many voyages to China, with whom they moved into an enormous terraced penthouse overlooking the Brooklyn Museum. That said, old habits died hard and his gallery was also nicknamed "Roselandia" after the sheer amount of rosé consumed there. Hunt still spent large chunks of his life watching soccer at Swift's bar or

Billy's Topless on Sixth Avenue, where for decades all the girls knew him by name and he was always capable of vanishing for days, his impossibly erratic timekeeping and lifelong ability to duck every sort of duty, from phone calls to meetings, only making him the more loved. This prevarication to the point of perversion meant that it took several decades to unpack his moving boxes, and when the stove broke he never got round to fixing it, cooking dinner for thirty on a single-ring hotplate instead. Last of the roll-up chain-smokers, Hunt was puffing till the end and likewise maintained his mordant wit, jesting with hospital visitors that they were only there because it was conveniently close to Sotheby's whilst concluding: "Really so many more people have come to see me on my deathbed than *ever* visited my gallery."

*Tim Hunt, art expert; born Cheam, England, September 22, 1957,
died New York City, November 26, 2017.*

JEF GEYS

“RURAL princesses, Penises, Bullet through window, Little crucifix in Mica, Jacket with military orders (St. Tropez), Masturbation vase.” Thus reads a sample from the *curriculum vitae* of Jef Geys—a handwritten chronological list of ideas, objects and actions, and numbered record of the variety and oddity of his oeuvre. Geys, who died aged 83, was the most ferociously local, political, funny and difficult of contemporary artists. Amongst this list number 287 stands out: “Blowing up the museum, 1970–71.” This was surely Geys's most notorious proposition, to dynamite the Museum of Fine Arts in Antwerp as a solo show; his plan typically included the fire brigade, Engineer Corps and a gunpowder factory in Balen, his adored hometown. Geys loved grassroots community activism as much as he loathed all larger institutions.

For a formidably political activist, Geys paradoxically found himself much honoured in later years by the Belgian state, representing his country at the 2005 Venice Biennale, producing stamps for the postal service, receiving the Flemish Culture Prize for Plastic Arts in 2000 and the Plastic Arts Prize of the Province of Antwerp in 2008. And you couldn't get more Belgian, as the equally Flemish younger artist Wim Delve comments: “Geys is a typically Belgian phenomenon, trickster artist, rural philosopher, an individualist rebel and strong and interesting artist.”

Born in Leopoldsburg where he only spoke the local dialect, Geys soon moved to Balen, a town of twenty thousand less than 20km from the Dutch border, which he made his proudly provincial HQ for a highly global career: “It's your environment that turns you into an artist.” For thirty years he taught art or “Positive Aesthetics” at the all-girls school, creating an immense map of the world in the yard and taking his students to meet Marcel Broodthaers in his studio. And it was with these children in 1964 that he first formulated

Women's Questions, a list of key demands about every aspect of femininity, eventually translated into every possible language. Geys also took over the freely-distributed community newspaper *Kempens Informatieblad* literally making it his own and publishing a special edition for all of his exhibitions.

Geys's CV began at age 13 at the School of Christian Brothers and he was clearly influenced by their didactic and democratic spirit and their commitment to social justice, Geys himself seemingly having taken the vow of poverty if not obedience. Asked by the city of Münster to contribute to their Skulptur Projekte, he was so impressed by the city's churches he had nothing to add himself, instead providing elevated platforms so visitors could inspect their facades up close. Curiously, pleasingly, whilst labeled "conceptual," Geys was clearly talented at drawing and painting, one of his earliest projects being the *ABC, École de Paris* (1959–61) in which he acquired the rules of drawing through a correspondence course. Likewise every year since 1963, Geys realistically painted on panel his annual *zaadzakjes* or seed bags — "Those little seed bags that are sold in the shops are attractive, but when you sow them you never get the result promised on the bag."

Geys loved the plant world and all rural resistance, strongly believing that *il faut cultiver notre jardin*; weeping as he burnt old letters to use as fertiliser; planting free cabbages for everyone; or driving his own homegrown sprouts round Belgium in his 2CV to show them the land as if they were tourists. His project for the Venice Biennale was an inventory of urban weeds with special properties, a work reprised in Detroit in 2010 with an ethnomedical specialist. Typically these shows were accompanied by a special edition of *Kempens Informatieblad*, the proceeds being donated to the Catholic association Caritas to help homeless people and refugees and generating some ten thousand euros.

Likewise whenever he had a commercial show (and despite his condemnation of "the mafia which calls itself the international art trade" and refusal to attend his openings, there were many) one

work would be donated to his gallery and others to a local charity. Geys's creativity was fecund and manifold: he developed the first adult colouring book in 1963, invented "*Fruitlingerie*," ran his own *Bar 900* and seven late-night drinking venues throughout Flanders, and was even long-rumoured to run a brothel to support his artistic activities. Being a passionate cycling fan, he determined to follow the Tour de France in 1969, thus photographing the first victory of his compatriot Eddy Merckx. And considering Geys organised a two-person exhibition of his work with that of a fourteen year old with a similar name, he was doubtless amused by the recent emergence of his exact homonym "Jef Geys," a physiotherapist and former professional cyclist.

In 1977 he built his own house with bare hands and salvaged materials, writing his name on the doorstep and putting it in the inventory: "Did it become a work of art when I put my name in the fresh mortar and gave it a number?" For Geys was always obsessively documenting, archiving, photographing every aspect of "the serial, monotone passing of time." He published an enormous book, *Al de zwart-wit foto's tot 1998*, which was five hundred pages in random order of all his black and white photographs until 1998, followed by *Day and Night and Day…* (2002), a thirty-six hour slideshow of some forty thousand photographs. In 2015, the Frans Masereel Centre started to publish his vast archive, two thick volumes with more than eight hundred scanned documents of past projects presented without explanation or hierarchy. Or as Geys put it conclusively in his distinctive handwritten capitals, "I'VE ALWAYS BEEN INTERESTED IN THE TRUTH BEHIND THINGS, THE MOTIVATION, GOING BACK."

Jef Geys, artist; born Leopoldsburg, Belgium, May 29, 1934, died Genk, February 12, 2018.

CLAUDE LALANNE

"IT is strange, we never changed ourselves…we are still doing exactly what we always were." Claude Lalanne played her own bafflement with pitch-perfect innocence; for how had this bohemian Surrealist, an artisanal craftswoman in her Chinese peasant jacket, horny-handed everyday metalworker, gardener and cook become a fabulously wealthy fashion icon?

At her death aged 93, Lalanne was suspiciously close to being a celebrity, certainly a point of reference for anyone who wanted to prove their own status within that modish zone where fine art, design and haute couture mingle. "Claude," her first name alone was a code word to a certain world, like using just "Jacob" rather than Rothschild—proof of membership.

But even with all their recent retrospectives and books Les Lalanne, Claude and her husband the late François-Xavier, still remained a shared cult secret. Famous yes, but only amongst the right people, their furniture, sculpture and jewellery traded and treasured amongst an international elite—the last exhausted fumes of the jet set, the final crust of *le gratin*.

The paradox was that for decades nobody had been willing to take Les Lalanne seriously within the contemporary art circuit and yet their credentials were nonpareil; as young and poor artists

at the fabled Impasse Ronsin, they were friends of not only Brancusi but also such Surrealists as Max Ernst, William Copley and Dalí, with whom Claude collaborated, as well as an entire generation of emerging avant-gardists from Yves Tinguely and Niki de Saint Phalle to Jimmy Metcalf and Larry Rivers, even cooking steaks on their studio stove for Yves Klein.

If the Impasse Ronsin was the founding myth of the Lalanne cult, their compound at Ury outside Fontainebleau was where we devout disciples had flocked for decades—a simple farmhouse in the simplest of villages where, behind a long stone wall Claude and François-Xavier maintained separate studios and an enviable communal existence. Having moved here at the prompting of Tinguely there was no shortage of local artist friends like Marcel and Teeny Duchamp and Jackie Matisse, nor adjacent grandeur whether de Ganay or Noailles, and the house soon became famous for its parties, a veritable flotilla of limos heading south from Paris in the night.

Les Lalanne were the ultimate exemplars of Picasso's dictum to live as a poor man with lots of money, the modesty of their world being a lesson in the taste that wealth alone can never purchase: whitewashed walls, wonderful art, warm worn furniture and an entirely personal *goût* impossible to replicate. An anonymous wooden door opened up to this enchanted private domain, with its crawling alligator, a baboon standing guard in the courtyard and a little gate leading to an enfilade of gardens, each wilder than the last and inhabited by a menagerie of sculpted beasts and benches, cast flora and patinated fauna.

Since the death of François-Xavier in 2008 Claude had enjoyed a full decade in which to really blossom into her own, increasingly recognised as just as creative, inventive and industrious as her late husband and indeed perhaps the more ambitious and worldly of the two, her energy and acumen seemingly redoubled as she hit her 80s. This ferocious work ethic—heading into her atelier no sooner than she had risen to spend the day solving the practical problems of her latest chair, necklace, chandelier or staircase—was the core of her personality. But it was mitigated by a most honest and open hospitality: this perfect hostess with her homegrown fruit and vegetables, suitably good bottle of Bordeaux and posey of garden flowers, ended every meal with her own justifiably famous *tarte tatin*.

Some could find her altogether *formidable* for she suffered fools badly and was easily wearied by the devious demands of

photographers and hagiographers, capable of turning frosty at the slightest perceived slight, her full *froideur* being a winter unto itself and impossible to thaw by mere flattery alone. It was also probably true that she preferred male company, often homosexual and of deliciously old-fashioned bitchiness, and took the slightest sadistic delight in teasing and tweaking, promoting and demoting, her private court.

Despite her petite presence Claude was a genuinely strong woman, physically, emotionally and practically, and her beauty— still notable even in old age – was of another era. Likewise her manner of speaking should really have been preserved like a rare threatened species, a mellifluous, high-pitched sing-song with an echo of vanished aristocratic diction; she had a voice designed for the telling of naughty stories and juiciest gossip, irresistible in its intimacy, "*et alors, mes chéris…*"

A highly attractive woman, it was hardly surprising Claude had gathered a considerable fan club around the world for whom any invitation to Ury was achievement in itself. And her uniquely con-fident style – cowboy boots and Maoist tunics, men's white shirts with paint brushes in the hair – had always proved irresistible to her many friends in high fashion from Christian Dior *lui-même* to young Karl, her lifelong soulmate Saint Laurent and an entire sub-sequent generation of designers, from Tom Ford and Marc Jacobs to Maria Grazia Chiuri.

After lunch Claude would retire to her white sofa where with Texan heels crossed high, cigarette at a jaunty angle and devoted dog she would trawl for the latest tittle-tattle, speed dialing one of her infinitely indiscrete friends whilst toying with a precious broach or cuff link, lifting it towards one with a teasing twinkle, "do you think you might like…?"

One of my last memories of Claude was of her digging wild cyclamen from her garden to give me, she herself wielding the spade with a determination that belied her 90-something years – a clod of black sod with the prettiest white and purple flowers,

costing nothing yet meaning everything. For surely it was a central metaphor of her personality that she took the natural, the soft and yielding, leaves, branches, flowers and by a process of galvanisation made them hard, strong and inflexible, her own admixture of the gracious and indomitable.

"Why not have this?" she might say and the generosity was not in the market value of the piece pressed upon one but in the initial generosity with which Claude had made it, the inherent act of "offering" which is the essence of all art-making—each artist's "gift" in every sense and one here accepted and acknowledged with suitable gratitude and admiration, grief.

Claude Lalanne, artist; born Paris, November 28, 1925,
died Fontainebleau, April 10, 2019.

ADRIAN DANNATT

"**D**OOMED" and "famous" were two favourite terms much bandied by Adrian Dannatt and he managed, to various degrees, to be both of them during his own existence. For having conspired to become genuinely famous as a teenage thespian — the sort of fame where he would be chased down the street for autographs — he proved largely doomed in any subsequent attempts to recapture nary a glimmer of such limelight, that curse of the child star ensuring the fustian obscurity of his later years. Never one for a career as such, and recoiling in horror from any question of "what do you *do*," Dannatt seemed to drift through a limbo of fecund ideas and abandoned initiatives, cunning schemes and failed coups — a fragile craft weighed with sunken dreams and lost promise.

Born in 1962 at home in the recently gentrified purlieu of Canonbury, North London, his parents were classic representatives of such a place and era: his father the highly-respected modernist architect Trevor Dannatt, his mother Joan an artist and art advisor at J. Walter Thompson. Such immediate family were certainly promising, his maternal grandfather being the Welsh writer and editor Howell Davies, his other grandfather being a well-known philatelist and photographer, and his Uncle George a music critic and painter; there was even a "Dannatt" butterfly named after a

distant relative, not to mention a great-grandmother directly related to Robert Louis Stevenson.

However unlike his elder sister Clare, the young Adrian proved an immediately disruptive and provocative charge—his consistently naughty behaviour made him the despair of all his teachers at his primary school, his prep school The Hall and the newly established crammer Trevor-Roberts from which he attended Westminster, where he was soon again the bane of the system. Great curiosity, verbal liveliness and a fine memory were subverted by wild outrage, anarchic insubordination and inappropriate levity, the sort of borderline ADHD Tourette's which today would ensure massive Ritalin.

Having answered an advertisement for a "cheeky boy" in his local paper *The Islington Gazette*, Dannatt found himself auditioning—reading along with Jodie Foster—for Alan Parker casting his first film *Bugsy Malone*, and though he did not gain this part actorly ambitions were clearly stoked. Thus when he spied another advertisement in the newspapers for the lead part in *Just William* he immediately responded with a suitably ink-splattered missive and after a series of auditions, including a group of television executives coming to watch him play the young Adolf Hitler in a school production, the part was his.

Just William ran for several years and was highly popular, ratings reaching nine million viewers, and with a Christmas Special, book tie-ins and a sing-along concert with The Wombles, Dannatt found himself seriously famous. His fellow thespians included everyone from Diana Dors and Freddie Jones to the young Julian Fellowes in one of his first roles, and James Jebbia the founder of Supreme.

Sadly, nothing again could ever match such grandeur, and as far as the British public was concerned Dannatt had soon vanished without the faintest trace into that final Dantean circle of child actor oblivion. A spell as stock-taker at Rowney's art shop ended ignominiously whilst tray and trolley duties as a breakfast waiter in the labyrinthine corridors of the Royal National Hotel did little

to advance his larger renown. Seeking more vibrant pastures, he visited Manhattan for the first time in the summer of 1981, staying at the infamous Marlton Hotel along with fellow resident Mickey Rourke, and appearing as an extra in a Japanese pop video and the cult film *Liquid Sky* (1982).

This was the beginning of a lifelong addiction to New York (not to mentioned long rumoured addictions to harder pleasures) and his obsessive all-night clubbing, at the height of that city's glorious decadence, set a hedonistic pattern that was to continue. Indeed Dannatt always remained a surprisingly good dancer, briefly employed as a gyrating youth on the 1980s music show *The Tube*.

Dannatt attended St. Chad's College up in Durham, an all-male theological seminary of a strictly Uranian bent, an Anglo-Catholic enclave of reactionary aesthetes who celebrated the then-illegal Tridentine Mass and where he was invited to join "Baps," a clandestine High Tory dining club. Dannatt had already tiptoed into journalism, topical quips for *Harper's & Queen* perhaps flatteringly comparable to those *faits-divers* of Félix Fénéon. Further journalism followed and having twice in a row been a finalist in *Vogue's* Talent Contest, Dannatt was dogged by such hack work for the rest of his life, banging out more jaunty prose over the long decades than is probably good for anyone. Having worked as a publicist for Gay Men's Press and written for *The Face*, he was recruited for the UK launch of *Elle* in 1985 — a decidedly good era to be involved in fashion magazines — and then became a producer at the BBC before being sacked after fisticuffs on stage at the Edinburgh Festival. Thus by the precocious age of 23, Dannatt had already been an actor, editor, writer and producer, bowing out from the world when most others began.

Living in an old-fashioned flat in Fitzroy Square, Dannatt was seemingly mainly devoted to the pleasures of life — a committed clubber of that period whether at Taboo, Delirium or the Mud, whose love of the sensual, of wine and women bordered on excessive. Thus it was hardly surprising that when in 1989 Dannatt

met his future wife on one of his regular visits to New York, she should have first assumed he was some sort of drug dealer. This was Delphine Burrus, the undoubted love of his life, whose stability and grace—not to mention her family's relative fiscal largesse—rescued him from the rockier shores of his rackety life. An artist and animator who had fled bourgeois Paris for Parsons, Delphine moved with Dannatt to Milan for his last actual employment as editor of *Flash Art*, and they subsequently lived together within that ever pleasing triangle of New York, Paris and London. There were also occasional sojourns in the Sologne, where they had been married in the village church in 1992, a union soon blessed by a daughter Maxine and son Louis.

A surely inherited taste for collecting—his father and uncle and their own father having been active collectors—led to an early bibliophilic passion followed by a most curious assembly of diverse artworks governed by the most recondite of interests and rock-bottom financial considerations. Similarly his impressive collection of clothes, including over two hundred shirts of the most fabled provenance, was only of interest because it had been assembled for so very little money, as a devotee of charity shops, junk stores and tertiary auction houses. That these books, paintings, sculptures, clothes and antique chairs were stored all over the world amongst long-suffering friends, acquaintances and family only added to their gypsy allure. For surely one of Dannatt's largest collections was of people, the odder and more improbable the better, and he certainly had no objection should they happen to own a small stately home or indeed any form of potential free accommodation. Always one for extremes, Dannatt was excited to speak to anyone anywhere which could lead to inappropriate or even dangerous acquaintance; and it must be admitted that reactions to his own personality tended to be equally extreme, instantaneous dislike being quite as frequent as lifelong amity.

Though he always claimed to have no interest in travel, Dannatt had somehow visited some distinctly exotic spots, including

Pyongyang, the Antarctic, Uluru and Zanzibar, all seemingly with no visible means of support. Likewise though he happily bemoaned his lack of achievements he had actually done far more than met the eye, whether publishing the occasional poems and short stories, writing architectural and artistic monographs, serving as Editor-at-Large of the New York literary journal *Open City* or placing a cartoon in *The Spectator*. Even his thespian ambitions were not entirely thwarted, with roles in various avant-garde artist films and voice-over work, though his big comeback remained achingly elusive.

Dannatt had latterly found work as a "curator" of exhibitions, at leading New York galleries such as Kasmin, as well as a rather grand antique shop on Jermyn Street, and such alternative Paris spaces as castillo/corrales and Shanaynay (where he exhibited the work of his own imaginary conceptual group The Three) or presenting Pop artist Robert Indiana at Frank Lloyd Wright's Price Tower in Oklahoma. But above all else it was the surprising fate of his volume of collected obituaries, titled after his favourite words "doomed" and "famous," which stood as some sort of concluding testimony, as he wrote at the very end of his own obituary, the final entry in the book, "like Max Beerbohm's Enoch Soames, this was a life haunted by its own inherent fictionality, a figure better suited to the pages of some minor novel of another era than to the brutal realities of everyday life in the twenty-first century."

Adrian Dannatt, resting thespian and occasional scribbler;
born London, August, 29, 1962.

Note to Page 188

It is a paradox of our times that to write about someone like Coston, a self-proclaimed anti-Semite seems somehow almost illegal, such is our current discretion and timidity, whilst at the same time horribly topical. We seem reluctant to even admit such a thing exists, or fear that we will be ourselves implicated by association, whilst in reality such spectres have now returned to haunt us with a vengeance. Once, long ago there existed blatantly, proudly, reactionary organisations such as The League of Struggle Against the Emancipation of Women or the Imperial League Against Social Democracy whose very titles seemed so archaic as to be comic and whose failure seemed self-evident. Indeed when my obituary of Coston was first published in 2001 he seemed a figure from an entirely vanished era, an improbable anachronism, and yet some twenty years later he is altogether representative of a certain political extremism which has become mainstream, if not quite legitimate, throughout much of the world. Yet simultaneously we have adopted various codes and niceties to try and guard against such evil spells, that if we do not name them ourselves, if we carefully skirt around the use of certain words, the badness itself will evaporate in compliance.

A Note on the Type

Originally this book was to be set in Palatino, not only a pleasing old-style serif typeface first launched in 1949 but also happily appropriate to the father of the publisher, namely Jean Claude Abreu, whose fabled family house in Cuba was named Quinta Palatino and where indeed he resided at the time of this typeface's invention and dissemination.

However, with the wisdom of our designer Mr. Kaplan this has been firmly changed to Firmin-Didot, an attractive font which is equally, curiously, appropriate to our publisher Miguel Abreu who has maintained a long friendship with both Laetitia and Charles Firmin-Didot, of the selfsame family.

The other typeface deployed has been chosen specifically for its "doomed" character, this being The Doves, which was "bequeathed" or thrown to the River Thames by the disgruntled publisher T. J. Cobden-Sanderson and only rescued from the mud bed by divers one hundred years later in 2014.

Acknowledgments

Some of these obituaries were previously published in different forms and different places including *The Art Newspaper, Artcritical, The Independent* and *The Elizabethan*, not least thanks to the excellence of such editors as Jamie Fergusson, Chris Maume, David Cohen, Katharine Robinson and Donald Lee.

The essay on Iolas first appeared in the catalogue *Alexander the Great: The Iolas Gallery 1955–1987* published by Kasmin Gallery, New York in 2014.

Acknowledgment shall also be happily made to the following: to the architect Liza Fior for a lifetime of friendship and laughter; to my darling wife Delphine Burrus for putting up with such curious characters – myself included – for the last thirty years; to Peter Nolan Smith "Famous for Never"; to Sam Hodgkin for sustenance of every sort; to Katrine & Danny Moynihan for their hospitality; and to the late Paul Kasmin for higher inspiration and amusement, not to mention actual occasional employment. To Duncan Hannah and Megan Wilson for their generosity, not least the Welsh-Collage-Hut on Dean Street; and to their Brooklyn neighbor, the great Hugo Guinness, without whom this book would have been hopeless, his inspired drawings proving invaluable; to the all-knowing designer Geoff Kaplan who worked with my ever dazzling editor Katherine Pickard on shaping and polishing this book – very much her book. Along with Pickard much gratitude is due to her copublisher at Sequence Press, namely the rightly revered gallerist, film-maker, editor, philosopher and enthusiast, last of the Cuban Marxist intellectuals, of course, Miguel Abreu. And to the Living Obit team, our designer and digital guru Dominic Latham Koenig and above all to our founder and chairman, that pan-international Chelsea-Swiss entrepreneur, film producer, art collector and philanthropist, the "Elon Musk of the Aveyron," Monsieur James Velaise, who so helped make this book happen, in every sense.

Nothing in this book is derived from the use of Google or Wikipedia.

Living Obit.

If you enjoyed this book you might well consider having your own obituary written by the same author—and whilst you are still alive. Living Obit is a service that provides a roster of top professional writers from whom you can choose your own personal memorialist.

Your designated biographer will then devote themselves to crafting a unique long-form essay all about yourself, working closely with you to create the pitch-perfect summation of your existence. Likewise, should you be searching for the strangest present ever, for that proverbial person who already has everything, Living Obit offers a special gift package guaranteed to cause surprise if not consternation. Yes, we look forward to shaping your story and celebrating your life so far in immortal prose.

Welcome to the future of your past.

www.livingobit.com

L - #0081 - 010720 - C0 - 216/140/17 - PB - DID2861223